Design for Business
Volume 2

First published in the UK in 2014 by
Intellect, The Mill, Parnall Road, Fishponds, Bristol,
BS16 3JG, UK

First published in the USA in 2014 by
Intellect, The University of Chicago Press, 1427 E.
60th Street,
Chicago, IL 60637, USA

Copy-editor: Michael Eckhardt
Production manager: May Yao
Typesetting: Holly Rose

Print ISBN: 978-1-78320-376-5
ePDF ISBN: 978-1-78320-377-2
ePub ISBN: 978-1-78320-378-9

Printed and bound by Gomer, UK

Creative Director
Ken Cato, AO

Design
Cato Brand Partners
www.catobrandpartners.com

Photographers
David Simmonds
Sandra Curtis
Callum Broom
Georgina Leeder
Stanley Taylor

Publisher
Intellect © 2014
Bristol, UK

Commissioning Editor
Kristin McCourtie

Production Editor
Luke Farrugia

Editor and Book Series Editor
Gjoko Muratovski

The goal of this conference is to improve professional design practice…Together, we advance; informed by research and enlivened by the rich dialogue that takes place at this event.

Foreword by Ken Friedman

The Design for Business Research Conference began with a simple thought: research has become increasingly significant in the world of business; therefore when designing products, services, experiences and processes we need today – as well as the organizations and systems that create them – research, scholarship and experimentation must inform designers' work.

As simple as this idea may seem, it is difficult to bring it into being. The working life of a design firm is a never-ending cascade of deadlines, projects and activities, and client budgets rarely stretch as far as we'd like them to. For better – and sometimes for worse – 'good enough' must do. But that's still a problem. As Danish-Australian designer Per Mollerup writes, 'Good enough is not enough'. The difference separates leading firms and first-rate designers from the rest of the pack.

As one of Australia's leading designers, and the prime mover behind agIdeas, Ken Cato decided there ought to be a way forward. His idea was to bring working designers and working researchers together in the context of the agIdeas Research Conference.

Since the first conference in 2010, the conference has grown immensely, and participants now come from across Australia and around the world to join us in Melbourne. While the majority of participants are researchers – as expected at a research conference – others come from industry. What is interesting is the breadth of research, the fact that some of our researchers work in industry, and the fact that more working design professionals have become interested in the conference and what we publish.

Building a conference takes time. A good conference develops over time: it necessitates finding a community at the same time as helping to build it. This process takes several years. We are no longer a new conference. Now we are growing towards our next stage.

The Design for Business Research Conference is interesting for the variety of topics that our papers address – and the variety of perspectives that they represent. There is a great deal of work to be done in the next few years in terms of answering questions which designers have previously solved purely through artistry and rules of thumb. The goal of this conference is to improve professional design practice.

The Design for Business Research Conference is a part of agIdeas Melbourne International Design Week – Australia's leading professional design event and one of the largest design events of its kind in the world. The conference is a part of this concept, and this sets the context for our contribution. Together, we advance; informed by research and enlivened by the rich dialogue that takes place at agIdeas.

Ken Friedman, Ph.D., D.Sc. (h.c.), FDRS

University Distinguished Professor
Swinburne University of Technology

Advisory Board Co-chair
Design for Business: Research Conference

The research presented in this book is the outcome of the Design for Business: Research Conference that was presented by agIdeas in April 2013 as part of Melbourne International Design Week, Australia.

agIdeas is one of the longest running and most highly respected design programs in the world. Celebrated Australian designer Ken Cato, AO, annually curates the program of events – held in Melbourne – with support from an advisory group of 50 international design leaders.

agIdeas aims to raise awareness about the power of design by exploring the differences it can make both within the field and beyond. It is unique in its diversity, its scale, its audience groups and its commitment to showcasing international design excellence.

This series of events caters for people from all areas of society:

- For designers who strive for excellence in creating innovative solutions based on an understanding of the multiplicity of human existence; who have a desire to draw on knowledge and research across disciplines; and who execute work with diverse, disruptive and adaptive creative practices.

- For businesses who want to create advantage by learning from some of the best examples of design-led innovation.

- For secondary school students who want to pursue a career in the creative industries.

- For design and business researchers who want to share rigorous knowledge in the area of design for business.

- For primary schools that want to develop creative problem-solving skills.

- For a community that demands a world that looks and works better.

agIdeas makes connections between those seeking innovation and some of the foremost creative minds on the planet – their ideas, their products, their services and their processes.

The program presents:

- A three-day design forum consisting of 40 speakers across disciplines, attended by 2500 designers.

- A business breakfast attended by 500 business and marketing executives.

- A design and business research conference attended by 200 design and business researchers.

- A secondary school careers forum and expo attended by 2500 secondary school students.

- A children's workshop attended by 600 primary school children.

- Open studios, workshops, panel discussions, public installations and exhibitions in collaboration with other organizations and cultural institutions available to the entire audience of over 100,000 visitors.

Since its inception:

- 580 of the world's leading designers have presented.

A G I D E A S 2 0 1 3

R E S E A R C H C O N F E R E N C E

Design For Business
Presented in association with Swinburne University of Technology
and The Victorian Government

- 100,000 delegates have attended events.

- 2300 have come together at the social gatherings.

- 52 young designers have benefited from travelling scholarships.

- 4800 volunteers have helped organize and stage the events.

- 400,000 people have visited its public exhibitions.

agIdeas is based on the premise that:

Great design makes a difference.

- Great design is a creative problem-solving strategy that results from the synergy between the rational and the intuitive, based on a deep understanding and focus on its end user. It is strategic and creative, allowing for innovative solutions that help us to see, interpret and be in our world differently.

- Design links creativity and innovation, providing opportunities to improve productivity and economic prosperity, and preserve and improve our standard of living.

- Great design comes from people who are capable of seeing differently, drawing on diverse knowledge and expertise, and combining the rational and the intuitive.

- Great designers require an understanding of the multiplicity of human existence, the desire to draw on knowledge and research across disciplines, and who have diverse, disruptive and adaptive creative practices.

- Great design comes from a community that demands a world that looks and works better. Firms that apply design as a strategic business capability generally outperform those that do not.

- Any community that wants to make the most out of its future in a world of limited resources needs a strong design culture at its core.

Our aim is to contribute to a strong and vibrant design culture. This book is a part of that.

Kristin McCourite
Manager and Director: Design Foundation

'Design is about solving everyday problems by overcoming limitations, challenges and constraints in a creative way. In a society that plans for its future in a world of limited resources, design certainly matters'.

Dr Gjoko Muratovski

Design matters: An introduction by Gjoko Muratovski

For the average reader of this publication, the question 'Why design matters?' is an unnecessary one. Yet, for most people, design remains an exotic profession focused on making beautiful things. Aesthetics is a part of design, but design is much more than that. Design is about solving everyday problems by overcoming limitations, challenges and constraints in a creative way. In a society that plans for its future in a world of limited resources, design certainly matters.

In order to make this message even clearer, we (the Design Foundation and agIdeas International Design Week) have partnered with the Victorian Department of State Development, Business and Innovation to establish 'Design Matters: Melbourne International Design Week' – a carefully curated program that celebrates international design excellence. Our goal is to build on Victoria's existing status as a national design hub in Australia so that it may become an international design centre.

For the time being, it seems that we are halfway there. Victoria already has a rich history when it comes to design. We only need to look around to see the bustling freeways, innovative buildings, advanced public transport, shared co-working spaces, stylish homes and high-quality locally-made products to realize that design is embedded in many aspects of the lives of the Victorians. Needless to say, agIdeas International Design Week has been held in the heart of Melbourne for over twenty years. But, there is potential for much more than this.

According to the Victorian Government, the design industry is a significant contributor to the Victorian economy, with an estimated 195,000 Victorians employed as designers or in related roles. While Victorian firms spend AUD$7.3 billion annually on design, research indicates that persuading non-users of the value of design remains a challenge.

That is why last year the Victorian Government released 'Victorian Design Initiatives 2012–15' – a AUD$10 million commitment to support best practice design in Victoria, grow awareness of design, build business capability and foster excellence in design skills. Central to these initiatives, the Government has launched the Design Matters public design program, which celebrates and promotes good design in Victoria, and which is also a sponsor of the agIdeas International Research Conference: Design for Business. The purpose of the Design Matters program is to emphasize the importance of businesses' use of design and the corresponding economic and community benefits, as well as to increase Victoria's national and international profile in design-led thinking.

The Victorian government understands that design is not just about aesthetics: design is an important business capability and a strategic resource. Companies that apply design as a strategic business capability generally outperform those that do not. By bringing together creativity and innovation, design provides companies with opportunities to improve productivity and economic prosperity, it helps our society to preserve our standard of living, and it allows us to plan for a sustainable future.

Our conference program works well with this initiative. A range of designers, marketers, business entrepreneurs, economists, academics and researchers have come together to share one common idea: the role of design in business. The result was an exciting day-long conference that transcended disciplinary boundaries and inspired audiences. Needless to say, the 2013 conference was a major success. We have registered yet another record attendance, and received some of the following feedback from the audience:

- 91.9% were satisfied or very satisfied from the conference;

- 93.4% agreed that the content and speakers were of a high quality;

- 97.8% see this conference as a good opportunity to review the work of their peers; and

- 100% agree that the conference met their academic requirements.

Based on the advice of the international experts that make up our review panel and advisory board, we make sure that we select only the best research papers. We strive for the highest quality, and for us this means a 90 per cent rejection rate of submitted proposals and papers. Every paper has gone through a rigorous double-blind review process by up to three reviewers who are experts in the topic of the paper. Another thing that makes this conference even more exciting is that we invite special guests, such as Per Mollerup, Quan Payne and Dan Formosa, to be a part of the conference and to join our conversation.

This year, Per Mollerup joined us as a keynote speaker. Per is a distinguished Scandinavian designer and author of numerous design books, including *Data Design: Visualising Quantities, Locations, Connections* (2013), *Wayshowing>Wayfinding: Basic & Interactive* (2013), *Brandbook, Branding / Feelings / Reason* (2008), *Wayshowing: A Guide to Environmental Signage* (2005), as well as the bestseller, *Marks of Excellence: The History and Taxonomy of Trademarks* (1997 / 2013), which has sold over 40,000 copies

worldwide. His keynote talk on simplicity in design is included here in this book.

Quan Payne, the former Global Art Director for Nike for the London Olympics and Director for Digital Sports Initiative of Nike+, joined the conference live from New York over Skype to co-deliver a presentation with me on Nike's design and marketing strategies for the London 2012 Olympics. Transcripts from Quan's talk, and from an additional interview conducted with him just weeks after the London Olympics, are presented here, as well as a case study I wrote on Nike's ambush marketing practices, which was based on conversations with Quan.

Dan Formosa, a New York-based design consultant and design researcher, and founding member of the iconic Smart Design studio, joined me for an onstage interview and Q&A session. Den is an award-winning designer who holds a bachelor's in product design, and a master's and doctorate in ergonomics and biomechanics. Over the course of many years, he has been working with companies such as Ford, HP, Johnson & Johnson, LG Electronics, Microsoft, and many others. Dan was also a part of the design team that worked on the very first IBM PC back in 1977. He is also behind the world's first Masters in Branding degree at New York's School of Visual Arts. A transcript from the conversation with Dan is also included in the book.

There are number of other works that are included in this volume, such as Stuart Gluth's essay on the importance of a research-led design practice in typography; Julian Major, Aoi Tanaka and Jenni Romaniuk's paper on colour and brand identity; Emily Wright's paper on packaging design testing methods;

Robert Crocker's study of greenwashing, sustainability and communication design; Nina Terrey's case study of organizational management by design; Gerda Gemser, Giulia Calabretta, Nachoem Wijnberg and Paul Hekkert's paper on strategic decision-making in new product development; Jan Jervis and Jeffrey Brand's research on how Australian businesses are hiring designers; and Elaine Saunders, Jessica Taft and David Jenkinson's exciting case study on the design partnership between the hearing aid company BHS and the design studio Designworks that has revolutionized this health-care sector.

As always, we aspired to bring together many different perspectives, research methods and practices from around the world. The authors presented in this book have a wealth of experience working for leading universities, academic publishers, international corporations and research centres, or highly innovative design practices. We hope that you will find their work interesting and engaging in the same way that we have found it.

Enjoy reading.

Gjoko Muratovski Ph.D., M.Des., BA (Des), Dip (Des)

Head of Department: Communication Design Auckland University of Technology

Chairman Design for Business: Research Conference

Book Series Editor: Design for Business

Per Mollerup
Swinburne University of
Technology

Prof. Per Mollerup is
Professor of
Communication Design at
Melbourne's Swinburne
University of Technology.
With an MBA and a
doctorate in design, he
previously served as a
Professor at the Oslo
National Academy of the
Arts, Norway. For 25 years
prior to that, Per ran
Designlab, a renowned
design office in
Copenhagen, specializing
in branding projects and
wayshowing systems. He is
the author of several books
on branding, wayshowing
and design.

'Simplicity should be part of the current design thinking conversation'.

Professor Per Mollerup

The missing link? Keynote address by Per Mollerup (edited transcript)

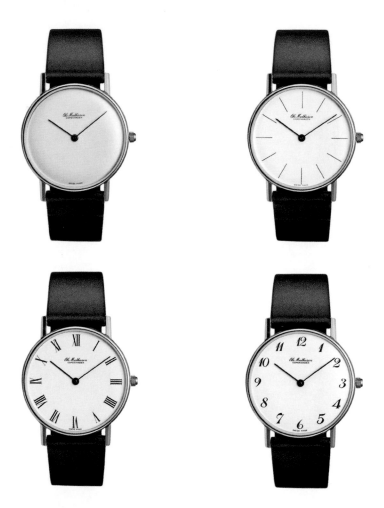

Top Left, Top right, Bottom Left, Bottom right

Figure 1: OM watch without hour markings, 1965 (Design Ole Mathiesen; Mfr. Ole Mathiesen, Copenhagen).

Figure 2: OM watch with strokes, 1962 (Design Ole Mathiesen; Mfr. Ole Mathiesen, Copenhagen).

Figure 3: OM watch with Roman numbers, 1962 (Design Ole Mathiesen; Mfr. Ole Mathiesen, Copenhagen).

Figure 4: OM watch with Arab numbers, 1962 (Design Ole Mathiesen; Mfr. Ole Mathiesen, Copenhagen).

The Missing Link?

The design thinking conversation has so far included such elements as how designers think, what kind of problems designers attack, how businesses should think, elements of economic thinking, and probably more. What has not been included are the results of designers' thinking. One reason for this conspicuous omission could be that we cannot generalize about solutions that include such disparate categories as credit card systems, wheelchairs, mobile music players and baby napkins.

But in fact, we can. The difference between Herbert Simon's (1969) proverbial present states and preferred states is simplicity. Good design makes life easier; it makes it simpler. By design, we simplify our lives.

That sounds simpler than it is. Simplicity is not just simplicity. It is not that simple. Simplicity is a complex and complicated concept. With simplicity, we fight a dragon with two heads: one is complexity, the other is complication. Complex means consisting of many interrelated elements; complicated means difficult to understand and analyse.

Simple is an antonym – a word that expresses the opposite – of both complex and complicated. 'Simple' means not complex and not complicated. Complexity is an objective, observable fact; it can be counted and measured. Complication, on the other hand, is a highly subjective matter. What is complicated to one person may be simple to another. What is complicated to someone who has not learned mathematics may be simple to someone who has. Complication, and by implication simplicity, are personal matters.

Being the antonym of both complex and complicated, simple is both an objective and a subjective quality. That is confusing. Most of the time, complexity and complication relate as cause and effect. 'A large work is difficult because it is large', said Samuel Johnson (1755, para. 83). The London Tube map is more complex and, however well-organized, more complicated than the transit map of the Copenhagen Metro. On the other hand, the Tube map does not become less complicated because you remove some parts. At some point, an ambitious information designer deleted the River Thames; the Tube map is slightly more complex with the Thames than without, but it is less complicated. It is easier to read and understand. In this case, added complexity reduces complication.

In most instances, complexity increases complication. Sometimes complexity even decreases complication. Have a look at the watch in Figure 1. The dial is very simple. If we make it slightly more complex – as in Figures 2, 3 and 4 – it becomes slightly less complicated to read. The watch without strokes or numbers is both more and less simple than the watches with strokes or numbers. That is confusing. The problem resides in the language. While we distinguish between complex and complicated, these words share one antonym: simple.

A more articulate language would split the monolithic word 'simple' into two simples with the necessary semantic distance. One simple would be the opposite of complex; the other simple would be the opposite of complicated. For the time being, I suggest quantity-simple and quality-simple. Quantity-simple is the opposite of complex. Quality-simple is

the opposite of complicated. The watch without strokes and numbers is quantity-simple yet complicated. The watch with numbers is complex yet quality-simple. Complexity is modern human context. If we want to reap the benefits of modern society, complexity is an intrinsic part of the deal. The trick is to limit the complication that so easily follows from complexity.

In his recent book, *Living with Complexity,* Don Norman (2010) discusses our need for complexity. He rightly states that complexity is a fact of the world, while complication is a state of mind. The book has been presented as an attack on simplicity. That is a 50 per cent wrong conclusion, which is caused by the missing distinction between quantity-simple and quality-simple. Accepting complexity does not necessarily mean defying simplicity. It is a question of good design to domesticate complexity by quality-simple solutions.

Oftentimes, we need complexity. A cyclist needs several gears to adjust to changes in road gradient and wind conditions. The gears give the bicycle the requisite complexity that allows the cyclist to maintain optimal movements by changing the distance that the bicycle advances per pedal stroke. Requisite complexity is not a carte blanche to add complexity to any design. Added complexity should be the result of carefully weighing the pros and the cons. Requisite complexity does not necessarily mean complexity presented to the user. In many cases, the designer chooses between shamelessly showing off complexity and politely hiding complexity behind the simplest possible foreground. As such, simplicity is distributed differently.

Functionality is our prime motive for seeking simplicity. The functionality of any tool or appliance includes three levels, each of which can be more or less simple. These levels are: visible affordance, readability, and operation. A tool's 'affordance' includes everything the tool can be used for. A tool's 'visible affordance' stands for the way the tool or appliance tells us what it can be used for, i.e. a printer, a photocopier or a fax machine. 'Readability' deals with the way the tool or appliance explains how it should be used. The simplest tools tell us without words how they should be used. User instructions are often repair design.

Oftentimes, products achieve a simple appearance at the expense of visible affordance and readability. The product does not reveal its use, what it can be used for and how it should be dealt with. Closet doors without visible hinges and without handles may appear extremely simple in terms of aesthetic appearance, but not in terms of first-time operation. In such instances, simplicity is distributed in favour of appearance, and at the expense of visual affordance and readability. The third level of a tool's functionality deals with the physical operation of the tool. Can we use the tool skilfully almost immediately? Or will it, like a violin, take years of study and practice before we can use it with some proficiency?

Difficult physical operation often makes first-time users insecure. Am I turning the handle in the right direction, or did I misunderstand the instruction? The iconic Citroën DS is a case in point. However original it appeared when it was first exhibited, the Citroën DS looked like a car. The visible affordance was OK. Readability was also OK. After the very first

introduction, the Citroën DS is easy to read and ride. Operation, however, implies more than use under perfect conditions; it also includes situations where smaller or greater parts of the appliance must be readjusted, repaired or replaced. Citroën DS owners know what I mean.

The simplicity of a tool is partly a subjective quality. To some degree it depends on the mental capacities of the user. In turn, these capacities depend on the user's practical experience with the tool in question and other similar tools. Things are simpler to the experienced user than to the beginner. Simplicity favours the prepared mind. The more we practice, the easier the work becomes. The problem is that in many cases we never get the critical experience because we only meet the situation once or a few times in our life. We remain beginners. Tools to be understood and handled by beginners must be designed with this in mind.

Users do not have time for learning.

When users do not have time to learn, but must understand and act intuitively, designers should go for simple simplicity. This is the case in many emergency situations. Designers of life rafts and other equipment for use in emergency situations design for instant understanding.

Users do not want to spend time on learning.

In other situations with less stress, users may not find it worthwhile to enter a longer learning curve, because the situation will probably not appear again. Again, designers will go for simple simplicity. For example, my Australian bank goes for simple simplicity. In their online banking, they do not take for granted that their customers can type or want to learn to. They therefore present the keys of the digital keyboard in alphabetical order. After all, they think their customers are literate.

Users want to invest in learning.

There are many situations where users are prepared to invest the necessary time and effort to learn something so well that they will find it simple. For most people it is OK to use days to learn to type. Owners of mobile phones find it worthwhile to use a few hours to become friends with their new darling. In these cases, designers will go for advanced simplicity.

Advanced simplicity means that the design requires previous learning or experience. Advanced simplicity takes advantage of this previous learning or experience, and enables the user to work more efficiently. iPhone and other smartphones go for advanced simplicity in two ways: (1) users must invest some time in learning to use that specific model; and (2) users should already be familiar with a typewriter keyboard. The digital keyboards use the qwerty pattern. Even the slim BlackBerry, where each mechanical key stands for two letters, uses the qwerty pattern. Sometimes a product should include both simple and advanced simplicity. Computer software often does that. It offers pedestrian ways to be used by beginners, and shortcuts to be used by experienced users.

Several kinds of electronic communication and entertainment devices follow two apparently contradictory trends. They get more and more functions, and they become smaller and smaller.

While there seems to be no lower limit for the size of electronics, the user interface must have a certain size to accommodate the demands of the human eye and, when appropriate, fingers. One apparent solution is to structure the control in hierarchical layers.

One watch has ten different functions, each addressed by one of ten dedicated buttons. It has a broad (shallow) information structure. Another watch has ten different functions, all addressed by one multifunction button that can be operated through layers in ten different modes. It has a deep information structure. Which watch has the simplest visual appearance? Which watch is the simplest to operate? Broad structures involve operation in space; deep structures involve operation in time.

The introduction of multifunction controls for deep information structures can cause problems to the users. Not all buyers of BMWs were enthusiastic when BMW introduced the iDrive system.

Manipulating a silver knob in a panel between the front seats, the driver has access to more than 700 functions dealing with driving, security, comfort and entertainment. What was meant as simplification was experienced by many users as complication. Deep information structures tend to have longer learning curves than broad solutions. Website designers also choose between broad and deep solutions. Google goes for a deep solution, whereas, surprisingly, website expert Jacob Nielsen and visual display expert Edward Tufte feature broad solutions on their websites. Simplicity is distributed differently.

The importance of simplicity in design increases steadily as life becomes more complex. Simplicity has always been an essential part of good design thinking. It should also be part of the current design thinking conversation. Splitting the monolithic simple into two words would be a good start.

References

Johnson, S. (1755), *A Dictionary of the English Language*, London: W. Strahan.

Norman, D. (2010), *Living with Complexity*, Cambridge, MA: MIT Press.

Simon, H. A. (1969), *The Sciences of the Artificial*, Cambridge, MA: MIT Press.

Stuart Gluth
University of South
Australia

Stuart Gluth has a master's degree from the prestigious French typographic research institute Atelier National de Création Typographique, as well as a teaching degree and an undergraduate qualification in industrial design, which has given him a rigorous approach to design methodology. He has published a number of papers on factors affecting the legibility of type, including type for print, the computer screen and signage. Prior to this, he headed design studios for the University of Melbourne and TAFE Queensland, and taught at the Queensland College of Art (now Griffith University). He is currently Studio Head of Graphic Design at the University of South Australia, and has published a number of papers on the creative application of knowledge.

Typography and research-led design practice

Typographic design practice continues to evolve by making use of theory, research and analysis in a design process that could lead to more effective visual communication. This includes knowledge available in physiology, psychology and neurology concerning the way we see, the way we read, the way the brain interprets the visual word, and the way that the brain is structured by its experience through learning and the culture of reading. This study will acknowledge that typography functions within cultural and aesthetic expectations that often include considerations to social, aesthetic and human factors. With this in mind, typographic design will be described as a model of visual communication design that needs to be driven by research, and not by personal preferences or fashion – as is often the case in practice.

Keywords
typography
research-led practice
integration of theory and design practice

Introduction

As businesses want their design to be effective in achieving its ends, the advantages of having design decisions made in the service of business and industry based on the application of underlying knowledge in the discipline appears to be self-evident. In the past several decades, the importance of design as a strategic business resource has become increasingly recognized. This can be seen in emergent concepts such as 'design thinking' and 'design management', which have been introduced in various business schools as methods of thinking that can improve the economic performance of many business endeavours (Poyner 2009). This highlights new challenges and possibilities for designers, and also calls for new thinking as to how designers engage with the business community, as well as how they may apply rapid changes in both culture and commerce.

It has now become even more important for designers to be able to effectively communicate and articulate their knowledge, and the research on which their design decisions are made. What we also need to keep in mind is that business ends are not always monetary – at least not directly. They may include improved communication or enhanced 'perceived' quality of products and services through various design elements, and these can be as important as the quality and function of the product itself. In addition, there are many organizations that are not for profit, such as government and various NGOs; however, they still may rely on the same design principles and practices as their commercial counterparts.

If designers had to 'know' everything about a given design problem in order to provide appropriate design decisions for these organizations in a complex and fast-changing environment, they would be overwhelmed. Instead they will need to know what processes to go through to find the needed 'knowledge' rather than rely on what they already know or what they have done in the past. Their practice will need to be based on research into the nature of the problem, the diversity of possible solutions, and how innovative use of media, materials and processes can be used to create possible approaches, while continuously reviewing and verifying that they are achieving what they have set out to do. Responding to this creative uncertainty, designers need to make sense of how these things interact with each other and change in a fluid way (Muratovski 2006). This emphasizes the need for a knowledge of process – i.e. how to go about it rather than what to do – and the need to know how to find out what is needed and what can be done through the application of research.

As an example, we may consider the explosion of information over the Internet and social media, where many of the print conventions have been adapted without question or curiosity as to their suitability for the medium, its resolution or the different ways in which it is used. Typographic design, in this case, needs to be based on informed decision-making, not on the personal preferences of the designer or the current design trends, nor on what the client thinks looks nice or what they think their customers may like. These are decisions that designers need to make based on grounded knowledge of the problem that they are trying to address. In line with this, Mike Press (1995: 1) claims that many practitioners consider that 'design […] has no theory and thus no research methodology of its own to understand itself'. He goes on to comment that designers seem

to be unaware of, or do not base their design decisions on, the underlying theory or knowledge of design at all, or they do so on a superficial level. According to him, it seems that design practitioners are often unaware that this knowledge exists, or they do not see that theory and research is a part of the design practice too. This will need to change.

Typography and practice

An observation into the practice of typographic design indicates that design decisions are frequently made on the basis of a knowledge that is gained through experience, or on a knowledge that is being transferred by lecturers to students in a classical master/apprentice fashion. Examples include the common belief that capital (upper-case) letters are more legible for signage such as street names or traffic signs, and the belief that serif typeface is more 'readable' than sans serif as text. These are perhaps the most obvious examples of things commonly accepted as 'established' by many typographic designers, but which have been discredited by later research (Gluth 2006a) or changed with revisions in familiarity (Gluth 1999; Pelli et al. 2006).

In the past, there have also been a number of examples of uncritical research methods applied to typographic design, some of which, unfortunately, are still commonly referenced in the literature. Examples of these include unverified statistical analyses such as that employed by Colin Wheildon (1990), where the divisions between data were deliberately manipulated to exaggerate the differences between the test results for the variables.[1] There has also been a lack of rigorous experimental methodology,

as can be seen in a number of examples in Herbert Spencer's book *The Visible Word* (1969).[2] For example, one traffic signage legibility test describes a situation where seats were arranged on the back of a truck, which then drove away from the signage, measuring the distance at which the subjects judged that they could no longer read it. This is a debatable test because the subjects already knew what the sign said. Another test for legibility consisted of laying signs out on a table and 'measuring' which one the subject was first attracted to read, but this test failed to consider the effect of proximity, different angle of view, etc. Then there is the so-called 'shaking table' test for the legibility of text, which measures whether people can read a text if it is placed on a shaking table. This test might actually be useful for the testing of text that is to be read on a train, but otherwise it is of very little use. In addition to this, even legitimate rigorous research can be incomplete or misleading when adopted out of context. For instance, recently there have been a number of articles published by psychology researchers that have documented work that appears to show that text set in type that is more difficult to read is more effective for short-term retention (Diemand-Yauman, Oppenheimer and Vaughan 2010; Hernandez and Preston 2013; Song and Schwarz 2008a, 2008b). Although it may be true in a limited context, I find this very contentious, especially when I am aware of the wider context of what is being communicated. My concern includes the effect on the reader when something is more difficult to read beyond merely making them remember it, possibly only for a short while. My question is: How will this influence their attitude and retention over time towards the same information?

An example of this may include a television advertisement that deliberately uses low production values and is disturbingly repetitive. This certainly gets you to remember the product name, but also informs you unconsciously that the product is of equally low quality. In this case, the long-term effects on learning and attitudes created in the reader have not been fully considered.

While many decisions in typographic design may be made on the basis of information or ideas lacking in authenticity or applied without critical thought, there is a credible body of research about legibility and reading which can be used to justify or discredit design decisions. Typographic design can be highly effective when it is placed in the context of research-led design practice, especially because we are able to measure many typographic efficiencies related to reading by relatively simple means, such as the time it takes for a text to be read, the distance at which we can read signage accurately and the quantity of retention. Reading is an important element that needs to be considered in typographic research, because this is a process that involves at least three distinct human characteristics. Firstly, there is the physical structure of the eye, which includes focus, movement, sensation and resolution. The very small part of the eye that is high enough in resolution to decipher type, the fovea (only about 15 per cent of the visual field), is seen as a major limitation for the speed of reading due to the need for repetitive saccadic jumps between focusable areas of text (Dehaene 2009; Pelli et al. 2007). Secondly, perception is the neurological structure and processes that allow the information to be resolved, interpreted, remembered, made sense of and stored.

As Dehaene (2009) and Pelli and Tillman (2007) point out, this 're-assembly' of the 'bits' that the eye sees is an incredibly complex and multifunctional process, but is essentially the same whether you are reading Mandarin or English. Thirdly, there is the psychology of perception relating to cultural experience, conventions, socialization and human learning, such as the ability to recognize and read poetry or traffic signs, Arabic or Latin, or decipher the Kanji writing system.

One of the critical characteristics we need to consider is the 'non'-conscious nature of reading. We no longer sound out or read all the letters of a word, or even a familiar phrase, as we did when we were learning to read. The black squiggles on the page are directly transferred into ideas in our brains without us being aware of the process. The process has become 'unconscious' (Dehaene 2009). In fact, it becomes very difficult to read if you try and make yourself aware of the process while you are reading, as it intrudes dramatically into our ability to absorb the ideas, thus indicating how non-conscious it has become. By the same token, 'subliminal advertising' was thought to be effective because the subconscious does not have any values; it is unable to judge things (Key 1974; Loftus and Klinger 1992). While this belief is now much more contentious (Bargh and Morsella 2008; Thurgood et al. 2010), this possibility may be particularly germane to the non-conscious process of reading, which may be seen to be an equally 'vulnerable' process. This may be true of many such human factors and cultural values. Then again, based on personal observations I can also say that many designers tend to ignore these issues, adopt them unquestioningly or are

simply not aware of them.[3] For that reason, designers need to consider what happens when the reading process is interrupted by poor legibility or readability, or how this can affect people's non-conscious evaluation or attitude to what they are reading.

Typography and research

While there is a history of somewhat ambiguous 'research' into typography, there is also a history of considered and thoughtful research. In an emergency or potentially unsafe situation – medical instructions, for example – we obviously need information to be presented as efficiently as possible. This also includes traffic or street signage, which needs to be read as accurately and quickly as possible so that the driver's eyes are off the road for as short a period of time as possible, while also ensuring the information is read accurately. There is considerable research (e.g. Bigelow and Matteson 2011) in these areas that may be very valuable to designers, even if just as a starting point. There is some research into the legibility of computer interfaces (Gluth 2004, 2006b; Vinot and Athenes 2012) and printed design (Gluth 1999) which could also help in making design decisions in the somewhat neglected above-mentioned areas.

Miles Tinker (1944) established very early on that readability (the ability to read easily) was directly related to legibility (the ability to clearly distinguish each letter from any of the others). He also demonstrated that serif type was read more quickly than sans serif. At that time, serif letters were used for text almost exclusively, so readers were certainly much more familiar with reading serif text. With the wisdom of hindsight, and through using design analysis (Gluth 1999) and modern technology (Pelli

et al. 2006; Sheedy et al. 2005), we can reason that the letters in sans serif type have greater contrast with each other than serif letters. Pelli et al. (2006) established that the less complexity a letter has (measured as the smallest ratio of the perimeter to the area of the letter), and provided it maintains its basic geometry, the more legible it becomes. In fact, this simplicity increases the visual differences between letters by increasing the differences in the negative spaces inside and between the letters (Gluth 1999). The reader's 'familiarity' with the letters is yet another thing that needs to be taken into account (Wong et al. 2011). Analyses of global writing systems from a westerner's perspective show that many of them tend to be very repetitive and lacking in contrast (Coulmas 1989; Ostler 2005), yet billions of people read these written languages with apparent ease. Whether some of these languages are harder or easier than others for native readers is a moot point, yet even though most visual languages have at least some inefficiencies and redundancies, they do function effectively. Then again, Dehaene (2009) argues that it is precisely these redundancies that carry subtle but important functions when it comes to readability.

There are many questions about how these kinds of factors, such as preference versus readability, affect the way we read and whether we remember it in the short or long term; as well as whether we like or dislike it, whether or not we are motivated by it, recognize it as truthful, important or authoritative, and so on. For example, in a basic research exercise into readability conducted at the University of South Australia with randomly selected participants, the readability of the text was set in a variety of different typefaces, variables and settings, including serif and

sans serif types. One test included a small group of about eight to ten mixed-gender 'middle-aged' subjects that were asked which they preferred and felt they read more easily. At the same time, we were testing how quickly they read the piece of text that was presented to them. The subjects said they preferred and thought that they read the serif type more easily, but our measurement showed that they read the sans serif faster. It has been established very early that text that is read faster is more readable (Tinker 1932).[4] The above example indicates the importance of rigorous testing, in addition to the great care needed to be taken between what is tested and the differences between the kind of opinions that might be arrived at by focus groups and what is verifiable fact. This is also an interesting indication of human factors (preference against efficiency), which may affect the readers' attitude towards what is read. Indeed, are they more likely to read something that is set in a typeface that they think is easier to read or which they prefer?

These issues indicate the importance of carefully establishing the nature of what designers are trying to do, and determining how they will know when they have achieved it, rather than just thinking that they have. Therefore, the main research question should be: How can we make people like what they read? How can we make the text appear authoritative? Or how can we make the text more efficient? While designers need to know what they want to communicate in order to determine how to achieve it, they also need to know how they can verify that this has been achieved.

Research-led practice for design

Designers searching for inspiration often read design magazines or analyse some existing solutions for similar problems to what they are dealing with. More commonly, practicing designers prefer to 'look' at design magazines rather than read research-based journals. As a result, the market is overflowing with design magazines that understand this desire to 'look' rather than 'read', and therefore they do not even explain the process behind the design, do not set out the methods and the reasons behind the design decisions, nor validate how effective the outcome has truly been. This is a very common problem in the design field. Typically, designers judge their worth by the awards given by their peers rather than whether it worked for the audience. Unfortunately, this culture tends to lead to superficial design outcomes.

Research, on the other hand, is an activity that results in new knowledge. In design, research is most effective when the gained knowledge is applied to design practice. When research is used as the basis for design decisions that generate innovative design solutions, this can be seen as a contribution of new knowledge to the field – yet the research behind the design process and its verification also needs to be communicated.

This applies to the following four parts of the design process:

- *Analysis:* What is the problem? Is it actually what the client thinks it is? This might include asking who the audience is and what the best way would be to reach them and communicate with them.

- *Synthesis:* How will the designer reflect on the problem? Creative idea generation is a focused, disciplined and verifiable process. This is not an artistic exercise.

- *Production: How can materials, media and processes be used in new ways?*
 Verification: Has the goal been achieved, or has something been made better by going through these processes? This may not necessarily be in a linear way, but perhaps by revisiting all steps in all possible ways and combinations. A possible consequence may be that the very process of verification changes what we set out to achieve (Cross and Cross 1995; Swann 2002)

Conclusion

The 'old' perception of creativity as an artistic, individual, specialized and inborn practice is changing. There is a new understanding that acknowledges creativity to be collaborative, community-based, cross-disciplinary, teachable and germane to most areas of human activity (McWilliam 2007). The role of the designer is no longer to know what to do in practice, but has become to know what processes to apply in order to arrive at effective possibilities. The most important aspect of this may be the use of research to inform practice. If designers are to function as communicators, idea managers and problem-solvers, a much greater depth of knowledge as to what design is and how it can achieve an effective outcome will be needed. To do this, designers need to apply rigorous research in their practice. Their education – both at design school and in practice – will need to focus on making available readings and resources that are relevant to and focused on effective design practice, rather than on assumed knowledge and self-reflection. To achieve this, designers need to create structures that expect this method of working from the very beginning of design practice, as well as during education in high schools, primary schools and even pre-schools. It should be understood that design is not art, but a creative problem-solving approach that is purposeful, disciplined, focused, structured and verifiable; not an individual process, but community-based and widely applicable one. Typography design in particular should not be developed for one situation or time, but will need to be flexible, adaptable and changeable for a future that has not been thought of yet. Most importantly, it should be driven by research.

References

Bargh, J. and Morsella, E. (2008), 'The unconscious mind', *Perspectives in Psychological Science,* 3: 1, pp. 73–79.

Bigelow, C. and Matteson, S. (2011), 'Font improvements in cockpit displays and their relevance to automobile safety', Paper presented at the *Society of Information Displays 2011 Vehicle Displays and Interfaces Symposium,* University of Michigan-Dearborn, Dearborn, MI.

Coulmas, F. (1989), *The Writing Systems of the World,* Oxford: Blackwell.

Cross, N. and Cross, A. C. (1995), 'Observation of teamwork and social processes in design', *Design Studies,* 18: 3, pp. 143–170.

Dehaene, S. (2009), *Reading in the Brain: The New Science of How We Read,* London: Penguin.

Diemand-Yauman, C., Oppenheimer, D. and Vaughan, E. (2010), 'Fortune favours the bold (and the italicized): Effects of disfluency on educational outcomes', *Cognition,* 118, pp. 111–115.

Gluth, S. (1999), 'Roxane: A study in visual factors affecting legibility', *Visible Language,* 33: 3, pp. 236–253.

Gluth, S. (2004), 'Designing text for the screen: Setting out the criteria for the legibility of type designed to be read from the computer screen', Paper presented at *'Futureground' Design Research Society International Conference,* Monash University, Melbourne, Australia.

Gluth, S. (2006a), 'Design factors affecting the legibility of text on the screen', Paper presented at *'Wonderground' Design Research Society International Conference,* Instituto de Artes Visuais, Design e Marketing, Lisbon, Portugal.

Gluth, S. (2006b), 'The legibility of street signs', Paper presented at *'Wonderground' Design Research Society International Conference,* Instituto de Artes Visuais, Design e Marketing, Lisbon, Portugal.

Hernandez, I. and Preston, J. L. (2013), 'Disfluency disrupts the confirmation bias', *Journal of Experimental Social Psychology,* 49: 1, pp. 178–182.

Key, B. W. (1974), *Subliminal Seduction: Are you Being Aroused by this Picture,* Upper Saddle River, NJ: Prentice-Hall.

Loftus, E. and Klinger, M. (1992), 'Is the unconscious smart or dumb?', *American Psychologist,* 46: 6, pp. 761–765.

McWilliam, E. (2007), 'Is creativity teachable? Conceptualising the creativity/pedagogy relationship in higher education', in *Proceedings 30th HERDSA National Conference,* University of South Australia, Adelaide, Australia.

Muratovski, G. (2006), *Beyond Design,* Skopje, Macedonia: NAM Print.

Ostler, N. (2005), *Empires of the Word: A Language History of the World,* New York: Harper Collins.

Pelli, D., Burns, C., Farrell, B. and Moore-Page, D. (2006), 'Feature detection and letter identification', *Vision Research,* 46, pp. 4646–4674.

Pelli, D. and Tillman, K. (2007), 'Parts, wholes and context in reading', *PLoS ONE,* 2: 8, e680. doi: 10.1371/journal.pone.0000680

Pelli, D., Tillman, K., Freeman, J., Su, M., Berger, T. and Majaj, N. (2007), 'Crowding and eccentricity determine reading rate', *Journal of Vision,* 20: 7–2, pp. 1–36.

Poyner, R. (2009), 'Design thinking or critical design', Lecture given at the Australian Graphic Design Association, Melbourne, Australia, 12 August.

Press, M. (1995), 'It's research, Jim...', in *Proceedings of The European Academy of Design; Design Interfaces Conference,* University of Salford, UK.

Sheedy, J., Subbaram, M., Zimmerman, A. and Hayes, J. (2005), 'Text legibility and the letter superiority effect', *Human Factors,* 47: 4, pp. 797–851.

Song, H. and Schwarz, N. (2008a), 'Fluency and the detection of misleading questions: Low processing fluency attenuates the Moses illusion', *Social Cognition,* 26: 6, pp. 791–799.

Song, H. and Schwarz, N. (2008b), 'If it's hard to read, it's hard to do: Processing fluency affects effort prediction and motivation', *Psychological Science,* 19: 10, pp. 986–988.

Spencer, H. (1969), *The Visible Word: Problems in Legibility,* New York: Hastings House.

Swann, C. (2002), 'Action research and the practice of design', *Design Issues,* 18: 1, pp. 49–61.

Thurgood, C., Patterson, J., Simpson, D. and Whitfield, T.W.A. (2010), 'Development of a light emitting diode tachiscope', *Review of Scientific Instruments,* 81: 3.

Tinker, M. (1932), 'The relation of speed to comprehension in reading', *School and Society,* 36, pp. 158–160.

Tinker, M. (1944), 'Criteria for determining the readability of typefaces', *Journal of Educational Psychology,* 35, pp. 385–396.

Vinot, J. L. and Athenes, S. (2012), 'Legible, are you sure?: An experimentation-based typographical design in safety-critical context', in *Proceedings of the 2012 ACM Annual Conference on Human Factors in Computing Systems,* Austin, TX: ACM, pp. 2287–2296.

Wheildon, C. (1990), *Communicating or Just Making Pretty Shapes.* Newspaper Advertising Bureau of Australia, Sydney, NSW, http://alexpoole.info/wp-content/uploads/2012/03/wheildon-1990.pdf. Accessed 23 January 2012.

Wong, A., Bukach, C., Yuen, C., Yang, L., Leung, S. and Greenspoon, E. (2011), 'Holistic processing of words modulated by reading experience', *PLoS ONE,* 6: 6: e20753. doi: 10.137/journal.pone.0020753

(Endnotes)

1. I later wrote to him to ask to see his original data so that we could evaluate it with more legitimate statistical analysis, but he claimed to have lost it. I still see this paper published from time to time in general magazines and referred to in online blogs, with people uncritically accepting the assertions in it.

2. This publication contains an extraordinary bibliography of over 450 references for early research into legibility, including nearly 100 references for Miles Tinker's publications between 1926 and 1965.

3. For example, we are not consciously aware of what makes someone or something beautiful or ugly: the proportions, symmetry, shape, health, fertility, etc. We just 'unconsciously' think they're beautiful or ugly.

4. Miles Tinker was perhaps the first modern rigorous and objective researcher into the legibility of print, and possibly also the most prolific.

Julian Major
Ehrenberg-Bass Institute
for Marketing Science,
University of South
Australia

After completing his
degree in marketing and
communication, Julian
Major joined the Ehrenberg
Bass Institute in 2011 as a
research associate. Julian's
research areas include
word of mouth, the role of
distinctive assets in
branding effectiveness, and
brand health tracking. His
work has been published
by the Australia and New
Zealand Marketing
Academy. In addition to his
academic publications,
Julian has worked on a
number of projects for
clients at the Ehrenberg-
Bass Institute.

Aoi Tanaka
Ehrenberg-Bass Institute
for Marketing Science,
University of South
Australia

Aoi Tanaka is a current
student undertaking an
honours degree in
marketing at the
Ehrenberg-Bass Institute
for Marketing Science at
the University of South
Australia. She originally
obtained her bachelor's in
media arts, where she
learnt digital design
principles and pursued
marketing as a sub-major. a

Jenni Romaniuk
Ehrenberg-Bass Institute
for Marketing Science,
University of South
Australia

Prof. Jenni Romaniuk is
Associate Director
(International) of the
Ehrenberg-Bass Institute
for Marketing Science, and
a Research Professor of
Brand Equity. She has
published for a wide range
of journals, including the
*Journal of Business
Research*, the *European
Journal of Marketing* and
Marketing Theory. As well
as her academic paper
contributions, she also has
a regular column in the
*Journal of Advertising
Research* called 'Marketing
Matters', and serves on the
journal's editorial board.
Alongside her academic
research, she regularly
consults with industry
clients around the world in
the areas of brand equity
strategy and metrics, word
of mouth, advertising
effectiveness and buyer
behaviour modelling. This
gives her a unique
perspective that is both
academically rigorous, but
also grounded in the
practicalities of
implementation in the real
world.

The competitive battleground of colours, logos and taglines in brand identity

Colours, logos and taglines can become distinctive assets when the majority of consumers uniquely link the element to the brand. These links help consumers to recognize brands on shelves, and provide extra cues in advertising to remind us of the brand being advertised. Brands will ideally want 100 per cent uniqueness so that the element is only associated with their brand. However, individual elements, such as colour, can be linked to multiple brands.

Our research examined the competitive nature of colour, logo and tagline associations. Drawing on three data sets in the alcoholic beverage category, we found logos were generally the best way to create unique associations, followed by colours and then taglines. This was possibly due to the rich sensory attributes that are available in visual elements, and the greater flexibility to create unique logos rather than drawing on an existing palette of colours. This research has key implications for how brand managers choose what types of brand elements to use and invest in.

Keywords
brand identity
branding
distinctive assets
colour
logo
tagline
uniqueness

Introduction

A brand's identity comprises two broad areas: the first is the brand name (e.g. Coca-Cola); the second group consists of the sensory cues that signal the brand name to consumers. These include colours, logos, packaging shapes, fonts, sounds, music, taglines, characters, celebrities and advertising styles (Hartnett 2011). If an element is sufficiently strong to evoke the brand name in a consumer's mind, it can be considered a distinctive asset for the brand, as per Romaniuk and Hartnett (2010).

Romaniuk and Nenycz-Thiel (2013) refer to two dimensions of distinctive asset strength: fame/prevalence, or how many people link the brand to the element; and uniqueness, which is a measure of competitive brand links to the same element. A strong, distinctive asset has 100 per cent prevalence and 100 per cent uniqueness. Drawing on the associative network theories of memory (e.g. Anderson and Bower 1979) and spreading activation theories of memory search (Collins and Loftus 1975; Raaijmakers and Shiffrin 1981; Tulving and Craik 2000), prevalence is built by co-presentation of the brand name with the element. Achieving prevalence is therefore under the control of the brand managers who can dictate the content of marketing communications and packaging. However, drawing on those same theories, uniqueness is determined by the presence of competitive brand links to the same element. This accessibility is based on competitor

activities or consumer confusion through misattributing the brand's activities to their competitors' (Burke and Srull 1988). Uniqueness is therefore less controllable by the brand, and as such, of value to research. Further, as Romaniuk and Gaillard (2007) show in an empirical analysis of brand associations across multiple categories, uniqueness in memory structures is difficult for a brand to achieve.

Colour is one of the most important elements of brand identity (Gaillard, Sharp and Romaniuk 2006; Piñero et al. 2010), but also an area of great competitiveness, with observations of the packaging in most categories revealing that many brands are vying to own colours. For example, Whiskas Australia has fought against Nestlé in the Federal Court of Australia in order to register its purple colour in Australia's cat food category (Golder 2010). Brands try to develop colour linkages. An example of this is Pepsi, which spent billions of dollars trying to link its blue colour to the brand (Grimes and Doole 1998). Companies recognize colour's importance, and therefore some legally protect their colour associations (Golder 2010).

Here we examine consumers' linkages between brands and colours, and the level of uniqueness of these links, as reflected in the lack of associations with competitor brands. An investigation of colours' uniqueness levels will provide brands with an insight into the nature of colour competitiveness in comparison with other elements. Like any concept in memory colours can have links to different brands (see Anderson and Bower 1979). For example, Qantas draws on the colours red and white, as does one of its main competitors, Virgin Airlines. Therefore, despite the strong use of the colour red by Qantas, it is likely that the airline travelling public also links red to Virgin. There are also a limited number of core

colours available, as well as considerable difficulty in trademarking colours (Hoek and Gendall 2010). This limit on the number of core colours makes it highly likely that any strong colour will have copycats at some point in time. This leads us to question the value of trying to build a colour as a distinctive asset vis-à-vis other brand elements.

Our research used multiple sets of data from brand health tracking surveys in the alcoholic beverages category. The uniqueness of colours, taglines and logos was compared. This information can help brand managers understand what elements should be invested in when attempting to build a unique brand identity.

Background
Distinctive assets: What are they and why use them?

Distinctive assets are non-brand-name elements that help consumers identify a specific brand from its competitors (Romaniuk, Sharp and Ehrenberg 2007). Elements include logos, colours, typefaces, taglines, music, characters, celebrities, taste, smell, shape and style of advertising (Gaillard 2007). Not every element that a brand employs on its packaging, advertisements or any other marketing communication can be regarded as a brand asset. For example, research studies by Tom (1993) and Reece, Vanden Bergh and Hairong (1994) have indicated that simply using brand elements in marketing communications did not lead to a successful linkage of brands and elements. Assets and added value to the brand is only produced when an element is uniquely associated with the brand by the vast majority of consumers (Romaniuk and Hartnett 2010).

There are various reasons why having distinctive assets is beneficial for brands. Firstly, distinctive

assets add more brand signals in advertising and on packaging other than just a textual representation of a brand name (Romaniuk, Sharp and Ehrenberg 2007). Distinctive assets offer greater creative flexibility to advertising creatives, who are often reluctant to include high levels of branding in advertising (Aitchison 1999), while still wanting to stand out in cluttered buying environments. This greater flexibility in how branding can be communicated has led to some academics suggesting that this could enhance the amount of attention paid to the branding in advertisements (Heath 2001a). It has also been suggested that consumers place high importance on these elements when trying to recognize and purchase items in buying situations (Gaillard, Sharp and Romaniuk 2006).

These extra cues in advertising can increase correct branding identification levels in advertising (Hartnett 2011). A high level of correct brand identification is extremely important, yet these are often low, with only around 40 per cent of people stating they have seen the advertisement and attributing the correct brand (Franzen 1994; Rossiter and Bellman 2005). Such low levels of correct identification are perhaps due to the low levels of attention that is given to advertising. For example, research by Paech, Riebe and Sharp (2003) found that only one-third of TV viewers actively watch TV advertisements. Furthermore, research by Pieters and Wedel (2004) suggested that the average time spent looking at a print advertisement is 1.73 seconds. Therefore, distinctive assets give more cues to help people identify who it is that is advertising.

These distinctive assets can also access senses that the brand name cannot. Marketers are now becoming more interested in the role that different senses play in consumers' memory (Lindstrom

2005). Research into human memory has provided insight as to how different senses are stored in different parts of the brain and can often complement each other (Franzen and Bouwman 2001). Furthermore, distinctive assets also provide richer sensory information to direct branding (Keller, Aperia and Georgson 2008). For example, the picture superiority effect states that pictorial elements are easier to recall and recognize than words (Childers and Houston 1984; Erdelyi and Becker 1974). Hartnett (2011) also found that visual distinctive assets (14%) produce higher increases in correct brand identification than verbal assets (7%) in taglines.

Associative network theories of memory

To understand the value of distinctive brand assets, it is useful to draw on the associative network theories (ANT), which is the most commonly adopted model of human memory. Philosophers and scientists have long pondered how the brain and our memory works; that is, how we encode, maintain and retrieve information from our brains. ANT was first developed by Anderson and Bower (1979), and has since been adopted into the field of marketing as a lens through which to view consumer-based brand equity (Keller 1993), brand salience (Romaniuk and Sharp 2004) and distinctive assets (Hartnett 2011).

According to Anderson and Bower (1979), under ANT, information in memory is stored as a series of nodes, with various links or associations between these. In terms of marketing, these nodes could be product attributes (which could relate to the product category), or be benefit- or situation-based. They could also be evaluations of the brand (Holden and Lutz 1992), or simple brand identification devices. For example, the brand Ford could be associated with a variety of pieces of information, from 'has four-wheel drive' (attribute), 'a quality brand' (evaluation)

or the colour blue (brand identification). These associations can then act as retrieval cues (Holden and Lutz 1992). For example, when a consumer sees a car advertisement with the colour blue, this can act as a cue to elicit the brand name 'Ford'.

Importantly, as discussed in Anderson and Bower (1979), links in ANT can vary in strength. Repetition increases the chance that a stored concept can be retrieved later on (Anderson 1983). Links that are already stored in long-term memory can be strengthened when we come across the stimuli again (Anderson 1983). In terms of advertising, this means that the links we store in memory need to be strengthened continually. This need for reinforcement is perhaps more relevant for a field like marketing, as consumers rarely take steps to actively learn advertising's content, but rather avoid it (Heath 2001b).

Links are also bidirectional and asymmetrical, meaning that there can be brand-to-associate links and associate-to-brand links, with these not necessarily being the same. Associate-to-brand links tend to be related to purchase situations, whereas brand-to-associate links are used for evaluating brands (Holden and Lutz 1992). For example, when seeing an advertisement with the Nike 'Swoosh' (an associate), this may cue the brand name Nike. This is an example of an associate-to-brand link.

The role of uniqueness in ANT is vital. Keller (1993) lists three criteria for strong associations: favourability, strength and uniqueness. The more competitive links a cue has, the weaker that link then becomes (Meyers-Levy 1989). To link this back to brand elements, Ford uses the colour blue, but then so does Volkswagen. Therefore, seeing a car advertisement that uses blue as a branding device may elicit Volkswagen, even if the advertisement is

for Ford. This example shows that there are competing cues in consumers' memory which could potentially lead to misattribution of marketing activities. We now discuss the specific elements examined in this research.

Individual elements examined

The role of colour in branding has received a large amount of attention in the marketing literature. However, the ability of colour to produce unique brand associations has not received as much attention. Our research examines the competitive uniqueness of colour, and compares this to two other brand identity elements – logos and taglines – so as to examine which elements are best for building unique associations.

Colour

Colour has been referred to as one of the main brand elements that can communicate the brand's distinctiveness in consumers' mind (Bottomley and Doyle 2006; Klink 2003). Consumers also place a high degree of importance on it as a means of brand recognition (Gaillard 2007). Lindstrom's (2008) test with 'Tiffany blue' illustrates a powerful example of a strong colour association with the brand. A blue Tiffany box with no brand name or logo was presented to 600 women in his test, with their heart rates rising by 20 per cent on average. Lindstrom concluded that the effect was caused through the distinctive blue colour, which evoked Tiffany in participants' mind, and raised associated feelings of relevant occasions such as engagements, marriages and babies. This signifies the potential of colour as a powerful brand distinctive asset to move both the mind and the senses.

Another characteristic of colour is its capacity to quickly capture consumers' attention when presented on-shelf or in advertising. When a consumer comes across an in-store display, up to 60 per cent of the first impression derives from colour (Heath 1997). Equivalently, various advertising studies have discovered that coloured print advertisements gain longer viewing time and better recall rate than black-and-white ones (Lohse 1997; Magazine Publishers of America 2009; Twedt 1952).

A registration of colour as trademark further demonstrates the importance of colour as a distinctive asset (Hoek and Gendall 2010). Conventionally, colour was not considered eligible for trademark registration until the first successful case of colour registration for Qualitex in 1995. Following this case, a number of brands, such as Tiffany, BP Oil and Heinz, have successfully trademarked and protected specific shades of colour, which further raised awareness of colour as a protected trademark for brands (Hoek and Gendall 2010). Another recent example of successful colour registration includes Whiskas for its own distinctive shade of purple. To register a particular shade of colour in a category, companies first need to prove that consumers identify the colour and associate the brand uniquely with their goods or service (Golder 2010).

Logo

A logo is a graphical image that signals the producer or manufacturer of the product or service (Henderson and Cote 1998). It appears in a wide range of marketing communications, from advertising and packaging to internal use (Henderson and Cote 1998). Logos are one of the main communication tools for a brand to deliver their brand image, draw attention through cluttered environments, and garner quick recognition of the product and producer (Henderson and Cote 1998). Therefore, brand recognition through logos is particularly helpful for low-involvement items where consumers spend a small amount of time on their purchase decision

(Kohli, Suri and Thakor 2002). The value of logos can be further emphasized with successful examples of Nike, whose logo is worth $3.6 billion, and McDonald's golden arches, which led the brand name to a brand value of $27.6 billion (Kohli, Suri and Thakor 2002). Significant changes are rarely seen in logos, although modifications and updates can be observed (Kohli, Leuthesser and Suri 2007).

Taglines

Taglines are a textual brand element, most commonly a concise phrase. Their primary task is to express what the brand is about (Kohli, Leuthesser and Suri 2007). Some taglines attempt to be persuasive, while others simply describe a product or service attribute (Keller 2003; Keller, Aperia and Georgson 2008). Further, it is suggested that taglines can be merely a creative device that do not have to include a meaning to be effective. Heath (2002) argues that information can be implicitly processed without consumers comprehending what the tagline actually means. Examples of taglines are 'Have a break, Have a Kit Kat' for Kit Kat, 'Wassup' for Budweiser, and 'Gives you wings' for Red Bull.

What is uniqueness and why is it important?

Uniqueness in marketing can take two forms: uniqueness in what a brand offers; and uniqueness in how a brand looks and feels in consumers' eyes. Uniqueness in what a brand offers is a view of differentiation. It is normally based on functional or perceived product differences. A 'differentiate or die' ideology is prevalent in marketing literature, and is particularly urged by Reeves (1961) and Trout and Rivkin (2000).

On the other hand, uniqueness in how a brand looks can be called distinctiveness (Romaniuk, Sharp and Ehrenberg 2007). This type of uniqueness means a brand can be unique or perceived to be different without trying to persuade or offer something functionally. A large part of this uniqueness is the use of brand elements to signal simply who the brand is and when building a unique brand identity. Using unique elements associated with a brand is considered to be a mental shortcut for consumers, and assists consumers with easier identification of the brand (Gaillard 2007).

The form of uniqueness that underpins distinctiveness differs from the uniqueness that underpins the functional side of differentiation (Romaniuk, Sharp and Ehrenberg 2007). Having a red can does not make Coca-Cola a better product, but it is vital, as it helps consumers find the brand – whether that be on the shelf or through marketing communications. As discussed earlier, retrieval of information is cue based. Whether exposure to a cue, such as a distinctive asset, will retrieve the brand name is dependent on the strength of links between nodes (Hartnett 2011), as well as the uniqueness of the nodes (Meyers-Levy 1989). Therefore, having uniqueness in how your brand is represented is important because it will facilitate retrieval of the brand information better, and uniquely evoke the brand in the consumer's mind.

This concept also supports a theory of advertising as creative publicity to generate higher salience (Ehrenberg et al. 2002), which would in turn reinforce consumers' memory about the brand. Reinforcement then retains accessibility of the brand in consumers' memory will assist in the brand being recalled more easily. Also, having elements uniquely associated to your brand makes a brand stand out in a cluttered marketplace, and thus more retrievable for consumers during a quick purchase decision (Gaillard 2007). The benefit of distinctive assets has been shown empirically, with distinctive assets

Category	Rum	Malt whisky	Malt whisky
Year	2010	2010	2009
Country	Spain	UK	US
Data collection	Online survey	Online survey	Online survey
Category usage screener	Drunk from category in last 4 weeks	Drunk from category in last 3 months	Drunk from category in last 3 months
Sample size	500	221	405
Sampling description	Those who had drunk dark rum in the last 4 weeks	Those who had drunk malt whisky in the last 3 months	Those who had drunk malt whisky in the last 3 months
Gender	Male = 63% Female = 37%	Male = 80% Female = 20%	Male = 80% Female = 20%
Age	18–24 yrs = 35% 25–34 yrs = 44% 35–44 yrs = 11% 45–54 yrs = 10%	25–34 yrs = 21% 35–44 yrs = 20% 45–54 yrs = 31% 55–64 yrs = 28%	25–34 yrs = 22% 35–44 yrs = 27% 45–54 yrs = 24% 55–64 yrs = 27%

Table 1: Key characteristics of data sets.

improving levels of correct brand identification when shown in conjunction with the brand name in print advertisements (Hartnett 2011).

Given the cluttered marketplace and busy lives of consumers, it is of utmost importance for brands to easily come to consumers' minds in both advertising and purchase situations. Uniqueness can play a valuable role in this. In this paper, we address the following research question:

RQ1: *How does the uniqueness of colour compare to other brand identity elements?*

Method
Data
Data was drawn from online consumer surveys and existing brand health tracking surveys. These surveys included questions on distinctive assets, and uniqueness scores were calculated from these. We drew upon three separate data sets from different brand tracking projects; however, all were categories of alcoholic beverages. This means that there were differences in the timeline, the country of the respondents, category usage screeners and sample size (these are outlined in Table 1).

This use of multiple sets of data helps ensure the internal validity of our findings, and ensures that the results were not due to something unique about an individual data set, such as the type of market.

According to Evanschitzky and Armstrong (2011), research based on a single set of data should be treated with cynicism, with multiple replications within research being ideal.

We have decided to stay within the category of alcohol. This is so that we can be more confident of the results in this category, rather than using smaller samples from a variety of categories. This provides us with more confidence in any conclusions drawn.

The countries chosen were based on data availability and so as to provide a range of countries for testing. These data sets were collected for a commercial client to assess the strength of their brand identity elements. The data were then repurposed for this research.

We decided to focus on three main brand elements: colours, logos and taglines. Gaillard, Romaniuk and Sharp (2005) found that symbols (closely related to logos), colour and taglines were the top three brand elements that consumers believed helped create a banking brand's visual identity. We chose these three elements because of their popularity in the marketing literature and industry practice.

Questioning approach

As per Romaniuk and Nenycz-Thiel (2013), an element prompted–brand unprompted approach was used; that is, respondents were prompted with the element (e.g. a colour such as red) and asked 'If there are any brands of [category] that you think of when you see that [logo]?' No brand lists were

Colour	Uniqueness %		
	Spanish Rum	UK Malt Whisky (2010)	US Malt Whisky (2009)
Blue	61	54	70
Maroon	47	N/A	N/A
Black	22	47	66
White	67	30	32
Red	35	N/A	N/A
Green	16	37	21
Gold	24	21	21
Yellow	16	22	19
Brown	26	11	17
Cream / Beige	N/A	12	13
Average	35	29	32

Table 2: Uniqueness scores for colour (main brand).

Spanish Rum		UK Malt Whisky (2010)		US Malt Whisky (2009)	
Tagline (Brand)	Uniqueness %	Tagline (Brand)	Uniqueness %	Tagline (Brand)	Uniqueness %
'Ron de los Dominicanos' (Brugal)	52	'Every Year Counts' (Glenfiddich)	31	'The Single Malt That Started It All' (The Glenlivet)	33
'El culto a la Vida' (Cacique)	37	'The Golden Rule' (Glenmorangie)	29	'The World's Most Richly Flavored Scotch Whisky' (Chivas Regal)	18
'Importado del pasado' (Cacique)	37	'The Malt' (The Macallan)	24	'Every Year Counts' (Glenfiddich)	17
'Un mundo de deseos' (Barcelo)	37	'The World's Most Richly Flavored Scotch Whisky' (Laphroaig)	22	'The Golden Rule' (Johnnie Walker)	17
'El sabor de Cuba' (Havana)	36	'The Single Malt That Started It All' (Glenfiddich)	21	'The Handcrafted Malt' (The Balvenie)	15
'Ron de rones' (Cacique)	35	'The Handcrafted Malt' (Glenmorangie)	19	'The Malt' (The Macallan)	12
'Vive ahora' (Barcelo)	30	'Best Spirit in the World' (Jack Daniels)	16		
Average	38	Average	23	Average	19

Table 3: Uniqueness scores for taglines.

provided and respondents could type up to three brand names.

Analysis approach
Following this, uniqueness scores were calculated. Uniqueness scores are the number of respondents who link the brand to the element divided by the number of respondents who link the element to any brand. For example, 90 out of 100 people could link the milk brand Farmers Union to the colour blue, but there could be 500 overall brand links to blue, giving it a low uniqueness score of 18 per cent. This allowed for averages to be created for each element within each data set, which were then compared. Further statistical testing was conducted on the uniqueness scores within brands. The number of people who mentioned at least

Spanish Rum		UK Malt Whisky (2010)		US Malt Whisky (2009)	
Brand	Uniqueness %	Brand	Uniqueness %	Brand	Uniqueness 0%
Brugal	94	Highland Park	65	Glenfiddich	52
Cacique	92	The Macallan	43	The Macallan	35
Legendario	85	Glenfiddich	42	The Glenlivet	25
Havana	60	Bells	24	Glenmorangie	10
Legendario	59	Glenmorangie	24		
Barcelo	45	Chivas Regal	21		
Average	73	Average	37	Average	31

Table 4: Uniqueness scores for logos.

Spanish Rum		UK Malt Whisky (2010)		US Malt Whisky (2009)		Overall
Element	Average Score %	Element	Average Score %	Element	Average Score %	Average
Logo	73	Logo	37	Colour	32	47
Tagline	38	Colour	29	Logo	31	27
Colour	35	Tagline	23	Tagline	19	32

Table 5: Uniqueness scores for each element in individual markets (from highest to lowest).

one brand for each individual element was used as the sample n. A proportional t-test was used to a significance level of 0.05.

Results and discussion
The results for the uniqueness scores for each element in the individual markets are shown below (Tables 2–4). Table 5 summarizes the ranking of the average uniqueness scores for the three elements in each market, graded from the highest to the lowest.

Tables 2 to 4 firstly show wide variation in individual data points for each element. For example, in Spanish rum, levels of uniqueness in colour range from

	Uniqueness %/n (sample size)					
Spanish Rum	Logo	Colour	Logo	Tagline	Colour	Tagline
Brugal	94*	61	94*	52	61	52
Cacique	92*	47	92*	37	47*	37
UK Malt Whisky (2010)						
Glenfiddich	42	37	42	31	37	31
Glenmorangie	24	21	24	29	21	29
Laphroaig					30	22
Bells	24	22				
The Macallan			43*	24		
US Malt Whisky (2009)						
Johnnie Walker					70*	17
Chivas Regal					17	18
Glenfiddich			52*	17		
The Macallan			35	69*		

Table 6: Comparison of brands with more than two elements / * = significant to p<0.05.

16–67%, logos from 45–94% and taglines from 30–52%.

Examining the uniqueness score averages in Table 5 gives an overall picture of how different brand elements perform against each other in terms of uniqueness. It is apparent that logos perform the strongest, having the highest score overall, as well as the highest in two of the three data sets. Colours and taglines have similar results.

Table 6 shows nineteen cases of individual brands within each data set that had at least two elements tested. Of these nineteen cases, twelve had a logo

present in the pair, and in 50 per cent of thcsc (n=6), the logo had a statistically significantly higher uniqueness score than the colour or tagline tested. The results trended in this direction in a further four cases. Only two cases had reversed results.

Of the twelve pairs that included colour, two results (17%) were statistically significantly higher, and a further three showed directional results in favour of colour. These results were evident when colour was compared to taglines. Colour performed less strongly when compared to logos.

Fourteen pairs included a tagline; of these, only one pair was significantly different in favour of a tagline (for The Macallan [US 2009]), while two other results (for Glenmorangie [UK 2010]) were directional.

This shows a general trend towards logos being the strongest element, followed by colours and taglines.

Discussion

One possible explanation of these results is the effect of picture superiority. Macklin's (1996) research found that memory was further improved with the help of visual cues, such as a picture or colour. It is also found that memory retrieval from pictorial representations is faster than non-pictorial ones (i.e. textual) (Kohli, Suri and Thakor 2002). In addition, there are a number of research results that strongly support the existence of the pictorial superiority effect. Paivio (1971) suggested that pictures are more memorable than words due to a greater and more unique encoding of pictorial images in memory, with their additional distinctive visual features. In this study, both colour and logos are visual elements, whereas taglines are verbal or textual. This added sensory information from visual

elements may help consumers uniquely attribute the element to the brand. Logos may perform better than colour as a visual element due to the greater creative flexibility in creating a logo. Comparatively, there is a limited array of colours for brands to use (Hoek and Gendall 2010). Also, trademarking colours, unlike logos, is a relatively new and complicated process (Golder 2010). This could be a reason behind stronger uniqueness for logos compared to colours.

Another explanation of the results is how marketers and brands use these elements. There is evidence that new taglines are frequently created for brands. For example, Pepsi has changed its taglines approximately ten times over the course of the previous century (Kohli, Leuthesser and Suri 2007). However, an element such as colour may outlast the marketers that selected it; hence, such longevity enables colour to hold a greater distinctiveness and memorability than other elements. Comparatively, a tagline is possibly an element that is more changeable when brands want to change their image (Kohli, Leuthesser and Suri 2007). Therefore, taglines may change from campaign to campaign, whilst colours and logos remain consistent. This puts taglines at a greater disadvantage when trying to create unique associations.

This difficulty in creating unique taglines may explain the finding of Katz and Rose (1969), who documented significant incorrect recall of taglines. They suggested the low level of correct recall could be a result of a high level of consumer confusion, especially in heavily advertised product categories with little brand differentiation. Kohli, Leuthesser and Suri (2007), however, state that taglines can be unique for brands when they are used consistently. Certainly, some individual brands were able to create

taglines with high levels of uniqueness. Therefore, the issue may not be in the intrinsic value of taglines, but rather how marketers use or abuse them.

Conclusions and future research

A unique brand identity is vital for brands, and distinctive assets can play a large part in making sure brands are not confused with their competitors. This research examined the unique associations that different types of brand elements possess. The results showed that logos performed best, followed by colours and finally taglines. The strong performance of logos and colours may be attributable to their visual qualities, which are easier to tell apart in comparison to words. However, individual taglines can still be strong, which suggests that taglines can be unique when used consistently over time. This has key implications for how brand managers select and invest in individual brand elements. Before investing in distinctive assets, marketers should know what elements are more likely to become unique before investing in elements that may be misattributed. This research looked at three types of elements in one broad product category. Extending this to other categories and other elements will produce more generalizable results

References

Aitchison, J. (1999), *Cutting Edge Advertising: How to Create the World's Best Print for Brands in the 21st Century*, Singapore: Prentice-Hall.

Anderson, J. R. (1983), 'A spreading activation theory of memory', *Journal of Verbal Learning and Verbal Behavior*, 22, pp. 261–295.

Anderson, J. R. and Bower, G. H. (1979), *Human Associative Memory*, Hillsdale, NJ: Lawrence Erlbaum.

Bottomley, P. and Doyle, J. (2006), 'The interactive effects of colors and products on perceptions of brand logo appropriateness', *Marketing Theory*, 6: 1, pp. 63–83.

Burke, R. R. and Srull, T. K. (1988), 'Competitive interference and consumer memory for advertising', *Journal of Consumer Research*, 15 (June), pp. 55–68.

Childers, T. L. and Houston, M. J. (1984), 'Conditions for a picture-superiority effect on consumer memory', *Journal of Consumer Research*, 11 (September), pp. 643–654.

Collins, A. M. and Loftus, E. F. (1975), 'A spreading activation theory of semantic processing', *Psychological Review*, 82: 6, pp. 407–428.

Ehrenberg, A. S., Barnard, N., Kennedy, R. and Bloom, H. (2002), 'Brand advertising as creative publicity', *Journal of Advertising Research*, 42: 4, pp. 7–18.

Erdelyi, M. H. and Becker, J. (1974), 'Hypermnesia for pictures: Incremental memory for pictures but not words in multiple recall trials', *Cognitive Psychology*, 6: 1, pp. 159–171.

Evanschitzky, H. and Armstrong, J. S. (2011), 'Research with built-in replication: Comment and further suggestions for replication research', *Journal of Business Research*, 66: 9, pp. 1406–1408.

Franzen, G. (1994), *Advertising Effectiveness: Findings from Empirical Research*, Henley-on-Thames: NTC Publications.

Franzen, G. and Bouwman, M. (2001), *The Mental World of Brands: Mind, Memory and Brand Success*, Henley-on-Thames: World Advertising Research Centre.

Gaillard, E. (2007), 'How brand distinctiveness is communicated, from a consumer's perspective', Master's thesis, Adelaide: University of South Australia.

Gaillard, E., Romaniuk, J. and Sharp, A. (2005), 'Exploring consumer perceptions of visual distinctiveness', Paper presented at the *ANZMAC Conference*, The University of Western Australia, Fremantle, WA.

Gaillard, E., Sharp, A. and Romaniuk, J. (2006), 'Measuring brand distinctive elements in an in-store packaged goods consumer context', Paper presented at the *European Marketing Academy Conference (EMAC)*, Athens, Greece.

Golder, T. (2010), 'Mars v Nestlé: Protection of colour marks in Australia', *Journal of Intellectual Property Law & Practice*, 5: 10, pp. 678–680.

Grimes, A. and Doole, I. (1998), 'Exploring the relationship between colour and international branding: A cross cultural comparison of the UK and Taiwan', *Journal of Marketing Management*, 14, pp. 799–817.

Hartnett, N. (2011), 'Distinctive assets and advertising effectiveness', Master's in Business Research thesis (SUSA 1493792), Adelaide: University of South Australia.

Heath, R. (2001a), *The Hidden Power of Advertising: How Low Involvement Processing Influences the Way we Choose Brands* (vol. 7), Henley-on-Thames: Admap.

Heath, R. (2001b), 'Low involvement processing – a new look model of brand communication', *Journal of Marketing Communications*, 7, pp. 27–33.

Heath, R. (2002), 'How the best ads works', *Admap*, 427 (April).

Heath, R. P. (1997), 'The wonderful world of color', *Marketing Tools*, 4: 9, pp. 44–51.

Henderson, P. W. and Cote, J. A. (1998). 'Guidelines for selecting or modifying logos', *Journal of Marketing*, 62 (April), pp. 14–30.

Hoek, J. and Gendall, P. (2010), 'Colors, brands, and

trademarks: The marketing (and legal) problem of establishing distinctiveness', *Journal of Advertising Research,* 50: 3, p. 6.

Holden, S. J. and Lutz, R. J. (1992), 'Ask not what the brand can evoke, ask what can evoke the brand?', *Advances in Consumer Research,* 19: 1, pp. 101–107.

Katz, M. and Rose, J. (1969), 'Is your slogan identifiable?', *Journal of Advertising Research,* 9: 1, pp. 21–26.

Keller, K. L. (1993), 'Conceptualizing, measuring, and managing customer-based brand equity', *The Journal of Marketing,* 57: 1, pp. 1–22.

Keller, K. L. (2003), *Strategic Brand Management: Building, measuring, and managing brand equity* (2nd ed.), Upper Saddle River, NJ: Prentice-Hall.

Keller, K. L., Aperia, T. and Georgson, M. (2008), 'Choosing brand

elements to build brand equity', in *Strategic Brand Management: A European Perspective,* Harlow & New York: Prentice Hall & Financial Times, pp. 128–170.

Klink, R. R. (2003), 'Creating meaningful brands: The relationship between brand name and brand mark', *Marketing Letters,* 14: 3, pp. 143–157.

Kohli, C., Leuthesser, L. and Suri, R. (2007), 'Got slogan? Guidelines for creating effective slogans', *Business Horizons,* 50: 5, pp. 415–422.

Kohli, C., Suri, R. and Thakor, M. (2002), 'Creating effective logos: Insights from theory and practice', *Business Horizons,* 45: 3, pp. 58–64.

Lindstrom, M. (2005), 'Broad sensory branding', *Journal of Product & Brand Management,* 14: 2, pp. 84–87.

Lindstrom, M. (2008), *Buyology: Truth and Lies about Why we Buy,* New

York: Doubleday.

Lohse, G. L. (1997), 'Consumer eye movement patterns on Yellow Pages advertising', *Journal of Advertising,* 26: 1, pp. 61–73.

Macklin, M. C. (1996), 'Preschoolers' learning of brand names from visual cues', *The Journal of Consumer Research,* 23: 3, pp. 251–261.

Magazine Publishers of America (2009), *Magazines: A Comprehensive Guide and Handbook 2009/10,* New York: Magazine Publishers of America.

Meyers-Levy, J. (1989), 'The influence of a brand name's association set size and word frequency on brand memory', *Journal of Consumer Research,* 16: 2, pp. 197–207.

Paech, S., Riebe, E. and Sharp, B. (2003), 'What do people do in advertisement breaks?', Paper presented at the *ANZMAC,* Adelaide, Australia.

Paivio, A. (1971), *Imagery and Verbal Processes,* New York: Holt, Rinehart and Winston.

Pieters, R. and Wedel, M. (2004), 'Attention capture and transfer in advertising: Brand, pictorial and text-size effects', *Journal of Marketing,* 68 (April), pp. 36–50.

Piñero, M. A., Lockshin, L., Kennedy, R. and Corsi, A. (2010), 'Distinctive elements in packaging (FMCG): An exploratory study', Paper presented at the *ANZMAC,* Christchurch, New Zealand.

Raaijmakers, J. G. W. and Shiffrin, R. M. (1981), 'Search of associative memory', *Psychological Review,* 88: 2, pp. 93–134.

Reece, B. B., Vanden Bergh, B. G. and Hairong, L. (1994), 'What makes a slogan memorable and who remembers it', *Journal of Current Issues and Research in Advertising,* 16: 2, pp. 41–48.

Reeves, R. (1961), *Reality*

in Advertising, New York: Alfred A. Knopf.

Romaniuk, J. and Gaillard, E. (2007), 'The relationship between unique brand associations, brand usage and brand performance: Analysis across eight categories', *Journal of Marketing Management,* 23: 3, pp. 267–284.

Romaniuk, J. and Hartnett, N. (2010), 'Understanding, identifying and building distinctive brand assets', Adelaide: Ehrenberg-Bass Institute for Marketing Science.

Romaniuk, J. and Nenycz-Thiel, M. (2013), 'Measuring the strengths of colour-brand links', Ehrenberg Bass Institute for Marketing Science Working Paper, Adelaide.

Romaniuk, J. and Sharp, B. (2004), 'Conceptualizing and measuring brand salience', *Marketing Theory,* 4: 4, pp. 327–342.

Romaniuk, J., Sharp, B. and Ehrenberg, A. (2007), 'Evidence concerning the importance of perceived brand differentiation', *Australasian Marketing Journal,* 15: 2, pp. 42–54.

Rossiter, J. R. and Bellman, S. (2005), *Marketing Communications: Theory and Applications,* Frenchs Forest, NSW: Pearson Education.

Tom, G. (1993), 'Marketing with music', *Journal of Consumer Marketing,* 7: 2, pp. 49–53.

Trout, J. and Rivkin, S. (2000), *Differentiate or Die - Survival in Our Era of Killer Competition,* New York: John Wiley & Sons.

Tulving, E. and Craik, F. I. M. (2000), *The Oxford Handbook of Memory,* Oxford: Oxford University Press.

Iwedt, D. W. (1952), 'A multiple factor analysis of advertising readership', *Journal of Applied Psychology,* 36: 3, pp. 207–215.

Emily J. Wright
Swinburne University of
Technology

Emily Wright is a lecturer in
communication design at
Swinburne University of
Technology, and works at
the intersection of design
practice, education and
research. She received her
BSc. in Design from the
University of Cincinnati, her
Master of Design from
Swinburne University and is
currently completing her
Ph.D. Her professional
practice includes over
fifteen years of design
work in publishing, brand
identity, packaging, and
environmental and web
design. She has worked
with a variety of clients in
the United States, the
United Kingdom, Mexico
and Australia, most notably
Houghton Mifflin, Rockport
Publishers, Nokia, Reebok
and Amerifee.

Allocating the consumer research budget: Trying out the new or the tried and true?

Interpreting and successfully applying consumer research within the design process can be a challenge. This is particularly relevant in the realm of packaging design, where evaluating proposed designs with consumers has become one way of quantifying design's contribution to the bottom line. However, the scope of this testing – i.e. what is tested, why and how – remains contentious. With the advent of new types of consumer testing, including consumer neuroscience, choosing how to allocate the consumer research budget has become fraught even further. This paper reviews the aspects of packaging appearance commonly tested in industry, as well as the various methods and tools available for highlighting strengths and weaknesses. A series of packaging redesign case studies are examined detailing how consumer research was applied and how it has impacted design success.

Keywords
packaging design
consumer research
design decision-making

Introduction

How consumers respond, interact and ultimately choose various product brands is an area of much investigation (Bloch 1995; Crilly, Moultrie and Clarkson 2004; Fournier 1998; Garber 1995; Hekkert 2006; Orth and Malkewitz 2008). Trying to gauge consumers' impressions of packaging is vital to successful sales, particularly in the area of packaged products, i.e. fast-moving consumer goods (FMCG), where consumers often make impulse purchase decisions at the point of sale (Connolly and Davidson 1996). Given the context of consumption, namely the crowded supermarket shelf, purchase decisions are made very quickly, often after less than a second. This split-second purchase decision relies on the visual appearance of the package. In the retail environment, the product's packaging is clearly the 'salesman on the shelf' (Pilditch 1972). Within the packaging industry, packaging appearance is considered so vital to how a product is perceived that a common saying is 'the package *is* the product', as the products contained within often differ very little in reality (Southgate 1995).

With the advent of new types of consumer testing, such as consumer neuroscience, choosing how to allocate the consumer research budget can be a challenge. This paper reviews the aspects of packaging appearance commonly tested in industry, as well as the various methods and tools available for highlighting strengths and weaknesses. In conclusion, a series of packaging redesign case studies are examined detailing how consumer research was applied and how it has impacted design success.

The challenge of design research

The last decade has seen many companies commit to the power of design and its ability to offer competitive advantage in the fast-moving consumer goods (FMCG) market. Companies such as Nestlé, PepsiCo, Procter & Gamble and Unilever have realized that investing in design research is vital to succeeding in design success in packaging design (Bedford et al. 2006). However, effectively applying consumer research to the design process remains a challenge. Two out of three new products fail within two years; therefore, testing with consumers can avert substantial loss of investment.

Designers agree that managing consumer research in the design process can be problematic (Calver 2004; Klimchuk and Krasovec 2006; Meyers and Gerstman 2005; Meyers and Lubliner 1998; Wallace 2005). While there is much research on packaging, the complex relationship between packaging, branding and consumer research truly emerges from the perspective of packaging design practice. Southgate (1995: 153) criticizes the sort of evaluation that takes place in order to assess package design success: 'There is a depressingly frequent abuse of qualitative consumer research which involves putting in a whole raft of different design concepts and asking the consumer to "pick a winner"'. Further to this point, Young (2002: 11) states:

Moreover, almost by definition, quantitative researchers speak a different language than design professionals, which makes it easy for them to come across as adversarial, particularly when they are transforming packaging designs into a series of numbers and data tables. Some researchers have provided solid grounds for concern through their misguided attempts to reduce packaging design to a mathematical equation; that is, 'take the most-favored logo and put it with the highest-scoring color'.

Millman and Bainbridge (2008: para. 8) concur:

There is a group of brand consultants and cultural anthropologists alike that believe now that it is not the actual research itself that is the problem. It is rather about how research is often misused, what type of design concepts and stimulus are tested, and how data are analysed that is most often at fault. When used correctly, research shouldn't stifle creativity but rather offer designers stronger inspiration and focus.

Furthermore, it can be difficult for designers to use empirical research results as a catalyst for creative ideas. Bruseberg and McDonagh-Philip's (2002) study reported that it was difficult for designers to relate market research data to the design process. On the other hand, designers have reported positive experiences with focus groups, as this is the method they are most familiar with and which they can most easily participate in by observing the study (Young 2002).

The literature
This paper reviews both scholarly and industry literature in an attempt to consider their different perspectives when gauging consumers' impressions of products. On the one hand, surveys in academic literature tend to focus on experiments of visual perception, product aesthetics and consumer behaviour psychology, with an emphasis on rigorous methodology to produce empirically sound results (Creusen and Schoormans 2005; Garber 1995; Rettie and Bruwer 2000; Whitfield and Slatter 1979). However, this is time-consuming, and necessitates special expertise and facilities. On the other hand, industry research is frequently used to contribute to the bottom line, and thus it can be more informal or shallow depending on the project's budget and timeline. Beyond the description of market research company services and a few published case studies, the knowledge can be hard to validate given that it is understandably proprietary. The next sections review the various types, methods and tools of packaging testing, ranging from the tried and true to newer approaches.

Types of testing
Consumer responses to packaging appearance can be measured so as to support design decision-making. Depending on the research goal, there are a variety of ways to test packaging design. Gold (2004) proposes three goals when testing packaging design appearance: image, visibility and memorability. Thomas (2007) from Decision Analyst suggests a few more: attention value, purchase interest, uniqueness (dissimilarity to competitive packages) and compatibility with the brand. Pradeep (2010) cites more specific areas based on the Neurometrics™ approach, including novelty, purchase intent, awareness/comprehension, attention, memorability and engagement. Testing aspects of packaging terminology can differ among organizations and academia depending on the discipline; however, there is consensus across the literature in key areas such as visibility, memorability, novelty, image/message and engagement.

Visibility
Visibility can be defined as how visible a package is on the shelf to a consumer, and is often used interchangeably with 'shelf impact'. As most purchase

decisions are quickly made at the shelf, the shelf impact of a package is vital to success. Aaron Keller from Capsule Lab, a package testing agency, states: 'The direct impact of change [to shelf impression] on sales is more measurable than advertising and PR' (cited in Weston 2004: 1). Therefore, many clients will test the package design with consumers before implementing a radical change to the design when commissioning research of a packaged product brand. Achieving effective shelf impact involves both visibility as well as 'memorability'.

Shelf impact can be tested with a tachistoscope (T-scope), as well as through eye tracking. T-scope testing involves showing the consumer images (in this case a package) for a short exposure of time, then testing how accurately the consumer can 'recall' that package.

Memorability

Testing what people recall or remember is also termed 'memorability' or 'saliency'. This technique has traditionally been used in advertising for testing the memorability of certain brands. However, Young (2006) argues that brand saliency does not necessarily translate to consumer purchase. Just because a consumer can remember what they see on a shelf does not mean they will want to buy it. Young's company, Perception Research Services, proposes that eye tracking is more effective than T-scopes, as it investigates what people are looking at specifically when they see a package. However, this approach has its limits, since it can be difficult to determine why someone is looking at a particular package, or whether that translates to consumer purchase. Another drawback with eye tracking is that it is often confined to a laboratory environment, quite different to how a person would see a package on the shelf while shopping. Lab testing is also limited to geographic location and not as accessible to a variety of consumers as, for example, an online delivery of such a testing tool. Many testing tools are

now delivered online, since this can provide large samples, quick results and are reasonably cost-effective compared to other methods, such as those mentioned above. They are much quicker, easier and cheaper than running laboratory or site-specific testing that requires the physical presence of the study participants. They also lend themselves well to the use of immersive multimedia technology, such as the use of motion and three-dimensional graphics.

Online-based testing provides 'numbers' or empirical data, and thus can appear to be the most significant research outcome for design decision-making. However, while this testing is quantitative, it is limited in that it only tests what a consumer notices and recalls. The impression the consumer has of the package can be difficult to test, not to mention the nuanced communication aspect of packaging, which is comprised of various communication elements like product and brand messages.

Novelty and typicality

Novelty and typicality are interdependent concepts, or rather opposites. What is considered typical or novel can be subjective, and depends on the context of the package and the consumer. Typicality is important in packaging, as it refers to how closely the package form relates to other competitor packages in the product category. Studies have shown that people prefer what they are familiar with, e.g. the preference for prototypes theory (Whitfield and Slatter 1979). Nevertheless, other research (e.g. Berlyne 1974; Coates 2003) has shown that people prefer designs that are typical enough to be categorized into the correct product category, while maintaining enough novelty to catch or hold their interest. Novelty can be defined as how different or unique the package form is in relation to other competitor packages in the product category. If a package is very novel, it may not be recognized as part of the product category, and therefore not considered for purchase. However, without some

novelty, all packages would look the same, leaving little room for differentiation amongst products. Loewy (1951), the famous industrial designer, put forward the concept of 'most advanced yet acceptable' (MAYA) as a helpful way to balance the concepts of novelty and typicality.

In his book *The Buying Brain,* Pradeep (2010), who works for NeuroFocus, asserts that the brain prefers new things, or more specifically, likes 'novelty'. While without the new the design industry would be out of a job, the debate between whether the brain prefers 'novel' or 'typical' has been an object of research on both sides of the argument. When considering FMCGs, studies show that a package must be typical enough to be recognized as part of the product category (Garber 1995). The rapid communication scenario of purchasing FMCGs could contribute to this, since the consumer often makes a purchase decision quickly (Rettie and Bruwer 2000). Given the short amount of time, the recognizability (relating to visibility and memorability) and appropriate categorization (relating to typicality and novelty) of products is vital to purchase decisions (Connolly and Davidson 1996). After these initial consumer response concepts have been processed, more complex messaging can be processed.

Image
Imagery tests capture consumers' impressions of packaging. This could include testing of the intended communication of the package, which includes product information and brand communication, i.e. is the pack communicating the necessary information? This communication is not limited to just messages in the written word, but also to visual communication elements such as imagery, pack shape, material, typography and use of colour. Questions explored here could include: Does the consumer understand what the product is offering and register the brand name? Does this package seem in synch with the brand (or 'on brand')? This also involves asking

consumers what they think about packages, which can be tested through interviews, surveys and focus groups. When testing for brand qualities, such as traditional or youthful, the use of semantic differential scales are often used.

Young and Asher (2010) propose that simplicity in messaging is important in packaging design, since it can be successful at 'breaking through shelf clutter'. Prioritizing messaging is vital, as consumers only can process a few elements when responding to packaging appearance. Young and Asher (2010: 22) go on to state: 'PRS Eye-Tracking studies have shown that shoppers typically "take in" only 3–4 elements when first viewing packages. Therefore, adding claims doesn't typically improve communication: It only creates clutter and divides shoppers' limited attention more narrowly'.

Engagement
'Emotional engagement' or 'affective consumer' response is complex, and has been investigated from a variety of perspectives (Desmet 2003; Hekkert 2006; Jordan 2000; Nagamachi 1996; Norman 2004). Affective response can be classified as positive, negative or indifferent, as well as either weak or strong. This depends on the arousal factor, i.e. how much emotion the person feels towards the package. The use of semantic scales have been used to gauge emotion; newer approaches apply biometric methods, i.e. measuring physiological responses, such as heart rate and eye tracking, in conjunction with measuring responses in the brain, such as with EEG or fMRI. The next section includes an example of the latter (also see NeuroFocus 2011).

Testing methods
Most companies do not have the capacity to conduct consumer testing in-house. They therefore commission market research firms to carry out packaging design testing. Market research firms'

	Focus groups	Preference questionnaires	Simulated choice methods	Market tests
What is measured	Open-ended answers, body language and behaviour; not suitable for statistical analysis	Importance weighting for various product attributes	Choices among products	Decision to buy and choice among products
Type of response process	Speculative, except when used to assess prototypes	The respondent must try to determine his decision weightings through introspection, then map those weightings into the response scale	A hypothetical choice, so the same process as the actual purchase — but without monetary consequences	An actual choice, with customers' own money, and therefore fully consequential
Typical use in new-product development processes	Early on to aid general product design; at user interface design for usability studies	Design phase, when determining customer trade-offs is important	Design phase, when determining customer trade-offs is important; may also be used as a forecasting tool	End of process, to forecast sales and measure the response to other elements of marketing, such as price
Cost and competitive risk	Low cost; risk comes only from misuse of data by the seller	Moderate cost and some risk of alerting competitors	Moderate cost (higher if using prototypes instead of descriptions) and some risk of alerting competitors	High cost and high risk of alerting competitors, plus the risk of the product being reverse engineered before launch
Technical skill required	Moderation skills for inside the group and ethnographic skills for observers and analysts	Questionnaire design and statistical analysis	Experiment design and statistical analysis (including choice modelling)	Running an instrumented market and forecasting (highly specialized)

Figure 1: Comparison of common market research approaches. Source: Ariely and Berns (2010)

methods range from quantitative to qualitative, as well as from generative to evaluative depending on the research goals. For example, a new product launch will require different testing than one needed by an incremental packaging design change or that needed by a well-known brand. Relying on both qualitative (e.g. focus groups, interviews and observation) and quantitative (e.g. surveys, T-scope, eye tracking and biometrics, neuromarketing, etc.) methods, market research firms are increasingly offering a variety of packaging testing services. The number of methods and types of testing is vast, and thus can be difficult to navigate. See Figure 1 for an overview of how they compare with each other.

Ariely and Berns (2010) review a variety of common testing methods, including focus groups, preference surveys, simulated choice and market tests. Of these traditional market research methods, focus groups

are low in cost and risk, and therefore preferred by design teams (Bruseberg and McDonagh-Philip 2002). Questionnaire and simulated choice methods are more costly, require a higher level of expertise and carry the risk of alerting competitors. The next section reviews a series of testing tools that feature how methods such as questionnaires and simulated choice look in action.

Testing tools

This section reviews types of packaging testing tools common within the industry, and reviews four different packaging testing tools offered by several well-known market research agencies. This is by no means an exhaustive list; countless market research packaging testing tools exist, with each company proposing their own proprietary version. The purpose of this review is to study four key examples of packaging testing methods and tools so as to

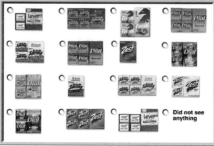
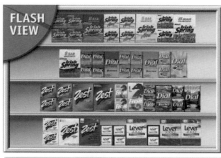

Figure 2: Packaging testing tool Shelf Impact.
Source: Harris Interactive (2011)

Figure 3: Packaging testing tool packs@work.
Source: AC Nielsen (2011)

demonstrate how the packaging testing techniques have evolved over time.

Shelf impact

We will start by reviewing Harris Interactive's Shelf Impact. Harris Interactive is a large market research consultancy that advises a variety of industries, including consumer packaged goods. Shelf Impact, its packaging design test tool, focuses on three packaging criteria: impact (standing out on the shelf); 'findability' (can the consumer recall where the package is placed on the shelf); and imagery (what is the emotional message of the package's appearance) (see Figure 2).

This figure features two screenshots of the Shelf Impact software interface. The first screenshot (a series of products on the sales shelf) is shown to the user or study participant for a short period of time. The second screenshot gives the user a series of product choices. The user must select which products they recall seeing by highlighting the button to the left of each product. This aims to measure the memorability or impact of the packaging.

Secondly, ACNielsen is a branch of the world's largest market research firm, The Nielsen Company, with offices worldwide. AC Nielsen offers marketing insight across a number of areas, including branding and packaging. It supports the consumer packaging goods industry with consumer research. Like Harris Interactive, Nielsen has a comparable online tool to test key performance indicators of packaging design – packs@work. A point of difference is that it simulates three-dimensional models of packages that can be manipulated by consumers, as opposed to Shelf Impact's two-dimensional graphics. This allows alternative views of the package, such as the side and back of the package. Figure 3 details the packs@work evaluation criteria, termed 'E.P.I.C.', which measures the empathy, persuasion, impact and communication of the packaging.

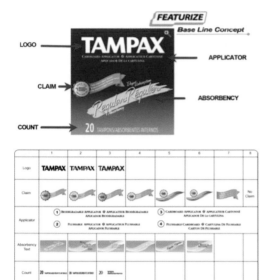

Figure 4: Packaging testing tool IDEA™.
Source: Affinnova (2003)

This figure shows three screenshots of the software. The first two screenshots demonstrate the packaging characteristics that are measured, i.e. E.P.I.C. The second screenshot shows how these measures are used to visualize the data analysis. The third screenshot features the interface the user or study participant would see, i.e. product choices, and the opportunity to purchase them, bin them or put them back on the shelf.

However, this tool appears to have been recently removed from the Nielsen Global website, and is now offered solely via the Nielsen's Taiwanese branch. Nielsen's NeuroFocus company, which applies neuromarketing and biometrics, seems to have superseded tools like packs@work. A more detailed review of NeuroFocus is presented in the next section.

Thirdly, Affinnova is the company that commissioned the IDEA™ (Interactive Design by Evolutionary Algorithm) technology (Affinnova 2003). IDEA™ was first developed for packaging design testing, but has since been extended to other applications. The IDEA™ technology utilizes algorithmic software that generates countless combinations of design variables, before surveying a multitude of consumers online (see Figure 4 for an example). These parts of the package design or design elements, such as colour, typeface and graphics, are called 'panel features'. The panel feature categories have between five and ten options. These options are combined in different ways using the IDEA™ technology. Companies such as Procter & Gamble and Cadbury-Schweppes have commissioned the tool to help with design decisions (Wallace 2005). The algorithm can create hundreds of various packaging designs using randomized combinations of visual elements, such as the brand logo, colour, typography, imagery, etc. These various random designs are then tested with consumers online to see if a favoured combination is found. This testing approach can be contentious, as packaging design elements are assembled randomly by a software program rather than by a packaging designer. The tool focuses on features of a package rather than the package design as a whole. This method is an example of an atomistic as opposed to a holistic approach. This could be problematic since the package design as a whole has not only aesthetic factors, such as colour, shape, material and size, but also brand communication and social meaning. The package design in a real-world setting is seen in context with other competitors on the shelf. These are aspects this testing tool does not address, instead comparing packaging design variations and measuring consumer preferences to these in isolation.

Figure 4 shows two screenshots of the IDEA™ software. The first screenshot features the package that is being tested (in this case Tampax tampons)

Figure 5: NeuroFocus. Source: Nielsen (2012)

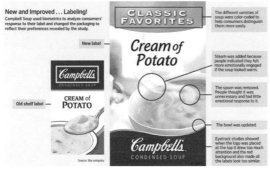

Figure 6: Neuromarketing analysis of Campbell's condensed soup (2010). Source: Williams (2010)

and the variables being measured, including logo, claim, count, etc. The second screenshot demonstrates the eight design options for each variable. Each of these options can be combined in innumerable ways using the IDEA™ computational algorithm, and the resulting packaging designs can be tested with consumers for preference.

Lastly, NeuroFocus, another Nielsen company, is reviewed due to it being one of the largest global providers of neuromarketing testing. Unlike the first three examples of testing tools shown, Neurometrics™ is an approach capable of testing

multiple areas, including novelty, purchase intent and awareness, as well as attention, memorability and engagement (as stated by Pradeep [2010] in his book, *The Buying Brain*). Figure 5 features the company's website, and shows an example of a consumer being tested with an EEG headset.

Ariely and Berns (2010) state the benefits of brain imaging for marketing include revealing hidden information that the consumer may not be consciously aware of. As with any method, its success relies on the context of its application. Marketers expect that the method can eventually be more cost effective than more traditional methods. The next section reviews a series of case studies that discuss how consumer research was applied to the packaging design process, including an example focused on neuromarketing testing techniques.

Case studies
The first case study – Campbell's condensed soup – is an example of neuromarketing in action. Figure 6 shows an analysis of 'the before and after' of the Campbell's soup package redesign. It highlights the research findings and how this was translated to packaging design revisions. Key findings included the need for a clearer communication of the soup range and the consumer's lack of emotional connection with the spoon, which was then replaced with the more positive emotional image of steam. To reach these conclusions, Williams (2010: 1) reports that in 'a two-year study, over 1,500 subjects were interviewed and tested using multiple methodologies – which ranged from traditional consumer feedback to cutting edge neuromarketing techniques'. This packaging redesign has been criticized by some in the brand and packaging design industry, who argue that these insights could have been identified by experienced packaging designers without the use of expensive and in-depth consumer testing. Neuromarketing's ability to reveal the consumer's response from how the body responds – via the

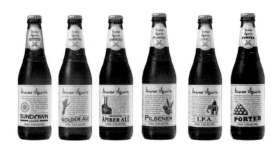

Figure 7: James Squire redesign (2011). *The original design.*

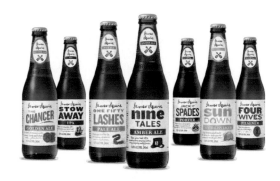

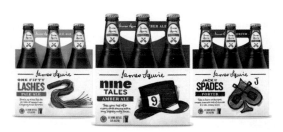

The new design. Source: Kelly (2012)

skin, face or brain, as opposed to relying on what people say they prefer – is the main benefit of the testing approach. However, there are no shortage of critics that are concerned with the 'hype' surrounding this area, particularly issues around transparency, regulation and ethics of the approach (Ariely and Berns 2010). Those in the industry question the pragmatics of how this research is applied to design projects. Marty Neumier (2010: 1) opines that:

People buy Campbell's not because of the steam but because they feel comfortable in the Campbell's 'tribe'. They simply believe that Campbell's is the 'right' product for them. And no amount of package tweaking will move the needle on that belief.

The more obvious finding of the Campbell's market research was a lack of differentiation across the product variant range, i.e. the consumer being able to identify the various soup ranges and flavours on the shelf. In the original design, the familiar Campbell's logo takes up nearly a third of the visual real estate and sits at the top of the package. This leaves little room to feature other important information, particularly the product variant information, i.e. 'classic favourites'. The product variant or soup range description could benefit from more prominence on the packaging, given that the Campbell's logo is very dominant in the original design; as a result of the testing, this has been amended in the proposed redesign (see Figure 6).

Lack of differentiation amongst the product variant range is a common challenge in packaging, particularly across large brand families that house multiple product ranges and variants. Two recent Australian packaging redesigns that focused on the clear communication of variant differentiation on the shelf include the James Squire and Vodka Cruiser rebrand projects (see Figure 7 and 8 for a more detailed description of the design projects). In this second case study, traditional research

Figure 8: Vodka Cruiser rebrand (2012). *The original design*

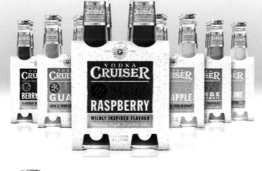

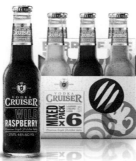

The new design. Source: The Package Design Blog (2013)

methods were carried out, namely focus groups. The research revealed that consumers found it difficult to distinguish between the beers on the shelf. To solve this problem, the redesign built a more in-depth brand story for each product by renaming the various beers across the range. The beer flavour variant brand name, 'nine tales, amber ale', takes its inspiration from James Squire's colourful life history. The redesign uses a series of illustrations and clear colour-coding to further differentiate the beer range; this is further emphasized on the six-pack, which supports its shelf impact. The design work is by DiDonato Partners for Lion, formerly Lion Nathan National Foods, a holding of Kirin Holdings Company Limited.

In the third case study, consumer feedback from focus groups confirmed both the confusion around identifying flavours (since there were so many choices), and the perception that the products had a similar use of vibrant graphics and colour. Vodka Cruiser's new design relies on clear, contemporary typography, simple colour-coding and an illustrative symbol system to differentiate amongst its varied product range. When comparing the original design with the new packaging, the use of colour and graphics are purposeful and strongly linked to product flavour, rather than being merely decorative. The design work is by Bonney Creative for Independent Distillers Group, a subsidiary of Asahi Group Holdings, Ltd.

Discussion
The broader context and complexity
Bianchi (2002) and Blijlevens, Gemserb and Muggec (2012) argue that the context of consumption is quite complex and constitutes a number of factors. These include cultural influences, situational factors, environmental distractions and visual references (Crilly, Moultrie and Clarkson 2004). The individual consumer will possess their own personal characteristics and preferences, and sensory

capabilities. Given that preference is very personal, this makes it difficult to generalize how all consumers will respond.

When considering the context in the packaging world, the shopping context should also be a primary focus. Young (2006) proposes various principles for effective packaging testing, the most important being to test the packaging with the consumer in the shopping context, i.e. on the shelf next to the product's competition. This involves in-store testing or a simulation of some type. Keeping the consumer in the real shopping context tends to provide more accurate data and avoids consumers becoming 'art directors'.

To add to this complexity, consumer response to the packaging and to the product brand must also be considered. The brand and the packaging are often tested as separate entities, as they are both comprised of complex elements. However, the packaging and the brand are so closely intertwined that it can be difficult to separate the two within a consumer's mind. The iconic bespoke Coke bottle is the ultimate example of how packaging can define the product brand (Marengo and Robinson 2010).

No one answer
Multiple tests – as well as multiple methods – are needed at different times in the design process in order to ensure a better chance of succeeding. Bidwell and Williams (2010) concurs by stating that multiple methods are ideal – or even better, data triangulation. Young (2006) cautions against the reliance on 'one number' from only one testing method, which may appear to simply quantify a design's impact on return on investment (ROI). While some forms of testing, such as simulated shopping, may appear to tell the full story, gauging consumers' reactions to packaged products is complex, and often necessitates a variety of testing approaches over time to get the full story.

Design and research must work together
As with any testing, the context and the appropriate application of results to the design process are vital to its success. As Asher (2012: 8) from Perception Research points out, 'Research is not only NOT the enemy, it is the designer's staunchest ally […] keeping appropriate concepts alive – even if daring and dispelling unwarranted directives (bigger logo, more claims, etc.)'. Cooperation between the design team and market researchers is paramount to the successful application of research during the design process. The James Squire and Vodka Cruiser redesign case studies demonstrate how the work of an experienced, talented packaging design team is also key to a good packaging outcome. While expensive market research tests such as eye tracking, neuromarketing or biometrics tests could have been applied, clients stick with the traditional focus group to identify how consumers perceive their brands, and thereby uncovered key communication problems within product range differentiation. The design team succeeded in creating a strong brand story, a clear communication of brand and product differentiation, shelf stand-out and visual appeal.

Conclusion
While Campbell's have successfully applied neuromarketing to some of their soup range packaging redesign, this heritage brand also paid homage to its historical and iconic design with the reintroduction of the Warhol-inspired soup cans. As Marty Neumier (2010) states in his critique of Campbell's redesign, it is the brand story that ensures consumer loyalty, and finding out how to resonate with the consumer takes far more than just applying a series of tests. While advances are being made in neuroscience and new testing approaches are becoming more accessible and affordable, testing designs with consumers is but one piece of the puzzle. It can pay to try the new; but when it comes to packaging, it is best not to forget the tried and true.

Figure 9: Limited edition Warhol-inspired Campbell's soup packaging. Source: Shear (2012)

References

ACNielsen (2011), 'packs@work', http://tw.en.nielsen.com/products/crs_packsatwork.shtml. Accessed 10 October 2012.

Affinnova (2003), 'Procter & Gamble and Tampax® use new evolutionary technology to improve package design development', Paper presented at the Advertising Research Foundation Annual Convention and Infoplex, New York, http://www.thearf.org/ Accessed 12 November 2012.

Ampuero, O. and Vila, N. (2006), 'Consumer perceptions of product packaging', *Journal of Consumer Marketing*, 23: 2, pp. 100–112.

Ariely, D. and Berns, G. S. (2010), 'Neuromarketing: The hope and hype of neuroimaging in business', Nature, 11: 4, pp. 284–292.

Asher, J. (2012), 'Research is not the enemy!: Today's tools and timeless best practices ensures success', DMI webinar, 18 January, http://www.prsresearch.com/fileUploads/DMI_webinar_PckgResrchIsNotTheEnemy_todistribute.pdf. Accessed 10 January 2013.

Bedford, C., Daniels, G., Desbarats, G., Phillips, P., Platt, M., Thurston, M. and Wallace, R. (2006), 'Profiting by design', *Design Management Review*, 17, pp. 54–59.

Berlyne, D. E. (1974), *Studies in the New Experimental Aesthetics*, Washington, DC: Hemisphere Publishing Corporation.

Bianchi, M. (2002), 'Novelty, preferences, and fashion: When goods are unsettling', *Journal of Economic Behavior & Organization*, 47, pp. 1–18.

Bidwell, J. and Williams, J. (2010), 'Neuromarketing', Paper presented at the *Western New England College 2010 Communications and Leadership Conference*, Western New England College, Springfield, MA, http://www.slideshare.net/bidwellid/neuromarketing-3702138 Accessed 17 January 2013.

Blijlevens, J., Gemserb, G. and Muggec, R. (2012), 'The importance of being "well-placed": The influence of context on perceived typicality and esthetic appraisal of product appearance', *Acta Psychologica*, 139: 1, pp. 178–186.

Bloch, P. H. (1995), 'Seeking the ideal form: Product design and consumer response', *Journal of Marketing*, 59: 3, pp. 16–30.

Bruseberg, A. and McDonagh-Philp, D. (2002), 'Focus groups to support the industrial/product designer: A review based on current literature and designers' feedback', *Applied Ergonomics*, 33: 1, pp. 27–38.

Calver, G. (2004), *What is Packaging Design?*, Mies, Switzerland: RotoVision.

Coates, D. (2003), *Watches Tell More Than Time: Product Design, Information, and the Quest for Elegance*, New York: McGraw-Hill.

Connolly, A. and Davidson, L. (1996), 'How does design affect decisions at point of sale?', *Journal of Brand Management*, 4: 2, pp. 100–107.

Cooper, R. and Evans, M. (2006), 'Breaking from tradition: Market research, consumer needs, and design futures', *Design Management Review*, 17: 1, pp. 68–74.

Creusen, M. E. H. and Schoormans, J. P. L. (2005), 'The different roles of product appearance in consumer choice', *The Journal of Product Innovation Management*, 22, pp. 63–81.

Crilly, N., Moultrie, J. and Clarkson, P. J. (2004), 'Seeing things: Consumer response to the visual domain in product design', *Design Studies*, 25: 6, pp. 547–577.

Desmet, P. M. A. (2003), 'A multilayered model of product emotions', *The Design Journal*, 6: 2, pp. 4–13.

Fournier, S. (1998), 'Consumers and their brands: Developing relationship theory in consumer research', *Journal of Consumer Research*, 24: 4, pp. 343–373.

Garber, L. L. (1995), 'The package appearance in choice', *Advances in Consumer Research*, 22, pp. 653–660.

Gold, P. (2004), 'Assessing what consumers see', *Brand Packaging,* 4, pp. 40–42, http://www.brandpackaging.com/articles/83716. Accessed 10 September 2012.

Harris Interactive (2011), 'Shelf Impact: Packaging evaluation system', http://www.harrisinteractive.com/MethodsTools/ProprietaryTools/ShelfImpact.aspx. Accessed 8 June 2012.

Hekkert, P. (2006), 'Design aesthetics: Principles of pleasure in product design', *Psychology Science,* 48, pp. 157–172.

Jordan, P. W. (2000), *Designing Pleasurable Products – An Introduction to the New Human Factors,* London: Taylor & Francis.

Kelly, D. (2012), 'Thirsty business: Brand identity and packaging design', Lecture conducted from Swinburne University of Technology, Melbourne.

Klimchuk, M. R. and Krasovec, S. A. (2006), *Packaging Design:* *Successful Product Branding from Concept to Shelf,* Hoboken, NJ: John Wiley & Sons.

Loewy, R. (1951), *Never Leave Well Enough Alone,* New York: Simon & Schuster.

Marengo, A. and Robinson, J. (1987), 'The Coca-Cola bottle', in *Design Classics* [TV series], London: BBC.

McDonagh, D. and Denton, H. (1999), 'Using focus groups to support the designer in the evaluation of existing products: A case study', *The Design Journal,* 2, pp. 20–31.

Meyers, H. M. and Gerstman, R. (2005), *The Visionary Package,* New York: Palgrave Macmillan.

Meyers, H. M. and Lubliner, M. J. (1998), *The Marketer's Guide to Successful Package Design,* Lincolnwood, IL: NTC Business.

Millman, D. and Bainbridge, M. (2008), 'Design meets research', *Gain: AIGA Journal of Business and Design,* http://www.aiga. com/content.cfm/design-meets-research. Accessed 10 June 2010.

Monö, R. (1997), *Design for Product Understanding* (trans. M. Knight), Stockholm: Liber.

Nagamachi, M. (1996), *Introduction of Kansei Engineering,* Tokyo: Japan Standard Association.

Neumier, M. (2010), 'Neuromarketing: Can it improve Campbell's soup?', *Liquid Agency,* 18 February, http://www.liquidagency.com/blog. Accessed 8 November 2012.

NeuroFocus (2011), 'Packaging', in AC Nielsen (ed.), *Case Study Executive Brief,* Berkeley, CA: AC Nielsen.

Nielsen (2012), 'NeuroFocus', http://www.neurofocus.com/index.htm.

Norman, D. A. (2004), *Emotional Design: Why we Love (or Hate) Everyday Things,* New York: Basic Books.

Orth, U. R. and Malkewitz, K. (2008), 'Holistic package design and consumer brand impressions', *Journal of Marketing,* 72, pp. 64–81.

The Package Design Blog (2013), 'Vodka Cruiser', 18 March, http://thepackagingdesignblog.com/?p=3080. Accessed 22 March 2013.

Pilditch, J. (1972), *The Silent Salesman,* London: Business Books.

Pradeep, A. K. (2010), *The Buying Brain: Secrets for Selling to the Subconscious Mind,* Hoboken, NJ: Wiley.

Press, T. A. (2012), 'Campbell channels Andy Warhol for new soup cans', *USA Today,* 29 August, http://usatoday30.usatoday.com/money/industries/retail/story/2012-08-29/campbell-soup-andy-warhol-target/57399686/1. Accessed 15 November 2012.

Rettie, R. and Bruwer, C. (2000), 'The verbal and visual components of package design', *Journal*

of Product and Brand Management, 9: 1, pp. 56–70.

Shear, Richard (2012), 'Andy Warhol, Target and the new Campbell's soup cans', *The Package Unseen,* 29 August, http://richardshear.wordpress.com/2012/08/29/andy-warhol-target-and-new-campells-soup-cans/. Accessed 5 November 2012.

Southgate, P. (1995), *Total Branding by Design: How to Make your Brand's Packaging More Effective,* London: Kogan Page.

Thomas, J. W. (2007), 'The basics of packaging research', *Decision Analyst,* http://www.decisionanalyst.com/publ_art/packaging.dai. Accessed 20 November 2012.

Wallace, R. (2005), 'Early and often: Harnessing the consumer's voice in packaging design', *PackageDesignMag.com,* November/December, www.affinnova.com/company/news/media/Affinova_earlyOften.pdf. Accessed 1 December 2008.

Weston, C. F. (2009), 'Market research: Shelf impact', *PackageDesign,* 3 December, http://www.packagedesignmag.com/content/market-research-shelf-impact. Accessed 6 July 2012.

Whitfield, T. W. A. and Slatter, P. E. (1979), 'The effects of categorisation and prototypicality on aesthetic choice in a furniture selection task', *British Journal of Psychology,* 70, pp. 65–75.

Williams, J. (2010), 'Campbell's Soup neuromarketing redux: There's chunks of real science in that recipe', *FastCompany,* 22 February, http://www.fastcompany.com/1558477/campbells-soup-neuromarketing-redux-theres-chunks-real-science-recipe. Accessed 5 November 2012.

Young, S. (2002), 'Packaging design, consumer research, and business strategy: The march toward accountability', *Design Management Journal,* 13, pp. 10–14.

Young, S. (2006), 'Measuring success: Using consumer research to document the value of package design', *Design Management Review,* 17, pp. 60–65.

Young, S. and Asher, J. (2010), 'Doing simple design well', *PackageDesign*, 3 August, http://www.packagedesignmag.com/content/doing-simple-design-well. Accessed 5 December 2012.

Gjoko Muratovski
Auckland University of
Technology

Dr Gjoko Muratovski has
twenty years of
multidisciplinary design
experience in Asia,
Australia, Europe and the
USA. He has collaborated
with a range of
organizations, including the
UN Association of
Australia, Toyota,
Greenpeace and the World
Health Organization. Dr
Muratovski is an advisor on
brand development
strategies for the
European-based agency
IDEA Plus
Communications, whose
clients include Audi, the
Heineken Group,
McDonald's, Porsche and
Volkswagen. He is also the
chairman of the 'agIdeas
International Research
Conference: Design for
Business', Area Chairman
for Business at the Popular
Culture Association of
Australia and New Zealand,
principal editor of the
*International Journal of
Design Research*, and book
series editor of *Design for
Business*.

Ambush marketing: Nike and the London 2012 Olympic Games

Ambush marketing is a term used to describe a practice by which a rival company tries to associate its products with an event that already has official sponsors. This case study aims to inform the field of corporate communications about the practice of ambush marketing by examining the tactics that Nike deployed immediately before and during the London 2012 Olympic Games, and of their effectiveness. The data collection for this study is based on a range of media reports, statements made by various stakeholders, and two exclusive interviews with Nike's former Global Art Director for the London Olympics, Quan Payne. The study confirms that ambush marketing can be a highly effective marketing practice – or at least it has been in this particular case – but that some ethical questions remain open with regards to this practice.

Keywords
Nike
London 2012 Olympics
ambush marketing

Introduction

When the founder of Adidas, Adi Dassler, designed the first ever running shoe, he gave them to the German runner Lina Radke to wear at the Amsterdam 1928 Olympics. She won gold, and Adidas has been a part of the Olympics ever since. As one of the main sponsors of the London 2012 Olympics, Adidas has spent over £100 million on sponsorship, marketing and advertising activities in the period between 2007 (when the Games were announced) and 2012 (when the Games were held) (Pagano 2012). In return, Adidas received the exclusive rights to be the only sportswear company allowed to reference the Olympics in their marketing campaigns, to use the Olympic logo on their products, and to dress all officials and volunteers at the Games. A great number of individual athletes and eleven National Olympic Committees and teams, including Great Britain, France, Germany, Ethiopia and Cuba, were also sponsored by Adidas and proudly wore the 'three stripes'. This has enabled Adidas to be virtually everywhere, including the entrance of the Stratford Westfield complex, where gigantic posters of athletes wearing Adidas sportswear 'welcomed' the visitors. The exclusive sponsorship rights enabled Adidas to become the dominating sporting goods company at the London Olympics (Pagano 2012). Or at least this was the case until Nike decided that they wanted to make their presence known as well.

Nike has a long tradition of sponsoring athletes and maintaining a high Olympic profile despite its non-sponsor status in relation to the Games themselves. However, given their non-sponsorship status, the only way that they could achieve such a high presence was by engaging in 'ambush marketing' (Briggs 2012).

In this paper, I will examine the role of ambush marketing in corporate communication strategies by studying the case of Nike and the London 2012 Olympic Games. The study will focus on two key design and marketing initiatives by Nike that were instrumental in raising their profile during the Olympics: the Volt running shoes and the 'Find Your Greatness' ad. The data collection for this study is based on a range of media reports, including statements made by various stakeholders, and two exclusive interviews with Nike's former Global Art Director for the London Olympics, Quan Payne. The study confirms that ambush marketing can be a highly effective marketing practice – or at least it has been in this particular case – even though some ethical questions related to this practice do remain open.

Ambush marketing

Ambush marketing is a term used to describe a practice by which a rival company tries to associate its products with an event that already has official sponsors. Drawing on their experience with the Sydney 2000 Olympic Games and the Melbourne 2006 Commonwealth Games, the Australian Government in their *Ambush Marketing Legislation Review* (2007) describes ambush marketing as a 'term of art used to describe a wide range of marketing activities by which a business seeks to associate its name, logos, products or services with an event for which it is not a sponsor' (Chan and Hudson 2007: 13). In addition to this, they also point out that there are two ways in which one can approach ambush marketing: from a narrow perspective, or from a broad one. The narrow approach, according to the *Review*, observes ambush

marketing as a practice that aims to deliberately confuse the public regarding a company's association with an event, and by doing so, weakening the marketing efforts of the true sponsors. The broad approach, on the other hand, defines ambush marketing as an activity 'that [can] capture, or leverage off, the goodwill surrounding an event, by suggesting or creating some involvement in, or association with, the event' (Chan and Hudson 2007). As the *Review* clearly points out, ambush marketing that does not contravene with intellectual property and/or trade practice laws is not an illegal practice. Neither does it include any 'express or implied misrepresentation as to sponsorship', in which case any such accusations may be expressly denied (Chan and Hudson 2007: 13). The distinction between the 'narrow' and 'broad' definitions of ambush marketing is very important; in this case, Nike's actions fall into the 'broad' category of ambush marketing.

Nike and ambush marketing

According to some critics, Nike has been engaged in ambush marketing practices since at least the Los Angeles 1984 Olympic Games, when they aired TV ads featuring Olympic athletes and used Randy Newman's song 'I Love LA' as a soundtrack. A marketing research conducted after the Games found that more people thought Nike was the official sponsor than Converse, the actual sponsor. Even at the Beijing 2008 Olympic Games, in which Adidas was again the official sponsor, Nike managed to create strong association with individual athletes, such the Chinese hurdler Liu Xiang, by providing them with Nike-branded equipment. To make Adidas' investment seem even less worthwhile, according to Byrnes (2012), nearly 80 per cent of people polled said they 'did not care' who the official sponsors were, while at the same time many Chinese viewers attributed Xiang's Olympic success to his Nike gear.

It is also worth mentioning that Nike has been performing ambush marketing campaigns at non-Olympic events as well. For example, during the 1996 UEFA European Football Championship, Nike used football images and players in a highly publicized billboard campaign (Meenaghan 1998: 312), and during the 2010 World Cup they launched an ad featuring flashes of the future lives of stars such as Wayne Rooney and Cristiano Ronaldo (Sweney 2012a); in both cases, they were not an official sponsor.

Official sponsors often see the appearance of their rivals' insignia as an attempt to create confusion about who actually sponsors the event, but this is not necessarily wrong or illegal behaviour. As Crow and Hoek (2003) point out, rival companies such as Nike have the right to promote their own sponsorship associations, even when they are not official sponsors of the event. For example, disputes between Reebok – the official apparel supplier to the US team at the Barcelona 1992 Olympics – and Nike – the sponsor of the US track and field team – highlights this problem well. In this case, Reebok accused Nike of stealing exposure and publicity they believed they had purchased when they obtained the sponsorship for the entire US team. Nike, however, argued that they have simply exploited a legitimate sponsorship opportunity that was open to them. Also, it has to be noted that Nike had contracts with individual athletes, such as sprinter Michael Johnson, long before Reebok acquired their team sponsorship deal (Crow and Hoek 2003: 6).

In line with this, the former Director of Commercial Rights Management for Vancouver's Olympic Organizing Committee, Bill Cooper, raises the question on whether it is right to call Nike an ambush marketer at all. According to him, Nike, with all their financial support for athletes, teams and

national Olympic committees from around the world, has a legitimate story to tell. On the other hand, as Cooper argues, other organizations who do not necessarily contribute to sports in any way, perform the most damaging format of ambush marketing by compromising the commercial integrity of the Olympic movement; hence, Nike should not be compared to them (cited in Stewart 2012). Quan Payne, Nike's Global Art Director for the 2012 Olympics, also points out that Nike has been an ongoing supporter of athletes and sporting teams for many years, and not only during sporting events. According to him, if Nike did not sponsor individual athletes or teams, many aspiring athletes would not be able to fund their training or afford the equipment, and essentially would not even be able to compete at the Olympics at all (Payne 20 April 2013 interview).

The ongoing relationship that Nike has with leading athletes helps them to establish a level of loyalty that can supersede other official sponsorships. For example, when Earvin 'Magic' Johnson accepted the gold medal for the Dream Team at the Barcelona 1992 Olympics, he triumphantly draped himself in the US flag. While this action was seen as patriotic, what he was actually doing during this key media opportunity was protecting Nike's investment in him by covering up Reebok's logo on his tracksuit with the flag-themed jacket. Then again, Nike is not the only one playing this game. At the Atlanta 1996 Olympic Games, official sponsor Reebok had a similar 'incident' with runner Linford Christie, who appeared at an official press conference wearing contact lenses showing the Puma AG logo (Pitt et al. 2010: 285).

Even though these types of marketing practices are not breaching any actual legal regulation, they are still seen as unacceptable for the Olympic host cities that depend on their sponsorship money to stage the Games. As a result, a number of new rules and laws have been created that can result in fines or even criminal charges for 'ambushers', with the result that many illegal ambush practices have been largely kept at bay (Hiestand 2012). That is why companies such as Nike, who want to be present at the Olympic Games but are not official sponsors, have to devise increasingly complex marketing tactics that would not breach any legally-binding rules.

Nike and the London 2012 Olympic Games

Of the many marketing initiatives that Nike launched around the London Olympics, two of them have been particularly instrumental in raising Nike's profile during the Games: (1) the introduction of the infamous neon-green/yellow Volt spikes shoes that all Nike athletes wore during the athletic competitions; and (2) the 'Find Your Greatness' video commercial that featured athletes competing in towns and places named London from around the world – with the exception of London, UK.

Initiative 1: Volt

The introduction of Nike's Volt footwear to over 400 athletes was something that few spectators could miss seeing. A 'sea of bright yellow shoes' – as it was described by the UK fashion magazine *Elle* (Lawrenson 2012) – dominated the running tracks. Their distinctive and ubiquitous neon colour created a stunning visual effect, and the massive numbers of athletes that were wearing them enhanced this effect even further (Lawrenson 2012). This stands as a great contrast to the pre-2012 Olympic Games when Nike (with rare exceptions) designed the shoes to match the uniforms of the individual athletes. While this solution created an overall visually strong appearance for the athlete, it did little for Nike, whose shoes simply blended in and were in effect concealed (Pathak 2012).

Then again, the reason why the Volt shoes stood out so much from the crowd is because they were scientifically designed to do so. As Nike spokesperson Brian Strong points out:

Ambush marketing: Nike and the London 2012 Olympic Games

Of all the colours of the rainbow, the human eye and visual system is most sensitive to the yellow/green zone. [...] The power of this visual signal is capitalised on when the background is highly contrasting, which the London Olympic track is – reddish. The human eye has relatively low sensitivity to red vs. much higher sensitivity to Volt colour. [...] Volt is a strong, dynamic colour and it has certainly become a visible signature of ours during the summer of competition. (cited in Briggs 2012)

In addition to the red track, Nike tested the colour against the blue and white of the fencing stage and the black and blue of the boxing ring to make sure that the shoes would be noticeable on such backgrounds as well (Briggs 2012). Prior to the games, Nike conducted focus groups with amateur, college and professional athletes in order to test the human appeal of the colour. The participants were asked to comment on different colours of the same shoe; athletes overwhelmingly selected the green/yellow neon Volt colour as being the most appealing to them (Pathak 2012). According to Martin Lotti, Nike's Global Creative Director for the Olympics, the Volt has now become the signature colour for Nike in the same way as light blue is for Tiffany; in return, it has become one of the most iconic images of the 2012 Olympics (cited in Pathak 2012). Nike's success with the Volt shoes is reminiscent of the 1996 Summer Olympics in Atlanta, when the company provided gold shoes to the American sprinter Michael Johnson, who achieved a new world record while wearing them (Stewart 2012). Considering that Nike was not allowed to use the Olympic Games in their advertising – although neither was any other sporting goods company except Adidas – this was a major marketing achievement.

Nike's marketing 'success' was based on a loophole in the regulations that protected the rights of the sponsors, as stipulated by the London Olympic Games and Paralympics Games Act of 2006 (Sweney 2012b). According to the regulations, shoes were classified as equipment, and athletes could not be banned from wearing shoes of their choice, even if they are provided by non-sponsor brand (Baxter 2012). At first, the London Games' organizers considered legal action against Nike, but decided not to proceed with this idea, because Olympians are allowed to wear whatever equipment they feel offers them the best chance of winning, and this should include shoes as well. Rule 40 of the Olympic charter, which limits athletes competing in the Olympic Games from appearing in advertising during and shortly before the Olympic Games, is meant to prevent ambush marketing activities which might create an impression that certain brands are associated with the Games when in fact they are not. The Rule, however, does not affect what athletes can wear during the competition. What the Rule states is that if the equipment manufacturer is not an official sponsor, then the athletes cannot promote the product outside of using the product during competition. This means that athletes with Volt shoes cannot tweet about them, or blog about them, or post pictures online about their shoes during the competition (Briggs 2012). Considering the widespread coverage that this issue received, both on social networks and through conventional media, this ban had no impact on Nike at all. By focusing on equipment and athletes, rather than institutions, Nike managed to integrate itself into the Games and achieve 'Olympic-size brand identification without an Olympic-size budget' (Briggs 2012).

Unfortunately for Adidas, this was not the first time they have been ambushed in a similar way. During the Beijing 2008 Olympic Games, they suffered an ambush by the most unlikely rival, Li Ning – a former Chinese athlete who won six medals during the Los Angeles 1984 Olympic Games. As one of their most esteemed Chinese athletes, Li Ning was the obvious choice for a torchbearer by the Beijing Olympic

Committee. However, for Li Ning, this also meant an opportunity to promote his own sports label to the world stage.

Since his retirement from gymnastics, Li Ning founded his own athletic apparel company that specializes in clothing and footwear bearing his own name. While Li Ning is a household name in China, and the fact that he owns a sporting company is a well-known thing, outside the country few people have ever heard about Li Ning's brand. Yet this soon changed after the Beijing opening ceremony. This key event, witnessed by an audience of over four billion viewers, showed Li Ning running in the 'Bird's Nest' arena, and then being dramatically hoisted in the air by cables before lighting the Olympic cauldron. Surprisingly, what the organizers and the sponsors did not foresee was that Li Ning would be wearing his own Li Ning brand of shoes during the event and not Adidas shoes (as they had obviously expected). The opening ceremony provided Li Ning with an unprecedented marketing opportunity to show off his own sports label to the world. According to some business experts, these were the greatest two or three minutes of free advertising in history (Pitt et al. 2010: 282). What is more, *Bloomberg Businessweek* even dubbed Li Ning's 'audacious' self-promotional stunt as 'the boldest case of ambush marketing ever pulled off' (Balfour 2008).

Initiative 2: 'Find Your Greatness'

On the eve of the London 2012 Olympics, Nike launched an inspiring video campaign entitled 'Find Your Greatness' that also managed to steal the limelight from the Olympic sponsor Adidas. With this ad, Nike tested the limits of the Olympics rules on ambush marketing. The ad depicted everyday athletes competing in places from around the world named London – expect London in the UK, which they could not show due to legal reasons. Yet, the message was clear enough to everyone: athletes performing in London in an ad by Nike.

While they were not allowed to make associations between themselves and London, UK, they created an engaging video narrative that associated them with athletes that exercise in small towns and places that bear the same name, such as London in Ohio, London in Norway, East London in South Africa, Little London in Jamaica, Small London in Nigeria, or at locations such as London Hotel, London Road and a London Gym (Marketing 2012). The campaign coincided with the Olympics opening ceremony and was launched in 25 countries. The video was visible on YouTube's home page as a rich-media billboard ad, and was supported by a website, Nike+ apps and products, outdoor and print ads, and a Twitter push using the hashtag #findgreatness.

The ad was designed to make a connection between Nike and the positive thoughts and feelings people have with the London Olympic Games using indirect association in the minds of the viewers. Justifiably, official sponsors had a right to be upset about this ad, and a legal action against Nike was considered. However, Nike did not take any chances: prior to the launch, they had the ad thoroughly vetted by Clearcast, the body responsible for checking whether TV ads are breaking the advertising codes policed by the Advertising Standards Authority. By following the correct procedure, Nike narrowly escaped a lawsuit by the London Olympics organizers (Sweney 2012a, 2012b). Responding to the mounting criticism on the issue, Nike's Vice President of Global Brand Design, Greg Hoffman, stated that '[t]he idea is to simply inspire and energise everyday athletes everywhere and to celebrate their achievements, participate and enjoy the thrill of achieving in sport at their own level' (cited in Sweney 2012a). Nike spokesperson Brian Strong adds that:

The Nike 'Find Your Greatness' spots feature everyday athletes from multiple locations called London around the world, to illustrate that greatness can be found by anyone, anywhere. We think that is

a powerful message at a time when the world is focused on London, UK. (cited in Briggs 2012)

Quan Payne, Nike's Global Art Director for the Olympics, provides a similar answer. According to him:

This campaign was about capturing the spirit of what Nike was all about […]. [With this campaign] Nike wanted to show that they are not just about the elite. They went back to the very foundation of the brand which is: If you have a body, you are an athlete. (Payne 8 September 2012 interview)

While the Olympic organizers were trying to thwart Nike's ad, a spokesperson for Adidas attempted to downplay Nike's campaign in a gentlemanly fashion: 'We have absolutely no issue with it at all. […] It is not for us to comment on it. There is no sign of ambush [marketing]. […] I don't think [Nike's ad] relates to the Olympics at all' (cited in Sweney 2012b).

The outcome

The so-called ambush marketing approach has proven to be a highly effective marketing practice for Nike. If we take into account the social media metrics surrounding the Olympics, then we can see that Nike was far more successful than Adidas, despite having the 'high ground' as the official sponsor of the event. According to *The Realtime Report,* the breakdown of the results shows the following:

- Over 16,000 Tweets associated the word 'Nike' with 'Olympics', in comparison with fewer than 9300 for Adidas.

- @Nike followers grew 11 per cent from opening to closing ceremonies, adding more than 57,000 to the brand, while @Adidas Originals grew only 4 per cent, adding 12,000 followers to the brand over the same period.

- 'Find Your Greatness' ad earned over 7000 more Tweets than Adidas' 'Take the Stage' campaign that was launched at the same time.

- Over the course of the Games, Nike added twice as many Facebook fans as Adidas. (McNaughton 2012)

Advertising Age reported similar metrics. According to them, within one week of the Games starting, Nike's 'Find Your Greatness' received the No.1 spot on the Viral Chart with 4.5 million views; Adidas' 'Take the Stage' placed at No.3 with 2.9 million views. While, 'Take the Stage' has had a total of 5.7 million views since they launched in April 2012, this shows that Nike had nearly caught up with them in a single week. In addition to this, an online survey conducted by Toluna in the US showed that 37 per cent of the participants identified Nike as an Olympic Sponsor, compared to 24 per cent that identified Adidas as the sponsor. This might be particularly frustrating to Adidas considering that Nike achieved similar results against them during the 2010 World Cup as well (see Russell 2012).

Ethical considerations

In the past, ambush marketing was thought of as 'devious, unethical tactic' and 'unfair marketing practice'; however, this opinion has changed, and ambush marketing in its broad sense is now recognized as a legitimate marketing practice by the broader marketing community and legislators (Shani and Sandler 1998: 371). Nevertheless, there are certain ethical issues with this practice that need to be taken into consideration.

While the merits of being an ambush marketer are clear for the rival brands – as the case of Nike shows – these benefits are essentially achieved at the expense of the official sponsors and organizers. Such activities are significantly weakening the impact of the official sponsors, and the logical consequence is

that corporate sponsors may lose interest in sponsoring events such as the Olympics, who rely on heavy corporate sponsorship in order to exist (O'Sullivan and Murphy 1998). This problem, however, does not seem to bother Nike.

According to Nike's Director of Global Event Marketing, Mike Pilkenton, as long as Nike is within its legal rights, they should be able to communicate their messages freely: '[W]e feel like in any major sporting event, we have the right to come in and give our message as long as we don't interfere with the official proceedings' (cited in Crow and Hoek 2003: 7). What this suggests is that ethical considerations do not form Nike's decision criteria. Instead, the company is focused on the legality of their actions and making sure that they will not breach any relevant statutes (Crow and Hoek 2003: 7).

On this point, Nike is correct. It is not their responsibility to solve the problems that the Olympic Committees have brought on themselves by introducing a sponsorship model in which only one company can dominate in each category. Therefore, as it seems that ambush marketing is here to stay, some experts recommend a restructure of the Games' sponsorship agreements as one way of tackling this issue.

Sponsorship and the Olympic Games

Sponsorship was always a part of the modern Olympic Games. The first Olympics, held in Athens in 1896, was made possible by a gift from a wealthy architect by the name of Georgious Averoff, by the sale of souvenirs and by advertising in the game program; Kodak, for example, was one of the advertisers at the time. As the Games evolved, so have the sponsorship arrangements. In 1912, the Olympic organizers allowed companies to pay for the right to use photographs of the competition for promotional purposes. In 1924, advertising was allowed to be present inside the Olympic Stadium, but the IOC later banned this practice due to public uproar. In 1928, companies were allowed to sell their products on-site, and Coca-Cola was one of the first companies to use this opportunity. As the Games gained momentum, sponsors became increasingly interested in becoming involved with the event. Between the 1960s and the 1980s, the Games recorded a large increase in sponsors: from 46 in 1960 to 628 in 1976. During this period of growth, there were no significant efforts in ambush marketing. Since sponsorship was an open marketplace, any company that desired to become a sponsor could do so; as such, there were no real incentives for companies to engage in ambush marketing. The situation changed in 1984 after the Games redefined the sponsorship market. For the first time, three categories of supporters were introduced: official sponsors, suppliers and licensees. In each category, the organizers introduced exclusive rights and limited the number of sponsors. They did this in an attempt to negotiate higher fees from willing sponsors, and this proved to be a good business decision on their end. However, this business practice pushed many rival brands to resort to alternative marketing tactics, and in return, ambush marketing was born (Shani and Sandler 1998: 369–370). Therefore, if the Olympic organizers are not willing to change the way their sponsorship agreements work, at the very least they should invest in educating the public about who the official sponsors are and what kind of problems ambush marketing can create for the future of the Games (Shani and Sandler 1998: 370–371; see also Crow and Hoeck 2003: 9–11; O'Sullivan and Murphy 1998: 363–364).

Conclusion

What this study shows is that ambush marketing does work, especially if this is supported by research and creative zeal, and executed with great attention to detail, if not purely for legal purposes. This, however, does not mean that sponsorship is an

ineffective marketing activity. Sponsorship is still a very attractive option for marketers, especially when they want to associate themselves with positive and highly visible figures or events. Yet, for multinational corporations eager to transcend cultural barriers and promote their standardized messages to a worldwide audience, there are very few opportunities for that. Sporting events such as the Olympics have the global appeal that these corporations want, but they provide expensive and limited sponsorship prospects. That is why brands like Nike have chosen to pursue an alternative route and engage in ambush marketing instead (O'Sullivan and Murphy 1998: 350).

Then again, this may not be the whole story behind Nike's ambush marketing strategy. Nike's decision to associate themselves with high-performing athletes, rather than with the organization that manages the event where the athletes are participating, appears to be a strategic decision on their end. In their advertising campaigns, Nike always puts the emphasis on individual athletes by glorifying them or encouraging them to do better. From this point of view, it makes sense for Nike not to be an official sponsor of the Olympics, and instead to stand behind the athletes (the people) rather than the Games (the institution). This seems to be an ideological choice grounded in the essence of the brand. Rebelling against the system and challenging the convention is simply a part of the brand image that Nike tries to project.

Then again, this position may change in the near future. With Adidas pulling out of the 2016 Rio de Janeiro Olympic sponsorship, and with Nike stepping in as the official sponsor – at least according to some sources (Stewart 2012) – it remains to be seen what their new corporate communications strategy might look like down the track, and whether this time Adidas will decide to ambush its arch-rival in return.

References

Balfour, F. (2008), 'Li Ning pulls off Olympic-sized marketing ambush', *Bloomberg Businessweek*, 10 August, http://www.businessweek.com/globalbiz/blog/eyeonasia/archives/2008/08/li_ning_pulls_o.html. Accessed 12 May 2013.

Baxter, K. (2012), 'London Olympics: Other shoe has dropped in Nike vs. Adidas tussle', *Los Angeles Times*, 6 August, articles.latimes.com/2012/aug/06/sports/la-sp-on-nike-adidas-20120806. Accessed 4 March 2013.

Briggs, B. (2012), 'Nike takes marketing gold with neon-yellow shoes', *NBC News*, 19 August, http://www.nbcnews.com/business/nike-takes-marketing-gold-neon-yellow-shoes-934825. Accessed 4 March 2013.

Byrnes, M. (2012), 'Not an official sponsor, Nike still gets more attention than Adidas at Olympics', *Atlantic Cities*, 26 July, http://www.theatlanticcities.com/politics/2012/07/not-official-sponsor-nike-still-gets-more-attention-adidas-olympics/2727/. Accessed 4 March 2013.

Chan, T. and Hudson, E. (2007), *Ambush Marketing Legislation Review*, Document prepared for IP Australia and the Department of Communications, Information Technology and the Arts (DCITA), Australian Government, Canberra.

Crow, D. and Hoek, J. (2003), 'Ambush marketing: A critical review and some practical advice', *Marketing Bulletin*, 14: 1, pp. 1–14.

Hiestand, M. (2012), 'Nike, famed for Olympic ambush marketing, tries new tack', *USA Today*, 25 July, http://content.usatoday.com/communities/gameon/post/2012/07/nike-famed-for-olympic-ambush-marketing-tries-new-tack/1. Accessed 4 March 2013.

Lawrenson, A. (2012), 'Nike trainers steal the show at Olympics', *Elle UK*, 6 August, http://www.elleuk.com/beauty/news/nike-trainers-steal-the-show-at-olympics. Accessed 4 March 2013.

Marketing (2012), 'Nike gazumps Adidas in stunning Olympic ambush', *Marketing*, 26 July, http://www.marketingmag.com.au/news/nike-gazumps-adidas-in-stunning-olympics-ambush-17209/#.UWEwZRi8Ey4. Accessed 4 March 2013.

McNaughton, M. (2012), 'How Nike stole social media gold from Olympic sponsor Adidas', *The Realtime Report*, 21 August, http://therealtimereport.com/2012/08/21/how-nike-stole-social-media-gold-from-olympic-sponsor-adidas/. Accessed 4 March 2013.

Meenaghan, T. (1998), 'Ambush marketing: Corporate strategy and consumer reaction', *Psychology & Marketing*, 15: 4, pp. 305–322.

O'Sullivan, P. and Murphy, P. (1998), 'Ambush marketing: The ethical issues', *Psychology & Marketing*, 15: 4, pp. 349–366.

Pagano, M. (2012), '£100m in sponsorship – And the Olympics have Adidas written all over them', *The Independent*, 25 July, http://www.independent.co.uk/news/business/analysis-and-features/100m-in-sponsorship--and-the-olympics-have-adidas-written-all-over-them-7973367.html. Accessed 4 March 2013.

Pathak, S. (2012), 'Meet the man behind Nike's neon-shoe ambush', *Advertising Age*, 20 August, http://adage.com/article/news/olympics-meet-man-nike-s-neon-shoe-ambush/236756/. Accessed 4 March 2013.

Pitt, L., Parent, M., Berthon, P. and Steyn, P. G. (2010), 'Event sponsorship and ambush marketing: Lessons from the Beijing Olympics', *Business Horizons*, 53, pp. 281–290.

Russell, M. (2012), 'Nike ambushes Adidas on world stage… again', *Advertising Age*, 31 July, http://adage.com/article/the-viral-video-chart/nike-ambushes-adidas-world-stage/236400/. Accessed 4 March 2013.

Shani, D. and Sandler, D. M. (1998), 'Ambush marketing: Is confusion to blame for the flickering of the flame?', *Psychology & Marketing*, 15: 4, pp. 367–383.

Stewart, M. (2012), 'Nike captures marketing gold with eye-catching Olympic strategy', *The Huffington Post*, 11 July, http://www.huffingtonpost.ca/2012/08/11/shoe-maker-captures-marke_n_1767419.html. Accessed 4 March 2013.

Sweney, M. (2012a), 'Olympics 2012: Nike plots ambush ad campaign', *The Guardian*, 25 July, http://www.guardian.co.uk/media/2012/jul/25/olympics-2012-nike-ambush-ad. Accessed 4 March 2013.

Sweney, M. (2012b), 'London 2012 Olympics will not take legal action over Nike ad campaign', *The Guardian*, 27 July, http://www.guardian.co.uk/media/2012/jul/27/london-olympics-legal-action-nike. Accessed 4 March 2013.

Gjoko Muratovski
Auckland University of
Technology

Dr Gjoko Muratovski has
twenty years of
multidisciplinary design
experience in Asia,
Australia, Europe and the
USA. He has collaborated
with a range of
organizations, including the
UN Association of
Australia, Toyota,
Greenpeace and the World
Health Organization. Dr
Muratovski is an advisor on
brand development
strategies for the
European-based agency
IDEA Plus
Communications, whose
clients include Audi, the
Heineken Group,
McDonald's, Porsche and
Volkswagen. He is also the
chairman of the 'agIdeas
International Research
Conference: Design for
Business', Area Chairman
for Business at the Popular
Culture Association of
Australia and New Zealand,
principal editor of the
*International Journal of
Design Research,* and book
series editor of *Design for
Business.*

Quan Payne
Chobani

Quan Payne, the former
Global Brand Art Director
for Nike during the London
2012 Olympics, is currently
the creative director at
Chobani, where he is
leading and overseeing
all creative development
across marketing, design,
experience and events. His
previous work for Nike
included developing
concepts, directing both
motion and stills for Nike's
key global brand and
product launches around
the Olympic Games
(including all those for the
Olympic Federation), as
well as the groundbreaking
cross-category look and
feel of Nike+. Quan also
worked at Frost* Design as
a design director. During
his tenure at Frost* Design,
he worked on amazing
projects for a wide range
of incredible clients,
producing internationally
award-winning works. As
a consultant from Frost*,
Quan also worked as
a Creative Director of
Woolworths in South Africa

Nike and the London 2012 Olympics – A conversation with Quan Payne (Part 1)

'Much of my job and time was spent on preparation and shooting all Nike's key athletes, such as Lebron James, Allyson Felix, Ashton Eaton, Perri Shakes-Drayton, and many more. Shooting athletes is nothing like shooting models – their time is precious, especially in an Olympic year'.

– Quan Payne

Introduction

This edited transcript is based on an interview between Dr Gjoko Muratovski and Quan Payne. Quan Payne is Nike's former Global Art Director for the London Olympics and former Director for Digital Sports Initiative of Nike+. This interview was conducted via personal communication through e-mail and Skype on 8 September 2012, several weeks after the closing ceremony of the Olympics.

Dr Gjoko Muratovski

Tell me about the work you did for Nike during the London 2012 Olympic Games.

Quan Payne

Being the Global Art Director for London 2012 meant that I was leading three key global initiatives that were launched around the Olympic Games. Mind you, Nike is not an official sponsor of the games. Adidas paid £80 million as a sponsor for the exclusive rights.

Nevertheless, we had to be present in one form or another around the Olympics. So one of these key initiatives that we launched during the Olympics was Nike's hugely innovative Nike+ shoe, which can actually tell you how high you jump, how many steps you take, and much more. The other was the general launch of the Nike Lunar 2012 shoes. The final one was Nike's 'Find Your Greatness' campaign. This campaign was about capturing the spirit of what Nike was all about. I was also in charge of the communications related to the product launches that were seen during the Olympic Games in London, including the infamous yellow Volt spikes shoes that all Nike athletes wore during the athletic competition.

Dr Gjoko Muratovski

How will you sum up your role as an art director for Nike?

Quan Payne

Apart from over 100,000 air miles, months in hotel rooms and sets with over 100 crew on hand, this was the same as any other creative job: coming up with an idea, making sure that it aligned with the brand values and was communicated at the right level for the consumer, then blowing it out across images, retail experience, online and motion.

Much of my job and time was spent on preparation and shooting all Nike's key athletes, such as Lebron James, Allyson Felix, Ashton Eaton, Perri Shakes-Drayton, and many more. Shooting athletes is nothing like shooting models – their time is precious, especially in an Olympic year. Weeks of preparation went into each shoot before the athletes arrived.

Dr Gjoko Muratovski

Tell me more about that.

Quan Payne

We worked with each sport category to ensure that we checked off on their specific needs. We balanced this with what we needed to achieve at a global level and stayed true to the authenticity of each athlete's sport category. This meant learning what the perfect foot strike should look like for running, what aerobic exercises Hope Solo does on the field, and where a defender should be if Lebron takes a rebound. We would run through the entire shoot the day before with body doubles to ensure that the lighting was perfect, and that every action that we asked the

athlete to do was possible and would give us the result we needed. This was taken to the extreme in our Miami shoot. We had to be prepared before we shot as to exactly where Lebron would take off, what height he would reach and how far he would travel when he dunked, as we were told by Nike's sports marketing and his agent that he would only do it four times for us. He was in a good mood and he dunked five times eventually. After the shoot came the long process of athlete approvals and finalizing imagery. Every single image that goes out to the public of any Nike athlete needs to be approved by that athlete. This can take time, as sometimes they don't like how they look in certain photos – as is the case with all of us on occasions. Regardless of that, things moved so fast. While I was shooting the athletes, Nike leadership was still approving final treatments. Unfortunately, a few of the motion pieces had to be changed heavily in post. There are a couple of them that are fundamentally untouched, and these are the ones that I feel are the most successful.

Dr Gjoko Muratovski
What kind of side projects were you working on as well?

Quan Payne
Along with the imagery and motion pieces, the other major chunk of my time went into developing the pinnacle retail experience: working on product presentations, visual merchandizing, shop windows, and even for Nike+ interactive experiences. This was another aspect of design that I had worked on, but not at such depth. I designed the broader architectural design structures that drove broad consumer flow, but almost everything in our pinnacle retail application was designed from scratch, including furniture and even product fixtures. From this we created retail directives that took our pinnacle vision and were applied not only by every Nike store around the world, but also by every retailer that sold Nike products globally. In addition to this, I was also working on a venue where the athletes could relax and get away from the Olympic Village.

Dr Gjoko Muratovski
What was the most amazing experience you had as a designer working for Nike?

Quan Payne
Suddenly seeing things that you created appear across the city, including billboards and department stores, was amazing. Standing outside Selfridges on Oxford Street in London, looking at a queue that extended round the block of young people waiting to get into a Nike pop-up store that contained my creative was something that I never experienced before. And not only that, I think that it is incredible that as a trained 'graphic designer' you end up doing such a wide variety of things. I would also have never thought when I graduated that I would be sitting on a specially designed Mad Max-style truck, with a Phantom camera hanging from a boom out the back, directing Olympic gold medallist Allyson Felix running through the streets of LA.

Dr Gjoko Muratovski
In 1996, Nike caused controversy with its advertising campaign during the Summer Olympics in Atlanta, which featured the slogan, 'You Don't Win Silver – You Lose Gold'. Nike's use of this slogan drew harsh

criticism from many sources, including several former Olympic silver and bronze medallists. How has Nike's Olympics advertising strategy changed since that time? What was the core message behind the London 2012 Olympics campaign?

Quan Payne

The creative output has significantly changed since. There was a new creative output during the Olympic Games based on a Nike's brand strategy – 'Finding greatness in every day'. Nike wanted to show that they are not just about the elite. They went back to the very foundation of the brand, which is: If you have a body, you are an athlete. At the same time, we looked at the retail side, which was about products and athletes. This was based on telling stories through each athlete, while highlighting the latest product benefits.

Dr Gjoko Muratovski

What kind of thought process goes in developing advertising and branding campaigns for Nike?

Quan Payne

This process is well defined at Nike. At the moment, Nike is focused on product superiority; so all campaigns revolve around new product innovations. This process follows a brief from category marketing (each category is responsible for a different sport, i.e. basketball, running, women's training, athletic training, etc.). This then informs the product's benefits, such as lightness or speed. This in turn drives the idea that can be communicated to the consumer through image and copy, while also aligning with the broader marketing plan and fitting it in with the brand language.

Dr Gjoko Muratovski

Can you give me an interesting corporate experience from working with Nike?

Quan Payne

As I mentioned, I worked on Nike's 'summer' initiatives that were launched a year before the Olympics. The creative part of the work was great and I really enjoyed it. After shooting Lebron James and working on the treatments, going to meeting after meeting was quite a different experience altogether. Pushing the creative through the various corporate layers can often make you forget what your brand means to the general public, and you lose yourself in the struggle with the corporate process. But, when I was sitting in a pub watching the third game in the NBA finals, and the commercial I directed came up on the big screen (Lebron dunking from just after the free throw line) – and everyone went silent and simply watched – I came to realization that I am not just helping to define the brand: I am helping to create the very culture in which the brand exists. This was also underpinned by the fact that 17 million people saw my ad that night. I would never have dreamt to have a reach like that when I worked in a design studio.

Gjoko Muratovski
Auckland University of
Technology

Dr Gjoko Muratovski has twenty years of multidisciplinary design experience in Asia, Australia, Europe and the USA. He has collaborated with a range of organizations, including the UN Association of Australia, Toyota, Greenpeace and the World Health Organization. Dr Muratovski is an advisor on brand development strategies for the European-based agency IDEA Plus Communications, whose clients include Audi, the Heineken Group, McDonald's, Porsche and Volkswagen. He is also the chairman of the 'agIdeas International Research Conference: Design for Business', Area Chairman for Business at the Popular Culture Association of Australia and New Zealand, principal editor of the *International Journal of Design Research*, and book series editor of *Design for Business*.

Quan Payne
Chobani

Quan Payne, the former Global Brand Art Director for Nike during the London 2012 Olympics, is currently the creative director at Chobani, where he is leading and overseeing all creative development across marketing, design, experience and events. His previous work for Nike included developing concepts, directing both motion and stills for Nike's key global brand and product launches around the Olympic Games (including all those for the Olympic Federation), as well as the groundbreaking cross-category look and feel of Nike+. Quan also worked at Frost* Design as a design director. During his tenure at Frost* Design, he worked on amazing projects for a wide range of incredible clients, producing internationally award-winning works. As a consultant from Frost*, Quan also worked as a Creative Director of Woolworths in South Africa.

Nike and the London 2012 Olympics – A conversation with Quan Payne (Part 2)

'Whether you like it or not, that was a focus on elevating those uniforms into superhero status by referring to superhero qualities. Nike's marketing strategy is very much about elevating the average person to greatness and to that superhero level'.

- Quan Payne

Introduction

This edited transcript is based on an interview between Dr Gjoko Muratovski and Quan Payne. Quan Payne is Nike's former Global Art Director for the London Olympics and former Director for Digital Sports Initiative of Nike+. This interview took place on 30 April 2013 during the agIdeas International Research Conference: Design for Business.

Dr Gjoko Muratovski

The conversation that we'll be having today with Quan is about the so-called 'ambush marketing' practices that Nike employed during the London 2012 Olympic Games. So what is ambush marketing? Ambush marketing is a term used to describe a practice by which a rival company tries to associate its products with an event that already has official sponsors. In this case, Nike was seen as a rival company ambushing Adidas, who was the official sponsor of the Games. For Nike, this almost resulted in a lawsuit by the London Olympic Committee. The charges were eventually dropped as unfounded and Nike's London campaign is now part of marketing history. While Nike has been criticized by the Olympic Committee for managing to project itself so prominently during the Games without having sponsorship status, at the same time it was praised by the advertising and marketing community for delivering a genius communication strategy. A week or two after the Olympics, Quan and I had many long conversations about Nike's design and marketing strategies, and basically about the whole experience of working for Nike on such a major project.

In the course of our conversation, what we have identified is that there were two key campaign elements that stuck in people's minds. The first one was the introduction of Nike's Volt shoes. The reason why the Volt shoes stood out so much in the crowd, regardless of the obvious 400 athletes who wore them, was because they were scientifically designed to do so. According to Nike's research, of all the colours of the rainbow, the human eye and visual system is most sensitive to the yellow/green zone. The power of the visual signal is capitalized even further when the background is highly contrasting, such as against the London Olympic track, which is red in colour. Bringing them together creates a striking effect. People simply can't stop staring at them. In addition to the red track, Nike also tested the colour against the blue and white of the fencing stage, and the black and blue of the boxing ring – which also worked well. The other campaign that brought Nike a strong association with the London Olympic games was the 'Find Your Greatness' ad. This ad pushed the legal limits of what was allowed from a non-sponsor of the London Olympic Games.

Quan, what can you tell us about the IOC's infamous Rule 40? What kind of challenges did you guys face in planning your campaigns?

Quan Payne

Basically, 'Rule 40' meant that no other company other than the approved sponsors for the Olympic Games were allowed to show athletes during the Olympics. However, this meant any athletes who were effectively professionals and were potentially going to compete in the Games. The Rule 40 issue – and it's quite a contentious one – extends beyond just athletes; it also is about imagery that refers to, is relevant to, or insinuates connections with the Olympic Games.

There was one story about the 'Olympic Police', who went around to all the storefronts in London during the Olympic Games monitoring whether there had any promotional campaigns that contravened Rule 40. As it happens, there was one butcher who actually strung up sausages in the shape of the Olympic Rings in his shop window and was given a cease-and-desist notice. So he had to take down the sausages, which was quite a funny thing to be reprimanded on. I think that this is really unnecessary for small businesses. Also, when the Olympics are coming to town, everyone's gets really excited and so enthralled to be part of the event that people can't help but celebrate this and be part of the festivities. It's unfortunate in some sense that the Olympic Games are so monopolized by these large sponsors that it takes away from the ability for these small businesses to compete.

Dr Gjoko Muratovski

Nike, on the other hand, is not a small business. Still, even for a major brand such as Nike, there are many challenges when it comes to staying relevant during such a major event that literally dominates over everything else that is happening at that time. And this becomes not only a legal challenge, but a creative one as well. In addition to this, this time you also had to compete in London, a truly global city, where all major brands are fighting to have their voice heard all the time – and twice as hard during the Olympics. So when it comes to achieving a brand impact in such a city where you are basically competing with the best of the best, what kinds of challenges would you say a brand like Nike was facing?

Quan Payne

I think that there are many challenges, but there are also many opportunities. Prior to that, Nike did the South African World Cup and we were faced with similar challenges there as well. But the engagement that you're able to do in a country like South Africa is a far lesser one compared to a place like London. What we are normally trying to do is to really build an engagement around our brand. This doesn't necessarily mean driving towards the actual Olympics, but feeding off the excitement and the festive nature of the atmosphere. Our whole campaign towards 'Find Your Greatness' was really geared at empowering the community versus driving towards a pinnacle athlete. I think that really shows in how we engaged the communities at the point. For example, during the Games we threw a lot of parties that were about social interaction, music and culture, and not necessarily just focused on athletes and the Olympics.

Dr Gjoko Muratovski

Can you tell us a bit more about the design of the shoes and apparel? What other elements did you guys take into consideration to enhance the visual effect of the athletes?

Quan Payne

It's funny because we spent so much time thinking and working on advertising campaigns – how we could engage the public and really make our brand presence known at the time – and as you said, at the end of the Olympics, all everyone could talk about was the Volt shoes. In this case, the shoes outperformed the ads. The shoes and the apparel were the key elements that Nike introduced as a way

of helping the visual aspect and drive of our athletes. We did the same with the speed suits. For anyone that's not familiar with these speed suits, they are basically the skin-tight suits that were really started by Cathy Freeman during the Sydney 2000 Olympics. On the inside of the arms, they put colours or white stripes, or contrasting stripes, to create somewhat of a Muybridge effect as the athletes would run. We called that the 'Flicker effect'. In this way, not only the shoes but also the bodies of the athletes created an effect that was really unique to our brand.

Dr Gjoko Muratovski

What I really like about the whole thing – and with the suits especially – is how Nike manages to create that superhero effect which is constantly present in your campaigns. This way of branding is something that works well with the whole idea of the brand, including the mythical name of the company, Nike – the goddess of victory – and this translates really well with the idea of introducing athletes as a kind of demigod.

Quan Payne

That was something that was also viewed within the logo creation around the US Olympic team. Whether you like it or not, that was a focus on elevating those uniforms into superhero status by referring to superhero qualities. Nike's marketing strategy is very much about elevating the average person to greatness and to that superhero level. It's something that is an easy metaphor that everyone understands.

Dr Gjoko Muratovski

Another thing that is quite interesting about Nike is the whole idea about empowering the average person, about empowering the 'underdog'. In a way, this is reflected with the anti-sponsor status Nike has with the Olympics. It's certainly not the case that Nike can't afford to be the sponsor of the Olympics, but I think that Nike chooses not to do so because it would rather associate itself with the underdogs, with the small businesses, with the people that can't do that. How would you comment on that?

Quan Payne

There's a little bit of history to that. One of the icons within Nike, and someone local to Oregon where I was based, is a guy called Steve Prefontaine. Basically, he was one of the best runners in the world at the time and really influential in the development of Nike products. What happened throughout that period of time was that the US Olympic Committee – and this applies to the International Olympic Committee in general – didn't necessarily support the athletes. And they still don't. When we talk about professional athletes, I know we all think of the LeBron Jameses, the Kobe Bryants and the Cristiano Ronaldos out there, but a lot of the athletes that are currently competing in the Olympics really struggle to get by and they actually wouldn't be able to compete without the support of sponsors such as Nike. Nike's incredibly influential not only in terms of giving people products, but also enabling them to actually train, giving them access to amazing facilities, building them training areas, and also paying for their flights to compete in events.

One part of my job during the Olympics was to build a Nike athlete's lounge – quite a large space in London that was really a place where athletes could come and get away from the Olympic Village. The

Village is not really that pleasant a place to be if you're trying to relax and you want to compete the next day. We gave away lots of what we call 'swag' in terms of products to the athletes. And a lot of these athletes that Nike sponsor, especially on small contracts, really don't have the access to even get shoes or materials unless they have a sponsorship. So I think in terms of your question, Nike's really always had been about empowering the athletes – emerging or established. For us, this resonates with the motto, 'If you have a body, you're an athlete' – and this extends to empowering everyone and allowing everyone to do the best that they can.

Dr Gjoko Muratovski

That is absolutely correct and this is the perfect way for a brand like Nike to position itself. The ideology behind the brand has been beautifully shown in the 'Find Your Greatness' ad, and I think that the ad really captured the essence of the Nike brand. The ad shows underdog athletes from all walks of life competing against all odds and conditions. This narrative works on many levels, and I think that many people can relate to these athletes in one way or another. Perhaps that is the reason why this ad was so well accepted by the public. On another point, the ad really pushes Rule 40 to the max by filming the ad on locations all over the world that are called London – except London in the UK, where the Games were actually held. This was clearly the gem of the ad: the idea of challenging authority, which is exactly the type of thing you would expect from a brand that likes to be seen as a non-conformist rebel.

Quan Payne

I agree with your point. The ad really underscores Nike's attitude in terms of that little bit of subversive rebelliousness; of, you know, taking Rule 40 and pushing the limits with the nod towards all the places that are called 'London'. It would have been easy to not do that and still have the same ad, but it's always nice to have the little smile that you get when you are breaking the rules sometimes, and to get that feeling that you're a little bit rebellious and that you're pushing the limits because you can.

Dr Gjoko Muratovski

That is what I love about the whole brand strategy of Nike. Nike projects the idea that they are not only about the Games, but they are also about challenging the rules, pushing the limits and setting new boundaries. And this has been reflected in the whole campaign around the Olympics. But I can't help to wonder what will happen if the tables eventually turn and Nike chooses to become an Olympic sponsor after all. There are rumours going on that Adidas is pulling out as a sponsor after many years, and that now the door is open for Nike to step in as an official sponsor. If Nike does step in as an official sponsor it would be interesting to see how they will change the way the sponsors behave. I wonder what your thoughts are on this if this does happen.

Quan Payne

I can't comment on whether or not they are going to sponsor the Olympics in the future. But what I can say, from what I have learned during my time at Nike – and this is something I do respect about them – is that Nike is very much about the spirit of competition. And competition drives creativity. Being on the opposite side is healthier from a creative point of view.

Dr Gjoko Muratovski

Thanks Quan. Let's open the floor for questions from the audience now.

Audience Question

Was there a sales lift from the Olympics' activities?

Quan Payne

What Nike really utilises the Olympics for is for creating what they call a 'brand defining moment'. Nike doesn't have any direct sales push during the Olympics other than some selected merchandise, and this is really a small part of their business. What Nike tries to do with their campaigns is really try to uplift people's emotions. Hence, the 'Find Your Greatness' campaign is really more anthemic in nature, and the focus is on building love for the brand versus creating a drive towards direct sales.

Audience Question

Was it your decision or your advice in terms of how far things could go? Whose decision was it to push Rule 40?

Quan Payne

In a company the size of Nike, things like this are not based on the decision of individuals. I was involved with certain parts of the campaign, but obviously the final decision comes down from the VP of marketing and their advice from legal, who are making sure that everything is within legal boundaries.

Dr Gjoko Muratovski

I know that the 'Find Your Greatness' ad, before it was officially launched, was vetted by the authorities. It was proofed so that they would not get sued. So nothing went to air before it was checked by the authorities. Nike was playing it safe, even though it appeared like they are crossing a line there.

Quan Payne

Correct. Everything that has an Olympic logo needs to go through vetting. The current company where I am now is actually an Olympic sponsor, and everything we do also has to be vetted first, regardless of our sponsor status.

Audience Question

Let's say Adidas are pulling out and Nike moves in. If Adidas do a similar approach to Nike, would a battle be fought? Or will Nike leave them be and say, 'Well, they are the underdog and we are the official now. So let them play the game that we've played'?

Quan Payne

I think for any business – and it doesn't matter if you are Nike or Adidas, or McDonalds, or whoever's a core sponsor of the Olympic Games – the investment in that is so substantial that you have to protect it. But as I am no longer with Nike; I can't really comment on that.

Dr Gjoko Muratovski

I think that it's time for us to close this session now. Quan, I would like to thank you for joining us today and being a part of agIdeas.

Nina Terrey
Thinkplace

Dr Nina Terrey is a partner at ThinkPlace design consultancy. Founded in 2005, and with offices in Australia and New Zealand, ThinkPlace was one of the first companies to apply design thinking to large-scale, complex problems typically faced by governments. Terrey also lectures at the University of Canberra and the Australian New Zealand Institute of Governance on design, citizen-centred governance and contemporary public sector management. Her research interests focus on the institutionalization of design in management work, specifically in the public sector. She has a doctorate in management, with an emphasis on 'managing by design'. Terrey is an accomplished public speaker and regularly speaks at conferences internationally. In 2012, she presented papers at the Design Management Institute's 'Innovation Through Design' conference in Boston, USA; at the 'Local Public Design' conference in Lille, France; and at the 'Design and Displacement: Social Studies of Science and Technology' conference in Copenhagen, Denmark. Terrey is also contributing a chapter to a forthcoming book from Gower Publishing entitled *Design for Policy*.

The role of design in building public value: The case of the Australian Taxation Office

The incorporation of design as a core management activity is increasingly seen as a fundamental source of transformation in the social world. This paper is based on an in-depth management case study from a recently completed Ph.D., which explored how one public sector organization, the Australian Taxation Office, is addressing organizational problems as design opportunities in ways that centres the human experience, thereby designing more efficient and effective public services. This non-traditional approach to management scholarship provides insight into the intersection of management, design and governance studies. This paper will present insights into how organizations can become more design aware and thus integrate design into their day-to-day work. Furthermore, the paper will present and discuss specific applications of design thinking to complex problems in the implementation and administration of policies. Importantly, this paper illustrates the shift from traditional command and control bureaucracy to a creative, innovative collaboration between managers and clients, with the aim of developing more humanly satisfying organizational forms.

The application of design thinking to complex systems of human interactions, such as the design of government services, is recognized in this study through the lens of networked actions and interactions, and of the multiplicity of non-human and human actors that provide a rich tapestry for analyses. This paper contributes to an exciting new future for design and designers who want to contribute to deep and meaningful outcomes which deeply satisfy people and society in the everyday.

Keywords
public value
design thinking
Australian Taxation Office
situational analysis
actor—network theory

Introduction

This paper proposes to look at an emerging application for design, and a growing and interesting field of research: the role of design in the public sector. This concept of design in the public sector is about building public value. The scholarship that looks at the role of design in building public value is increasing, in part at least, because the sum total of benefits experienced by a multiplicity of people in the design and delivery of public services constitutes public value, and getting this right is critical to effective governments and desirable communities. This is opening very new and exciting domains for designers wishing to attend to both their educational projects and careers; for scholars and teachers wishing to build broader problems/opportunities into design and management teaching; and for stimulating public sector organizations to consider a role for design in their organizational life. This paper explores the role of design in public management in one case organization – the Australian Taxation Office (ATO). It presents some results from a Ph.D. study that proposed that if we want public organizations of the future to embrace designerly ways of being (Cross 2006), then we need to pay attention to those organizations that already consider design as a particular approach to their work. We need to understand how these organizations have allowed design into their operations, and to study the characteristics of these organizations in the hope of finding qualities and characteristics that other organizations – both new and existing – can emulate. This paper will draw from empirical evidence gathered from the Ph.D. study, which analysed the application of design thinking in the ATO over a five-year period. This paper will not go into the intricacies of the ATO, nor look at its tax administrative work, but rather take a considered view of the embedded meaning of design as a legitimate role in the organization. The structure of this paper is divided into four parts: part one discusses the data sources and methods used to analyse these data sources; part two discusses the current literature on public value and the growing predominance that design has in public organizations; part three discusses five themes developed in the Ph.D. research which defined the qualities of the organization, and which demonstrate a legitimate role for the use of design in the everyday work of the ATO; and part four draws some insights as to how embedded meaning indicates the qualities or characteristics of a designerly organization.

Methods

There is limited evidence of large, complex public sector organizations incorporating the development of human-centred design into their management work and then sustaining this over a long period. This paper presents some findings from a Ph.D. research which explored the adoption and embedding of design as a management practice in the Australian Taxation Office (ATO). This research defined the concept of 'managing by design' as a means to bring a stronger focus to the human experience: as the tax system represents a core component in terms of its management work, the ATO was able to practice human-centred methods and approaches in everyday management practices. The ATO is one of the largest government organizations in Australia, employing over 22,000 employees. It is responsible for the administration of taxation and superannuation legislation in Australia, which means millions of human interactions each year. The ATO is a pioneer in applying design methods to its administrative work (Body 2007; Junginger 2006; Terrey 2010a, 2010b). The research design used a multiplicity of

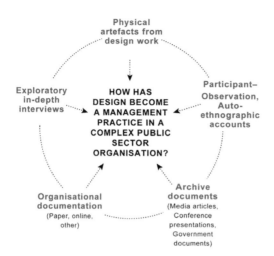

Figure 1: Methods used in the research.

methods, including: exploratory in-depth interviews with designers and management in the ATO, ranging from junior levels through to very senior public managers; a review of organizational documents; gathering design artefacts produced by the ATO; and auto-ethnographic accounts from the author's own experiences as a designer there (Figure 1).

The purpose of using a wide range of methods and data sources was to build a rich picture of what it means to conduct design in the ATO. The gathering and analysis of data was conducted iteratively over three stages. Each of these stages involved gathering, analysing and writing research notes. The initial data set – a set of in-depth exploratory interviews – was carefully analysed and coded word-by-word, and themes were developed using grounded theory (Charmaz 2006). These thematic codes were iteratively refined and built on over the course of the study. As the research progressed, the

analysis and framing of the research inquiry was influenced by a theoretical and methodological framework of combined theory, as well as a methods package consisting of grounded theory (Glaser and Strauss 1967), situational analysis (Clarke 2003, 2005, 2009) and the actor–network theory (ANT) (Callon 1986, 1999; Latour 1999, 2005; Law 1999, 2007). The emphasis here on the combined package is that the lens of situational analysis helps in both the visual analysis of the data and in seeing the data in terms of a collection of 'elements' (Clarke 2003). Moreover, the relations between these elements elicit significant insights that informed the research results. Further to the use of situational analysis, ANT drew attention to the 'human' and 'non-human' elements, and the importance of the networked view of these. ANT brought attention to the materiality, the semiotic relations between the elements (e.g. designers), the artefacts they made, and the interactions they had with other people in and outside the ATO, thus enabling a deeper, more practiced appreciation of design in the everyday life of management work. ANT brought forth an emphasis on the creation and evolving nature of networks of elements, and how the temporal nature of these networks is contingent upon strategies, interventions and other actions taken by actors within the networks. This opened up the analysis and research inquiry into such areas as: Who is influencing who? Are others enrolled in design; and if so, how? What has permitted design to 'stick' in these networks? What might be the meanings of design in the organization? How might these meanings give clues to the imprint of design? And how might this be useful for other organizations?

Literature
Design as a role in building public value
The idea of public value means the 'ability for a public sector organisation [or a collection of organizations] to create something substantively valuable' (Alford and O'Flynn 2008: 4). This concept of public value, as presented by Moore (1995), has been discussed

and built on in governance studies over the last two decades. Of interest to this paper are arguments that public value is created when public organizations successfully meet the needs of citizens (Church and Maloney 2012). This presents a strong connection to the role of design in creating public value, as design is about being human-centred; it is also about understanding the needs and desires of citizens and users; furthermore, it is a collaborative and ongoing means to engage citizens in the making of products and services that they will eventually live and work with in everyday life. The inclusiveness of design is an important discourse that is gaining momentum in the public management literature. Trends in public sector management emphasize productive citizen engagement and participation in public policy and service design. These trends relate to the displacement of the citizen or end user of public services from a partial role towards a more participatory one in public sector management. This implicates the public sector organization and the changes needed to occur in its institutional arrangements so as to enable these different practices.

The connections between successfully meeting the needs of citizens – and using design to understand these needs – and co-creating new public services was addressed in a paper authored by Parker and Heapy (2006) entitled *The Journey to the Interface: How Public Service Design Can Connect Users to Reform*. The authors argued that service design – which is concerned with improving and enhancing the service experience by taking a human-centred or user view at the interface of services – can be productively applied to public services, and thereby 'uncover the seeds of a renewed sense of legitimacy for public services' (Parker and Heapy 2006: 16). The authors state: 'if applied systematically, service design can offer a vision for the transformation of public services, as well as a route to get there' (Parker and Heapy 2006: 81).

In public management theory, discussions into creating opportunities for citizen participation in public policy and administration has been gaining momentum since public management reforms of the 1980s (Osbourne and Brown 2005: 59). The emphasis towards increased democratization when designing public policy and public services points to more deliberative and participatory processes with which to engage citizens (Osbourne and Brown 2005: 62; see also Leadbeater 2004; Leadbeater, Bartlett and Gallagher 2008). This has been driven by arguments suggesting that citizens' engagement in participatory processes strengthens democracy, improves trust between communities and government, maintains system integrity, and builds towards consensus and public value (Bingham, Nabatchi and O'Leary 2005; Dryzek and List 2003; Gutman and Thompson 1996; King and Stivers 1998; Thomas 1995; Yang and Pandey 2011). In an analysis of citizen engagements used to address significant community problems in New York and Chicago, Fung (2003: 33) concluded that 'engaging ordinary citizens in empowered deliberations about the operations of government can increase legitimacy, bring crucial local knowledge to bear on public action, add resources, and enhance public accountability'. In simple terms, this means public managers engaging the public or the community in processes of change. These changes relate to rules, regulations, laws and services, either through payment of taxes, receiving benefits, or accessing health benefits or the police service. Denhardt and Denhardt (2000: 32) conceptualized this shift as community-centric: 'administrators should see citizens as citizens (rather than merely as voters, clients, or customers); they should share authority and reduce control, and they should trust in the efficacy of collaboration'.

This view of collaboration between public administrators and citizens in Australia has been promulgated by the Moran Review's Ahead of the

Game – Blueprint for the Reform of Australian Government Administration March 2010, which proposed nine key reforms, the first of which stated 'Deliver better services for citizens' and the second indicated 'Creating more open government' (Moran 2010). These reforms are active and deliberate attempts to change cultural features of Australian public services (Christensen et al. 2007: 122). The emphasis within these reforms is on citizen-centred policy-making and program delivery, or involves including citizens as 'active participants' (Moran 2010: 38), as was stated in an earlier review document preceding the Moran Review:

[C]itizen centred means placing the citizen at the centre of the entire public service endeavour. This requires a meaningful commitment to actively engage and empowering people at all points along the service delivery chain—from high-level program and policy formulation all the way to the point of service delivery, and capturing feedback from the users of services. (Australian Government 2009: 28)

This extract amplifies the relative location and relationship of the citizen with the public manager in the service delivery chain – from the initial stages of policy through to implementation and access to public services. It also implicates the public manager and citizens as being located much closer in proximity to each other. By 'location' here we mean the representation and presence of the citizen in the processes, as well as the work of the public manager; in other words, the proposed citizen-centred view means the public manager takes a much closer, more considered and human reference in their work, akin to a partnership model. This is different from traditional and (still quite dominant) views of the citizen as a purchaser – a removed and abstract statistic akin to a transactional model relationship. Briggs and Lenihan (2011: 41) describe this as:

[A] transactional relationship is essentially a one-way street. It is a means to the end of delivering something to the customer. To put this differently, in a citizen-centred approach, the relationship must be balanced. Neither the client nor the service provider should have too much influence or control.

This opens up the much-needed debate about the role of public managers, and how they can effectively 'engage and empower people' in the service delivery chain. The Moran Review states that senior executive service leaders and Australian public service leaders at all levels need to model and drive behaviour in areas such as 'citizen-centred service delivery' (Moran 2010: 50). This further demands an exploration of what is meant by citizen-centred service delivery behaviour. In a key-note address at the National Conference of the Institute of Public Administration in Australia, Bourgon (2008: 398) pointed out that 'citizen engagement includes the measures and institutional arrangements that link citizens more directly to the decision-making processes […] to influence public policies, programs and services in a manner that impacts positively on their lives, both economic and social'.

The point that Bourgon makes about 'institutional arrangements' draws attention to people and skills, governance, design processes for change, management arrangements, and tools and technology used to enact citizen-centred philosophy. These institutional arrangements have been scarcely discussed to date in the public management literature on citizen engagement and the design of public services. This same point was raised in an Australian Parliamentary Library research paper entitled 'Citizens' engagement in policymaking and the design of public services': 'in many democracies, citizen participation in policymaking and service design has been debated or attempted, but too infrequently realised […] genuine engagement in co-production of policy and services requires major shifts in the culture and operations of government

Administrative design
An impost
Balancing outcomes and community experience
Breaking tribal behaviours
Codesign
Collective understanding of change
Coming from different angle
Common sense approach
Community perspective
Compliance
Conceptualisation of something
Continually shaping the administrative system
Crucial role
Current philosophy on design
Deep understanding of the user
Design equals change
Design is a verb
Design is fluffy
Designing across our layers of design
Designing it outside in
Different things to different people
Discipled but flexible process
Driven by needs of government and community
Efficiency
End to end
Engaging in conversation with the right minds
How's it going to work in practice
Interaction
Making things easier
Method of process to solve a problem
Multi-disciplinary
Natural systems
No dumb outcomes
Not just about users
Obligations
Outcome based
Past design philosophy
Past perceptions on design
Principles
Process supporting getting the box ticked
Representing products and services interacting with users
Stop doing and think
Strong user interaction focus
Systems thinking
Ta Office perspective
Third party interaction
Understanding intent
User experience
Visualisation
Way of thinking

Table 1: List of codes from data analysis under theme 'Meaning of Design'.

agencies' (Holmes 2011: executive summary).

This last point on the culture and operations shifts is precisely the territory that needs research. This gap raises questions such as: What capabilities do public sector organizations require? What might this change in institutional arrangements look like? How long does it take? What works and what does not?

The proposition stated earlier – that design has a legitimate role in the creation of public value – raises a proposition that design as a capability within public organizations is needed. There are a few cases of public sector organizations reorganizing so that design becomes characteristic of how they work. The National Health Service (NHS) in the UK has adopted design into their work and called it 'experience-based design': '[This] builds on the core principles of user-centred design and has helped healthcare staff capture effectively, and understand, the patient's actual experience rather than relying on opinion or their interpretation of the journey taken through healthcare services' (Maher 2008: 11).

The New Zealand Inland Revenue Agency embedded a design capability into its work. Inspired by work in the ATO, they have fashioned their own meaning of design and emphasized service design as part of their culture (McLean, Scully and Tergas 2008).

This leads to the results discussed in this paper as to how to define the qualities of a designerly organization. In addition, we ask: How might these qualities or meanings of design inform other public organizations about design's role in having a place in the institutional settings, and in playing a role in building public value?

Results
Five situated meanings of design
The research gathered and analysed multiple

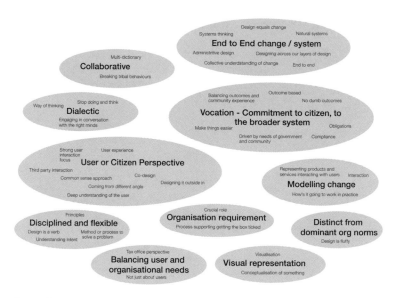

Figure 2: Initial clustering of codes 'Meaning of Design'.

accounts of design practices in the ATO, and then drew these accounts into actor–network maps so as to see the actors and networks in action. The designers, business areas, external groups (such as the Treasury), citizens, senior leaders, materials, design artefacts, prototypes and mind-maps collectively enable managing by design; that is, situated action throws light on the emergent meanings. So how might we consider these meanings? The initial coding indicated a range of meanings (see Table 1). These were then clustered into broader groups (see Figure 2), which were subsequently clustered into five themes (see Figure 3). The five thematic meanings are: collaborative and dialectic; commitment to the citizen or end user; knowledge construction; creative, visual and material; and disciplined and rigorous. These five themes present unique characteristics that are observable in the ATO, and when in action present a different management style to the traditional bureaucratic approach (See Table 2).

Collaborative and dialectic

At the core of the 'managing by design' performances are this coming together of many actors. There is the collaboration between actors around common goals. Whether the goal is to make an administrative product or resolve an organizational issue, the managing work is done with others. The emphasis on working with others includes crossing boundaries within the organization and outside. The outside includes the end user or the taxpayers, who represent important constituents in designing the organization's processes and products. The collaborative characteristic of managing by design is intentional and is contingent upon key actors in the organization. The role of 'design facilitators' in the case organization provides a mechanism for

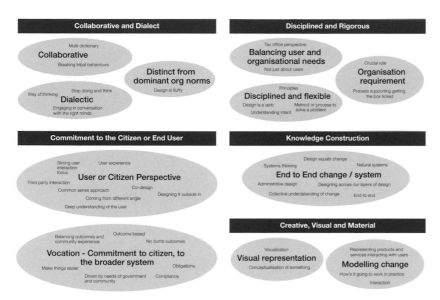

Figure 3: Themes of 'Meaning of Design'.

members of the organization and other key actors to effectively collaborate. The interactions are inherently actor-to-actor, with dialogue standing for the non-human actor. The importance of dialogue between multiple actors is a present feature in the ATO when managing by design.

For example, it is common to see organizational members gathered in a room, organized in ways such as small groups, and working with materials such as blank paper and markers to create visual diagrams of problems, solutions and ideas, before holding dialogues that are expertly facilitated and managed. These images are not limited to junior staff or projects: they can also be seen with the most senior people of the organization working together, and at events comprising citizens, business owners and professionals.

Commitment to the citizen or end user

The recognition of and commitment to consider the taxpayer or the end user is fundamental to managing by design. The commitment to bring the voice of the users of the tax system as both active participants in designing products is an important feature of managing by design, as is locating them conceptually when exploring impacts of new policy design. The introduction of the end user was a symbolic shift from the expert to the layman or woman. This helped shift the view from internal tax law, policy and rules to an emphasis on the interactions between tax products and end users. The notion of the product and the interaction is a fundamental meaning of design in the ATO. This constitutes a deep psychology of human-centeredness, which juxtaposes traditional tax accounting with the legal position, which is inherently about the policy, the law,

the rules and the processes. This means that managing by design is inclusive of a broad spectrum of impacts – including the legal and internal view – albeit with attention to the translation and impacts for end users or taxpayers. This gives managing by design a unique and localized position in the work of the ATO, as it complements the work of the organization.

For example, design work encourages the creation of personas and life-size diagrams of people; these posters are put up around the office or used in workshops to bring the citizen to life and make them visible in the dialogue. The materiality of these personas is significant because it brings a consciousness of who is part of the design solution – the end users – and what requirements they need addressing.

Construction of knowledge

It was found in the research that managing by design occurs in situations where there is a need to produce new knowledge. The production of knowledge is apparent because managing by design is employed in the generation of new ideas, as well as in changes to existing practices, processes or products. It is performed through processes of translation and invention by actors who play different design and management roles. This meaning connects to the previous meaning of 'collaboration', because the situations of knowledge construction are in most cases multi-actor; for instance, multi-organizational units, multi-tax system roles, multi-taxpayers and multi-organizational perspectives. The important productions of non-human objects such as design product prototypes (e.g. forms or design documents that describe how the change to the tax system will be experienced by taxpayers) are evidence of new knowledge. The other important knowledge package is the understanding of actors in the tax system and their experiences. The remarkable point in this knowledge is that the understanding of experience is

generated from the process of managing by design, and not just from a survey or market research approach where knowledge sits in a report often generated by external research companies. In managing by design, knowledge is created in the process of designing, and the tacit knowledge rests across all actors involved in the process.

For example, the production of artefacts and visual communication design is a standard practice in every design project. The designers take pride in producing compelling narratives of the design solution. They create products such as blueprints which elegantly display the design solution – from exploring the intent, the users and how they are affected to the needs of users, the products and services to meet these needs, and the supporting processes, people and technology to enable these interactions. These can be lengthy documents collectively owned by all people involved in the design process. The blueprint represents all tacit knowledge on the design project; they are critical knowledge parcels which travel across the organization.

Creative, visual and material

The production of knowledge is done in particular ways in the practice of managing by design. The actors involved use materials differently from the methods of traditional management in that they use diagrams more often than lots of words. They create physical examples of products or prototypes, and use these as a means of interacting with other actors. They sketch and draw the problems, and use whiteboards and large sheets of paper to visualize their work. There are actors who have skills in visualization (often called 'information designers'), and design facilitators who visualize conversations through mind-maps and models of conversation as actors collaborate – or as one participant expressed it, 'design emerges in front of their eyes'. This way of working is distinctly managing by design. The performances of creativity, visualization and

Managing by design occurs when public management work is performed by taking a more human-centred, participatory, visual and physical approach to bring change and create preferred futures.	
This means in practice:	
Commitment to the citizen or end user	Recognition of and commitment to the taxpayer or the end user is fundamental to managing by design. The commitment enables the voice of tax system users to be active participants in designing products, as well as locating them conceptually in exploring implementation impacts of new policy design. This also extends to an understanding of impacts on end users for all changes.
Collaborative and dialectic	Collaboration between actors around common goals. Whether the goal is to make an administrative product or resolve an organizational issue, the managing by design work is done with others. The emphasis on working with others includes crossing boundaries within the organization and outside of it.
Creative, visual and material	Materials used in different ways to traditional management as a means of interacting with other actors, e.g. heavy use of diagrams rather than lots of words; creation of physical examples of products or prototypes used.
Disciplined and rigorous	Disciplined performances ranging from engaging taxpayers or citizens in designing new products; disciplined conversations amongst senior leaders through facilitated conversation; and disciplined exploration of changes to the tax system due to proposed new policy changes.
Construction of knowledge	The production of knowledge is apparent because managing by design is employed in situations of new ideas, as well as due to changes to existing practices, processes or products. It is performed through processes of translation and invention by actors who play different design and management roles.

Table 2: Summary of the meaning of design

materializing design are exposed by using rooms dedicated to designing.

For example, in the early days at the ATO, when managing by design became a distinct practice in the organization, a physical area was established that removed all the desks and created an open space. Large pinboards were brought in. Tables with wheels for easy reconfiguration, large printable whiteboards on wheels for ease of use, and a plotter printer that printed large pages for diagrams and other visualizations made up the design space. These changes to the physical elements of the organization created physical spaces for managing by design to occur. These are symbolic changes to the organization that create meaning for managing by design.

Disciplined and rigorous

In the study, managing by design followed disciplined performances, ranging from engaging taxpaying citizens in designing new products and disciplined conversations amongst senior leaders through facilitated conversation to exploration of changes to the tax system due to proposed new policy changes. These disciplined practices are seen as a distinct quality of managing by design in the ATO. According to one senior leader, when the design of

administrative products takes a participatory approach, i.e. by designing with end users in mind, managing by design becomes:

[A] commitment to client consultation which allows us to get, in a less scientific way, feedback as to their client aspirations and frustrations and also allows us to get feedback from them on the usability of various ideas and products. […] one of the things that's very good about the design science that's been brought to the ATO is this more scientific approach to design. (Senior leader 2009 interview)

The emphasis on 'scientific' can be interpreted as meaning managing by design is systemized and helps build knowledge.

For example, the design project work in the ATO is coupled closely with good project management. The stages of design work are clearly identified in project work, and design principles are followed so as to guide how these stages are executed, such as having user-centred work as a key principle so that engagement with them is planned wherever possible. Another example is a shared intent, whereby no design project proceeds unless it has held a collaborative workshop or discussion across a number of people key to the design project. The design process in the ATO mandates certain design artefacts be produced as part of each stage of the design project. This ensures discipline in the approach.

Discussion
What can we learn about the characteristics of designerly public sector organizations?
The five themes of design discussed make a unique contribution to management theory because they offer empirical evidence that pubic managers are practicing innovative and designerly ways of working, and this directly points to the new emergent manager

who seeks to derive public value by taking a design approach. These qualities are inherent in interactions across the organization; they are observable management traits, which differ significantly to traditional bureaucratic management styles. It is important to point out that these same themes of design in management practice are just as relevant to private sector organizations. Therefore, these concluding comments can equally apply to both private and public sector organizations who seek to build public worth or public value with their respective constituents and clients. There are three discussion points to close out this paper. Firstly, the management needs to recognize assemblages of knowledge rather than silo expert knowledge. It is true that organizations have always been 'designed' in some way, e.g. the structures and 'design' practices are often driven by management research, which would provide the knowledge needed to design the best structure (Galbraith 1973). This is based on predetermined expert knowledge. But what is discussed here in 'managing by design' is a different sort of design – design that assembles people and things to create new knowledge – and this is generated through participatory practices. So instead of making internal decisions, where 'design' of, for instance, the structure of an organization was assumed to be able to be grounded in expert knowledge, taking a managing by design approach is more multifaceted and multi-perspective, and involves coming together through collaborative practices to define the new structures. Expert knowledge may be part of the mix, but is still recognized as partial. Taking a managing by design approach encourages the organization to break away from the 'silo' mentality in which each person contributes their expert knowledge in a sequential breakdown of the task. In post-structuralism, knowledge is contested in all areas; moreover, it is partial and shaped by the groups and cultures that make it. There is no universal set of known things, of

ways of organizing, or an a priori certain knowledge that can be learned in universities then applied in management. What comes to count as knowledge is created by the circumstances of how it is produced. This is recognized in this case study – and these are the new approaches to management work.

Secondly, managing by design is employed in situations of new ideas, as well due to changes to existing practices, processes or products. This is a particularly important point to highlight because this situates managing by design. This reference to new or changed management situations is important to acknowledge because in the public management context, public managers do many types of work and not everything is about change.

It is helpful to place a boundary around the activity of design so that public managers can be deliberate about when they enact designerly ways of working. Public managers carry out work that is about making change and creating preferred futures when managing by design is employed. In the research, three locations for managing by design were explored, all of which dealt with some sort of change. The first involved work of designing and developing a new administrative tool (a form); the second involved the exploration of a strategic, organizational problem-seeking change; and the third translated new tax policy and measures into administration design. It is in this type of work that design methods, standardized practices and design people can be usefully employed.

Thirdly and finally, managing by design is based on the creation of distinct roles in the organization with which to perform, lead and practice design, thus creating recognition that design is a professional skill set. It is a new skill set that can be learned and enacted by many players, and it holds its own profile so that the organization can recognize its

commitment to conduct design. This brings forth the placement of design as a distinct role in the public organization, which in turn implicates human resource strategies such as: attracting and developing designers and public managers in design theory and practice; budget commitments to fund and dedicate organizational resources to conduct design projects; property and place strategies to locate and create work environments that facilitate enactments of design activities, such as simulation rooms, open spaces for workshop configuration, whiteboards and work benches; and strategic planning initiatives where design capability is allocated projects to deliver, thereby moving the organizational products and services forward to meet new policies and other future directions.

The premise of this paper was to discuss what a public sector organization intent on creating public value might look like, which, as proposed here and concurrently supported in the literature, can be achieved by taking a design approach. The case study of the ATO offers empirical evidence of what this means in practice. The concept of managing by design was presented here alongside five main themes: collaborative and dialectic; commitment to end user or citizen; construction of knowledge; creative, visual and material; and disciplined and rigorous. This brings to attention the features of a more contemporary public organization: assemblages of knowledge; bounding design to change projects; and dedicating design to distinct roles in the organization's structures.

Therefore, 'managing by design' is when management work is performed through a more human-centred, participatory, visual and physical approach to bringing about change and creating preferred futures, and consequently building public value in the process.

References

Alford, J. and O'Flynn, J. (2008), 'Public value: A stocktake of a concept', Paper presented at the *Twelfth Annual Conference of the International Research Society for Public Management,* Queensland University of Technology, Brisbane, Australia.

Australian Government (2009), *Reform of Australian Government Administration: Building the World's Best Public Service,* Canberra: PMa Cabinet.

Bingham, L. B., Nabatchi, T. and O'Leary, R. (2005), 'The new governance: Practices and processes for stakeholder and citizen participation in the work of government', *Public Administration Review,* 65: 5, pp. 547–558.

Body, J. (2007), 'Design in the Australian Taxation Office', *Design Issues,* 24: 1, pp. 55–67.

Bourgon, J. (2008), 'The future of public service: A search for a new balance', *The Australian Journal of Public Administration,* 67: 4, pp. 390–404.

Briggs, L. and Lenihan, D. (2011), 'Co-design: Toward a new service vision for Australia?', *Public Administration Today,*

January–March, pp. 35–47.

Callon, M. (1986), 'Some elements of a sociology of translation: Domestication of the scallops and the fishermen of St Brieuc Bay', in J. Law (ed.), *Power, Action and Belief: A New Sociology of Knowledge?,* London: Routledge, pp. 196–223.

Callon, M. (1999), 'Actor–network theory – the market test', in J. Law and J. Hassard (eds), *Actor Network Theory and After,* Oxford: Blackwell Publishing, pp. 181–195.

Charmaz, K. (2006), *Constructing Grounded Theory: A Practical Guide Through Qualitative Analysis,* London: SAGE.

Christensen, T., Laegreid, P., Roness, P. G. and Rovik, K. A. (2007), *Organization Theory and The Public Sector: Instrument, Culture and Myth,* Abingdon: Routledge.

Church, L. and Maloney, M. (2012), 'Public value provision: A design theory for public e-services', Paper presented at the *SRII Global Annual Conference,* 27 July, San Jose, CA.

Clarke, A. (2003), 'Situational analyses: Grounded theory mapping after the postmodern turn',

Symbolic Interaction, 2C. 4, pp. 553–576.

Clarke, A. (2005), *Situational Analysis: Grounded Theory After the Post Modern Turn,* Thousand Oaks, CA: SAGE.

Clarke, A. (2009), 'Situational analysis workshop', School of Public Health, The University of Sydney.

Cross, N. (2006), *Designerly Ways of Knowing,* London: Springer-Verlag.

Denhardt, R. B. and Denhardt, J. V. (2000), 'The new public service: Serving rather than steering', *Public Administration Review,* 60: 6, pp. 549–559.

Dryzek, J. S. and List, C. (2003), 'Social choice theory and deliberative democracy', *British Journal of Political Science,* 33: 1, pp. 1–28.

Fung, A. (2003), 'Deliberation where you least expect it: Citizen participation in government', *Connections,* Fall, pp. 30–33.

Galbraith, J. (1973), *Designing Complex Organizations,* Reading, MA: Addison-Wesley Publishing Company.

Glaser, B. and Strauss,

Λ. (1967), *The Discovery of Grounded Theory: Strategies for Qualitative Research,* Chicago: Aldine.

Gutman, A. and Thompson, D. (1996), *Demoncracy and Disagreement,* Cambridge, MA: Harvard University Press.

Holmes, B. (2011), 'Citizens' engagement in policymaking and the design of public services', Research Paper no. 1 2011–12, Canberra: Politics and Public Administration Section, Parliamentary Library, Parliament of Australia.

Junginger, S. (2006), 'Change in the making – Organisational change through human-centred product development', Ph.D. thesis, Pittsburgh, PA: Carnegie Mellon University.

King, C. S. and Stivers, C. M. (1998), *Government Is Us: Public Administration in an Anti-Government Era,* Thousand Oaks, CA: SAGE.

Latour, B. (1999), 'On recalling ANT', in J. Law and J. Hassard (eds), *Actor Network Theory and After,* Oxford: Blackwell Publishing, pp. 15–25.

Latour, B. (2005), *Reassembling the Social: An Introduction to Actor-Network-Theory,* Oxford:

Oxford University Press.

Law, J. (1999), 'After ANT: Complexity, naming and topology', in J. Law and J. Hassard (eds), *Actor Network Theory and After*, Oxford: Blackwell Publishing, pp. 1–14.

Law, J. (2007), *Actor Network Theory and Material Semiotics*, http://www.heterogeneities.net/publications/Law2007ANTandMaterialSemiotics.pdf. Accessed 27 January 2014.

Leadbeater, C. (2004), *Personalisation Through Participation: A New Script for Public Services*, London: DEMOS.

Leadbeater, C., Bartlett, J. and Gallagher, N. (2008), *Making it Personal*, London: DEMOS.

Maher, L. (2008), 'How the NHS is thinking differently', in E. Thomas (ed.), *Innovation by Design in Public Services*, London: SOLACE Foundation & The Guardian, pp. 10–12.

McLean, K., Scully, J. and Tergas, L. (2008), 'Inland Revenue New Zealand: Service design in a regulatory context', *Design Management Review*, 19: 1, pp. 28–37.

Moore, M. (1995), *Creating Public Value: Strategic Management in Government*, Cambridge, MA: Harvard University Press.

Moran, T. (2010), *Ahead of the Game: Blueprint for the Reform of Australian Government Administration March 2010*, Canberra: Australian Government Department of the Prime Minster and Cabinet.

Osbourne, S. and Brown, K. (2005), *Managing Change and Innovation in the Public Service Organisations*, Abingdon: Routledge.

Parker, S. and Heapy, J. (2006), *The Journey to the Interface: How Public Service Design Can Connect Users to Reform*, London: DEMOS.

Terrey, N. (2010a), 'Distributed design management in a large public-sector organization: Methods, routines, and processes', *Design Management Journal: The Evolution of Design Management*, 4: 1, pp. 48–60.

Terrey, N. (2010b), 'What might corporate citizenship look like in a government organisation? Potential for human-centred design approach to foster corporate citizenship', *The Journal of Corporate Citizenship*, 37, pp. 89–100.

Thomas, J. C. (1995), *Public Participation in Public Decisions: New Skills and Strategies for Public Managers*, San Francisco: Jossey-Bass.

Yang, K. and Pandey, S.K. (2011), 'Further dissecting the black box of citizen participation: When does citizen involvement lead to good outcomes?', *Public Administration Review*, 71: 6, pp. 880–892.

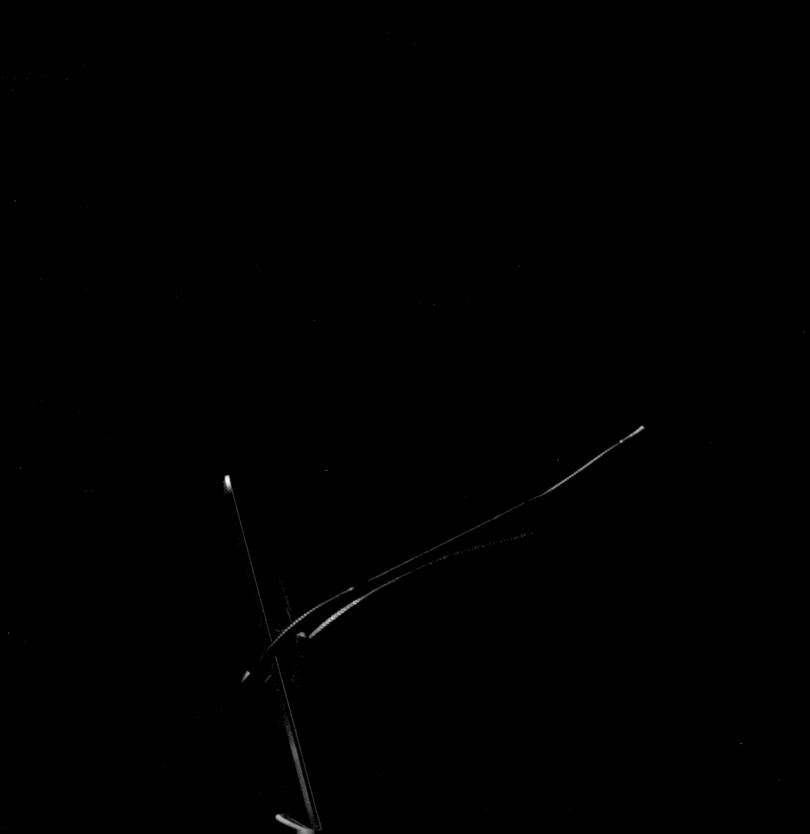

Gerda Gemser
RMIT University

Prof. Gerda Gemser is Full Professor of Design and Business, working across the Design Research Institute and the School of Finance, Economics and Marketing at RMIT University. Gerda earned her Ph.D. at the Rotterdam School of Management, the Netherlands. She has held positions at different universities in the Netherlands, including at the Delft University of Technology. She has been a visiting scholar at the Wharton School at the University of Pennsylvania and the Sauder School of Business at the University of British Columbia. Her research interests include design effectiveness and design management. She has published in many recognized management and design journals, including *Organization Science, Organization Studies, Journal of Management, Journal of Product Innovation Management, Design Studies* and *International Journal of Design*.

Giulia Calabretta
Delft University of Technology

Dr Giulia Calabretta is an Assistant Professor at the Faculty of Industrial Design Engineering, Delft University of Technology. Giulia obtained her doctorate in marketing from ESADE Business School in Barcelona. Afterwards, she worked as a postdoctoral fellow in the marketing department at the BI Norwegian Business School in Oslo. Her research interests are in the area of innovation and design management. Currently, her research is focused on understanding how design skills and methods can be effectively integrated into companies' strategies and processes, with a particular interest on the role of designers in innovation strategy and early development. Her research has been published in such journals as the *Journal of Product Innovation Management, Journal of Business Ethics* and *Journal of Service Management*.

Nachoem M. Wijnberg
University of Amsterdam

Prof. Nachoem M. Wijnberg is Full Professor of Cultural Entrepreneurship and Management at the University of Amsterdam Business School. He has a Ph.D. from Rotterdam School of Management. From 2001 to 2005, he was Professor of Industrial Economics and Organization at the University of Groningen. He has held visiting positions at Cass Business School in London, and at the Institute for Innovation Research at Hitotsubashi University in Tokyo. He has published widely in scientific journals – such as *Organization Science, Organization Studies, Journal of Management, Journal of Management Studies and Human Relations* – on the subjects of strategic management, organization theory, entrepreneurship and innovation, especially in the context of the creative industries. Nachoem is also a poet and a novelist.

Paul Hekkert
Delft University of Technology

Prof. Paul Hekkert is Full Professor of Form Theory and head of the industrial design department at Delft University of Technology. Paul conducts research on the ways products impact human experience and behaviour, and also leads the international project UMA (Unified Model of Aesthetics). Paul has published articles dealing with product experience and aesthetics in major international journals, and is co-editor of *Product Experience* (2008). He also published *Vision in Design: A Guidebook for Innovators* (2011), a book that describes an approach to design and innovation. Paul is co-founder and chairman of the Design and Emotion Society and chairman of the executive board of CRISP, a national collaborative research initiative for and with the Dutch creative industries.

Collaborating with design consultancy firms for effective strategic decision-making in new product development

Collaborating with design consultancy firms for effective strategic decision-making in new product development

In order to contain risks and increase the profitability of innovation efforts, firms frequently engage in joint innovation activities with external sources of knowledge such as design consultancies. Innovation literature has given limited consideration to the strategic role that design consultancies can play in the innovation efforts of their clients. A plausible explanation for this may reside in the difficulty to assess and quantify the quality of their output, given the intangibility of the output itself and the difficulty of connecting a knowledge-intensive output to clients' performance indicators. By analysing the data from seven dyadic case studies, we examine design consultancies' impact on their clients' strategic decision-making as a way of capturing their strategic role in clients' innovation efforts. We conclude that design consultancies can influence clients' strategic decisions by enhancing the two main strategic decision-making mechanisms identified by the literature: rationality and intuition. Design consultancies' impact on strategic decision-making is then transferred to some indicators of innovation performance. An early involvement in problem definition and long-term relationships with clients seems to strengthen design professionals' influence.

Keywords
strategic design
decision-making
rationality
intuition

Introduction

Knowledge has been identified as the most strategically important aspect of a firm's resources (Grant 1996). To access new knowledge, firms are increasingly engaged in inter-firm collaborations (Grant and Baden-Fuller 2004). As shown in prior research, access to external sources of knowledge can result in better new product development (NPD) processes, higher innovativeness and better organizational performance (Barczak, Griffin and Kahn 2008; Rothaermel and Deeds, 2004). Given the prominence of the phenomenon, theoretical and empirical research has quickly emerged on knowledge-driven inter-firm collaborations, as well as their causes and consequences (Hagedoorn 2002).

Design consultancy (DC) firms have progressively established themselves as key external sources of specialized knowledge for firms pursuing successful innovation (Cross 2004; Hargadon and Sutton 1997). Design consultancy firms can cover all the different design areas, ranging from graphic design to interior design, architecture or human–computer interaction. In this paper, we focus on product and service design firms that are hired to assist clients in their NPD process.

Despite the increasing size of the DC industry, and the growing amount of activity at the DC–clients interface, both academic research and business practice have developed limited knowledge on how to optimize this knowledge-driven collaboration and maximize its innovation outcome. This lack of progress could be put down to some DCs' intrinsic characteristics, which are typical of professional service firms (PSF) (Von Nordenflycht 2010). PSFs are companies that: (1) master a substantial body of complex knowledge (expertise); (2) rely on this body of knowledge as their main source of revenue; and (3) use relatively limited capital assets for producing their outcome. One of the main challenges for PSFs – thus also for DCs – is the issue of transactional ambiguity in PSF–client interaction, which is considered the main reason for scarce theoretical and empirical research on the topic (Alvesson 2011; Sturdy 2011). Transactional ambiguity refers to the difficulty of quantifying and assessing the quality of PSFs' output, even after its production and delivery. Since most of the literature on knowledge-intensive collaborations is based on the measurability of the collaboration output (e.g. patents), it is difficult to conduct empirical research that extends existing theories to PSFs, and thus to DCs.

This paper attempts to overcome the issue by studying the relationship between DCs and their clients from a strategic decision-making (SDM) perspective. To do this, we focus on whether the collaboration with DCs contributes to clients' SDM. We propose that DCs may influence the different mechanisms – i.e. rationality and intuition – through which clients take strategic decisions in NPD strategy and processes (Elbanna and Child 2007). Given the explorative nature of our research, we use a qualitative empirical approach, and draw conclusions based on seven dyadic case studies of NPD collaborations between DCs and their clients.

Strategic decision-making research

SDM research focuses on the processes through which firms take strategic decisions. Strategic decisions are decisions implying: high uncertainty in the final outcome; prolonged courses of actions; significant resource commitment; and the involvement of several decision-makers (Eisenhardt and Zbaracki 1992).

Despite the existence of different views on SDM

process (for an overview, see Elbanna 2006), there is agreement on the two core mechanisms for taking strategic decisions: rationality and intuition (Elbanna and Child 2007). Rationality refers to a rational and linear decision-making process, which includes problem formulation, the collection and evaluation of all relevant information, a comprehensive generation of alternatives, and a consequent assessment and choice (Elbanna 2006). In intuition-based decision-making, decisions are taken on the basis of 'affectively charged judgements that arise through rapid, non-conscious and holistic associations' (Dane and Pratt 2007: 40).

NPDs can be regarded as a set of strategic decisions (Krishnan and Ulrich 2001). According to different NPD research streams and empirical evidence, both SDM mechanisms – rationality and intuition – seem to coexist during NPD. Specifically, according to the information processing perspective on innovation (Galbraith 1973), NPD is a process dealing with innovation's uncertainty reduction by collecting and processing as much information as possible through its different stages. Thus, NPD is a rational process, and its performance depends on a firm's capability of eliminating different sources of uncertainty (Moenaert and Souder 1990). Due to time pressure, information processing limits and innovation's intrinsic nature, uncertainty cannot be completely eliminated, but rather managed and exploited by resorting to executive judgement, i.e. an intuition-driven decision-making approach (Hodgkinson and Healey 2011).

Through our empirical study, we aim to provide insights into how the interaction with DCs can improve both decision-making processes in NPD.

Method
Given our exploratory aims, we opted for a multiple case study design (Eisenhardt 1989; Yin 2003), which studied seven new product (service) development projects. We focused on NPD projects in which the innovating company hired a DC to provide support in the creation of new products or services.

We used a dyadic approach for our case studies; that is, for each case we collected data from (1) interviews with design professionals involved in the selected cases; and (2) interviews with key informants from the company that subcontracted the DC. Additionally, we used secondary sources – project documentation (briefs, reports, presentations, supporting visual material), websites and informal observations – to complement and triangulate the interview data (Bonoma 1985). The interviews were semi-structured and open-ended, with the same interview guide (with some adaptations) for both types of informants. We performed a total of 36 interviews. Table 1 provides summary information regarding the NPD projects considered in the case studies, as well as for the informants and interviews.

The analysis followed the general approach indicated by Eisenhardt (1989: 532) – 'it is the connection with empirical reality that permits the development of a testable, relevant, and valid theory' – and the steps described by Miles and Huberman (1994). To deal with the dyadic data, we attempted to match the answers from the two parts on the different topics for each case, and included in the findings only the issues where there is sufficient agreement between the respondents. Subsequently, we conducted a cross-case comparative content analysis to corroborate patterns emerging in each case and thus draw conclusions (Eisenhardt 1989; Miles and Huberman 1994). This iterative procedure resulted in the propositions discussed in the following paragraphs.

Findings
Our findings show that DCs improve clients' NPD decision-making processes by affecting clients'

Name	Project description	Interviews	Type of informants
Project A	New services related to public transportation	8 (6DP, 2CL)	DP: project manager, 2 strategic designers, creative director, interaction designer, service designer. CL: project manager, marketing director.
Project B	New service for a cultural institution	6 (3DP, 3CL)	DP: project manager, 2 strategic designers, CL: marketing director, brand manager, service manager.
Project C	A portfolio of 100% recycled new products	3 (2PD, 1CL)	DP: 2 strategic designers. CL: owner & general manager.
Project D	New products for greenhouse lighting	4 (2PD, 2CL)	DP: 1 strategic designer, 1 product designer. CL: project manager, R&D manager.
Project E	New services for a pharmaceutical company	4 (2PD, 2CL)	DP: 2 strategic designer. CL: project manager, service manager.
Project F	New bicycle accessories	7 (3DP, 4CL)	DP: project manager, 1 strategic designer, 1 product designer. CL: NPD manager, R&D manager, service manager.
Project G	New street furniture	4 (2DP, 2CL)	DP: project manager, 1 strategic designer. CL: project manager, architect.

Table 1: Description of case data. Notes: DP = design professionals; CL = innovating company

capability of using both rationality and intuition. This impact on clients' NPD decision-making mechanisms can subsequently enhance certain NPD performance indicators. Additionally, the impact is stronger in cases of long-term relationships between the DC and their client. Our findings are summarized in Table 2 and illustrated in the following paragraphs.

DCs' impact on clients' rational processes in NPD decision-making

Our findings show that DCs can impact their clients' decision-making in three ways: by improving NPD problem formulation: by providing declarative and procedural knowledge; and/or by extending clients' knowledge through knowledge brokering.

With regards to the first contribution, our respondents indicated that due to a lack of experience, time constraints or political biases, clients do not have good skills in NPD problem formulation – the first, fundamental step of a rational decision-making process. For instance, it is not unusual that behind a request for a new product design there is a product portfolio or a feasibility problem that the client is not aware of or not willing to recognize. Consequently, problem formulation can be too narrow or even erroneous, thus jeopardizing NPD execution and performance.

As our data show (see Table 2), design professionals are able to help their clients overcome biased and narrow problem formulations as a result of their

Collaborating with design consultancy firms for effective strategic decision-making in new product development

Outcome of collaboration	Drivers of improvement	Proof quotes
Improved rationality	Clear problem formulation	"They came to us and said that they needed a new website. […] Once we found out what kind of organization they were […] and the technical issues to take into account, we understood the challenges they were facing. We started to propose basic technology architecture, propose a vision of design, and propose ways to accomplish these quite radical changes. And we proposed that for them to do that, they would have to adopt a different brand [identity]" (Project B, design professional).
	Procedural knowledge	"The structuring part or the process of development: that was very much a role of [the design professional], as this sort of chairman of this brainstorm discussion. [Their role] in structuring the development of this brand design discussion. I see what as a very important role of [the design professional]" (Project B, client)
	Knowledge brokering	"We are somehow capable to refresh [our client's] knowledge on a very regular basis. They cannot do that within their own knowledge. There is a lot of what I always call 'cross-overs'. What we learn in one project we can apply in another project. What we learn in a big project for [a big client] we can apply in a project for a small start-up. A lot of what we do is juggling with that knowledge and find the right pack to sell to the client" (Project G, design professional).
Improved intuition	Reducing reliance on intuition	[Referred to customer experience flow as designed by the design professional] I like it because it gives you an overview. It is quite easy to name all the different touch points of an organization in a relatively ordered way, which is for us to identify the week points in [our services]" (Project E, client).
	Externalizing cognitive maps	"The moment that they came up with the first sketch and design for the website and the paper material was a turning point. Since this network organization was young as well as the people sitting around the table, words could mean anything. But when they started to visualize words… that was an important communication tool that helped us enormously to get sharper in where we were standing for in that moment" (Project B, client).
Length of relationship	Trust	"[Trust] is a very important feature. That's necessary because you open up your organization and you are very fragile. If I had the feeling that the [design professional' cannot be trusted […] the project wouldn't have developed". (Project B, client)
Improved NPD performance	Speed	"Yes I think what they do is now completely focused and I think that's the best thing we achieved. And there's a lot of focus in the company. And if there's focus everything goes easier and faster" (Project B, client).
	Internal coherence	"After we got the assignment [for the development of new services] the first thing we did is to establish the value proposition of the client. […] At any moment we always had to remind the client of the value proposition, what we were trying to achieve during the project. They are always drifted away by the particular task they are doing or by the daily things" (Project E, design professional).
	External coherence	"And now finally I can see that each new product we developed with [the design professional] fits its product family and it's suitable for the target group which we developed" (Project G, client).

Table 2: Summary of the findings.

holistic and associative thinking, and can make sense of the disparate elements of an ill-defined situation, as is often the case in NPD projects. Respondents find that time spent investigating clients' real needs in the early stages and then collaboratively (re) defining the assignment is invaluable in reducing NPD uncertainty, and thus to improve the rationality of NPD decision-making.

As to the second contribution to rationality, our findings show that firms generally hire design consultancies to fulfil NPD knowledge voids in product design and engineering, i.e. DCs' declarative knowledge. Indeed, when firms use a rational decision-making approach, they strive to consult all the information relevant to the decision area in order to improve decision alternatives' generation, before finally select the optimal one (Elbanna 2006). Given the uncertainty and the number of knowledge domains affecting strategic decision-making areas (e.g. innovation), firms increasingly turn to external sources (like DCs) to achieve information completeness. As shown by the proof quotes in Table 2, DCs are an external source not only of deliberative knowledge, but also of procedural knowledge, i.e. the strategies, rules and skills for acquiring, storing, retrieving and manipulating declarative knowledge (Cantor and Kihlstrom 1989). In our data, NPD tasks for which DCs provide procedural knowledge include concept definition and its translation into a product design, as well as more strategic tasks such as portfolio management and NPD alignment with clients' innovation and branding strategy. In these tasks, DCs indicate to the clients the set and sequence of decisions to be taken in order to complete the task in a satisfactory manner.

Additionally, our results suggest that firms increasingly hire DCs because of their knowledge brokering capability, i.e. their capability of learning about potentially useful technologies or product/ service solutions by working for clients in multiple industries, and transferring that knowledge into new products/services for industries where there is little or no prior knowledge of these technologies or product/service solutions (Hargadon and Sutton 1997).

Through knowledge brokering, firms gain access not only to DCs' specific knowledge, but also to knowledge domains previously regarded irrelevant. According to our interviewees, this not only increases available information, but also facilitates the concluding stage of clients' rational decision processes – i.e. the choice of the optimal alternative – since DCs' positive experience in other industries is regarded as valuable evidence for assessing decision alternatives.

Proposition 1: DCs facilitate clients' rational processes in NPD decision-making by (a) improving problem formulation; (b) providing domain-specific declarative and procedural knowledge; and (c) generating knowledge brokering.

DCs' impact on clients' intuition processes in NPD decision-making

When asked about DCs' most valuable skills for improving their clients' NPD decision-making processes, respondents on both sides often mentioned DCs' ability of visualizing and materializing issues by means of the drawings, sketches and models that DCs commonly use to support their interpretive processes. According to our respondents, these artefacts help clients to better understand their market and its future direction; to become aware of their core strengths; to detect hidden problems; to comprehend brand associations; and to reduce the perceived uncertainty of developing new offerings.

These examples refer to highly uncertain decision-making areas in NPD and innovation strategy in general, for which firms cannot rely entirely on rational processes, but rather need to turn to intuition

synthesis. Using intuition in decision-making is generally regarded as inferior to rational processes (Dane and Pratt 2007). DCs' material and visual artefacts can both reduce client's reliance on intuitive mechanisms, and when this is not possible, improve the quality of intuitive judgement.

Since material and visual artefacts make the mental processes through which individuals within the organization make sense of things observable and explicit (Rafaeli and Vilnai-Yavetz 2004), choices previously perceived as intuitive become rational, thus reducing decision-makers' reliance on intuitive synthesis. Additionally, according to the literature, 'expert' intuition could be as good as rationality; this is achieved when decision-makers develop – usually through experience – complex cognitive maps of the decision domain (Dane and Pratt 2007). By making clients' cognitive maps explicit, designers' material and visual artefacts facilitate the sharing and the explicit learning of NPD-related cognitive maps. As such, triggering more effective intuitive judgements when using intuition is unavoidable.

Proposition 2: DCs' visualization and materialization capabilities (a) reduce clients' reliance on intuition in strategic decision-making; and (b) improve clients' effectiveness in intuitive decision-making.

Overall impact on NPD performance
In addition to the specific effects during each step, integrating intuition within a rational decision-making process has a cumulative positive effect on the overall process and its outcome.

According to our respondents, one implication of collaborating with DCs is a faster NPD, mainly due to the more focused decision-making and the reduced amount of subsequent mistakes. As a further explanation, and based on previously discussed findings, faster NPD is a consequence of the

additional deliberative and procedural knowledge provided by the DCs, which leads to a more structured execution of certain NPD tasks. Additionally, reducing clients' reliance on intuition while helping them develop expert intuition can diminish the chance of wrong decisions, and thus the number of mistakes in the implementation.

Respondents also detected an increase in NPD internal coherence as a result of their collaboration with DCs. Internal coherence refers to the coherence across NPD stages, as well as between NPD strategy and execution. A decision-making process implies taking into account a set of objectives and constraints across different stages. By enabling a sharp and thorough definition of objectives, a clear problem formulation – as facilitated by the collaboration with DCs – is the first step towards internal coherence. Additionally, since by nature design professionals operate by recognizing and maintaining patterns of coherence (Dane and Pratt 2007), DCs help clients maintain coherence with their objectives and constraints throughout the entire process. For similar reasons, collaborating with DCs improves the external coherence of the decision process and its outcome, namely how NPD corresponds with other strategic decisions within a company.

Proposition 3: DCs' impact on NPD decision-making increases (a) speed; (b) internal coherence; and (3) external coherence.

Characteristics of the PSF-client relationships: Length of the relationship
All the respondents agreed that DCs' influence on clients' decision-making is higher if there is a long-term, trusting relationship. Only after repeated satisfactory transactions did clients become aware of the full range of DCs' capabilities, hire them for broader tasks other than product design, and ask

DCs for their insights on more strategic NPD decisions, such as concept generation or portfolio management. Developing long-term, trusting relationships is a condition for success in any kind of inter-firm collaboration. However, given the high level of ambiguity and uncertainty associated with the knowledge-intensive nature of the design industry, the issue is particularly relevant for DCs (Alvesson 2011). As explained in the introduction, the DC–client collaboration is characterized by high transactional uncertainty as a result of the difficulty in assessing the quality of DCs' outcomes. Further ambiguity in the relationship is brought about by the 'institutional uncertainty' characterizing the DC's industry (Glückler and Armbrüster 2003), namely uncertainty surrounding DCs' nature and scope, which is mainly due to the lack of formal institutional standards relating to professionalization, industry boundaries and products quality.

Under conditions of uncertainty, partner choices are driven by personal trust based on previous experience (Glückler and Armbrüster 2003). Once established, experience-based trust enables reciprocal and enduring relationships, and organizations will tend to increase the volume of transactions with trusted DCs by making the collaborations more frequent, as well as by broadening their scope.

Proposition 4: DCs' impact on clients' intuition and rationality – and on overall NPD decision-making – is stronger in long-term DC–client relationships.

Concluding remarks

By examining seven dyadic cases of NPD collaborations, we found initial evidence of DCs' capability to affect clients' strategic decision-making in the area of innovation. Specifically, DCs can enhance both client's rationality and intuition – the two core strategic decision-making mechanisms –

and some indicators of NPD overall performance. An early involvement in problem definition seems to strengthen DCs' influence, as does long-term relationships with clients.

In the coming months, we plan to extend this analysis in several ways. First, we will collect dyadic data for some additional cases in order to improve the validity and generalizability of our findings. Additionally, this paper describes the PSFs' capability of contributing to their clients' strategic decision-making, but the intensity and effectiveness of the contribution has not yet been examined. In our additional data collection, we would like to focus on this aspect so as to draw conclusions on whether DCs play an advisory role in strategic decision-making or whether they replace the clients in making some decisions. Additionally, we would like to add an observation of DC–client interaction moments in order to capture additional nuances on how DCs affect their clients' rationality and intuition. Analysing dyadic case studies will culminate in creating and testing a theoretical framework of drivers of effective DC–client collaboration. With effective strategic decision-making as the dependent variable, drivers can include: DCs' skills and capabilities that make them able to effectively influence their clients' strategic decision-making; clients' characteristics facilitating the interaction with DCs and the assimilation of DCs' knowledge; and characteristics of the DC–client relationship.

References

Alvesson, M. (2011), 'De-essentializing the knowledge intensive firm: Reflections on sceptical research going against the mainstream', *Journal of Management Studies,* 48: 7, pp. 1640–1661.

Barczak, G., Griffin, A. and Kahn, K. B. (2008), 'Perspective: Trends and drivers of success in NPD practices: Results of the 2003 PDMA Best Practices Study', *Journal of Product Innovation Management,* 26: 1, pp. 3–23.

Bonoma, T.V. (1985), 'Case research in marketing: Opportunities, problems, and a process', *Journal of Marketing Research,* 22: 2, pp. 199–208.

Cantor, N. and Kihlstrom, J. F. (1989), 'Social intelligence and cognitive assessments of personality', in R. S. Wyer and T. K. Srull (eds), *Advances in Social Cognition* (vol. 2), Hillsdale, NJ: Erlbaum, pp. 1–60.

Cross, N. (2004), 'Expertise in design: An overview', *Design Studies,* 25: 5, pp. 427–441.

Dane, E. and Pratt, M. G. (2007), 'Exploring intuition and its role in managerial decision making', *Academy of Management Journal,* 32, pp. 33–54.

Eisenhardt, K. M. (1989), 'Building theories form case study research', *Academy of Management Review,* 14: 4, pp. 532–550.

Eisenhardt, K. M. and Zbaracki, M. J. (1992), 'Strategic decision-making', *Strategic Management Journal,* 13, pp. 17–37.

Elbanna, S. (2006), 'Strategic decision-making: Process perspectives', *International Journal of Management Reviews,* 8, pp. 1–20.

Elbanna, S. and Child, J. (2007), 'Influences on strategic decision effectiveness: Development and test of an integrative model', *Strategic Management Journal,* 28, pp. 431–453.

Galbraith, J. R. (1973), *Designing Complex Organizations,* Boston, MA: Addison-Wesley Longman.

Glückler, J. and Armbrüster, T. (2003), 'Bridging uncertainty in management consulting: The mechanisms of trust and networked reputation', *Organization Studies,* 24: 2, pp. 269–297.

Grant, R. M. (1996), 'Toward a knowledge-based theory of the firm', *Strategic Management Journal,* 17, pp. 109–122.

Grant, R. M. and Baden-Fuller, C. (2004), 'A knowledge accessing theory of strategic alliances', *Journal of Management Studies,* 41: 1, pp. 61–84.

Hagedoorn, J. (2002), 'Inter-firm R&D partnerships: an overview of major trends and patterns since 1960', *Research Policy,* 31, pp. 477–492.

Hargadon, A. and Sutton R. I. (1997), 'Technology brokering and innovation in a product development firm', *Administrative Science Quarterly,* 42: 4, pp. 716–749.

Hodgkinson, G. P. and Healey, M. P. (2011), 'Psychological foundations of dynamic capabilities: Reflextion and reflection in strategic management', *Strategic Management Journal,* 32, pp. 1500–1516.

Krishnan, V. and Ulrich, K. T. (2001), 'Product development decisions: A review of the literature', *Management Science,* 47: 1, pp. 1–21.

Miles, M. B. and Huberman A. M. (1994), *Qualitative Data Analysis: A Sourcebook of New Methods* (2nd ed.), Beverly Hills, CA: SAGE.

Moenaert, R. K. and Souder, W. E. (1990), 'An information transfer model for integrating marketing and R&D personnel in new product development projects', *Journal of Product Innovation Management,* 7: 2, pp. 91–107.

Rafaeli, A. and Vilnai-Yavetz, I. (2004), 'Emotions as a connection of physical artefacts and organizations', *Organization Science,* 15: 6, pp. 671–686.

Rothaermel, F. T. and Deeds, D. L. (2004), 'Exploration and exploitation alliances in biotechnology: A system of new product development', *Strategic Management Journal,* 25: 3, pp. 201–221.

Sturdy, A. (2011), 'Consultancy's consequences? A critical assessment of management consultancy's impact on management', *British Journal of Management,* 22, pp. 517–530.

Von Nordenflycht, A. (2010), 'What is a professional service firm? Toward a theory and taxonomy of knowledge intensive firms', *Academy of Management Review,* 35: 1, pp. 155–174.

Yin, R. K. (2003), *Case Study Research: Design and Methods* (3rd ed.), Thousands Oaks, CA: SAGE.

Jan Jervis
Bond University

Dr Jeff Brand
Bond University

Ph.D. candidate Jan Jervis has taught creative media at Bond University for over ten years. She started her career in fashion design, later moving into graphic design, and eventually became a master of multimedia and academic work. She is the recipient of three Excellence in Teaching Awards and a member of the founding group for the Bachelor of Interactive Media and Design program. Jan is an author of papers on teaching research project production to diverse learners, and on the polysemy and primacy of design. She is now a full-time researcher investigating cross-disciplinary design communication for business leaders, as well as consulting for two young companies regarding their design, merchandise and online presence.

Professor Jeffrey Brand Ph.D. (Michigan State University) teaches and researches emerging media and audiences in the Communication and Creative Media unit at Bond University. He is author of the Interactive Australia and Interactive New Zealand series of national computer games audience studies, and of the book *Sources of News and Current Affairs* (with Prof. Mark Pearson). Jeff is a consultant to government and industry clients including the Australian Communications and Media Authority, the Australian Classification Board, SBS, and the Interactive Games and Entertainment Association. His current work explores computer game audiences, with a focus on policy, serious games and the convergence design of books and games.

Designing competitive edge through job ads: A content analysis of seek.com.au

The word 'design' appears regularly in all types of dialogue, going far beyond traditional design disciplines. Yet an understanding of design appears dependent on the perceptions assigned by individuals across a wide and varied spectrum of professions. This paper examines the communication discourse on design across Australian businesses by analysing job listings on seek.com.au, a leading employment, recruitment and career portal in Australia and New Zealand. The research questions ask: (1) what design knowledge is requested by employers in their job advertisements; (2) what industries and professions are presented in the design features; and (3) whether design is acknowledged as a competitive necessity. A content analysis of 399 seek.com.au job listings was conducted using systematic sampling of over 15,000 listings in which the keyword 'design' was featured. The analysis included over 100 measures, representing eighteen variables related to the research questions. Results show only engineering job listings used the word 'design' in a consistent manner, indicating that design serves a competitive advantage in that field. Other disciplines or categories are not so clearly defined, indicating how the word 'design' is used inconsistently and for a varied range of functions, as well as being deployed more by business strategists than by marketers.

Keywords
design
dialogue
design thinking
design language
job ads
content analysis

Introduction

The word 'design' is used extensively in dialogue. It is used in conversation, in business and related communications; it is associated with education, trade and professions. This centrality of design in discourse, combined with unparalleled technological advances, occurs as many traditional design disciplines morph, change and align with previously dissociated fields. These previously dissociated fields and disciplines are instigating a wider scope for design. In Australia, The Prime Minister's Taskforce on Manufacturing report, 'Smarter manufacturing for a smarter Australia' (Australian Government, Department of Industry 2012), placed design as central for innovation and economic growth. Similarly, the Australian Design Alliance called for a national design policy. A national framework of design, they say, is essential if Australia plans to be counted on the world stage (Australian Design Alliance 2012). Despite these declarations, many organizations fail to recognize design as a strategic tool that can be implemented to enhance their business development (Kotler and Rath 1984).

The differing perceptions of the word 'design' in a global context are causing confusion among some business managers and leaders as they transition towards a future of extreme ambiguity (Boland and Collopy 2004). IBM, Sony and Apple, among others, are acknowledged as fostering a design culture through management leadership (Jeong Song and Chung 2008), but many in business management are portrayed as indifferent to, if not hostile towards, the word 'design'. They are charged with making assumptions that design is associated with nothing more than window decorations and clothing (Nussbaum 2007).

An understanding of design and its meaning is reliant on the perceptions assigned by individuals across a wide and varied spectrum. For instance, designers – or those who design – view change as a constant source of opportunity for radical innovation and problem-solving. By comparison, a marketing professional – one who promotes a product or service to the public – may view change as irregular, and a threat to sales and forecasts (Beverland and Farrelly 2011). For the marketer, change requires a management strategy. An absence of shared meaning of design between two professionals can lead to miscommunication in a collaborative environment, which could subsequently affect strategic development in business. Furthermore, misunderstandings about design are exacerbated in education, where design is not yet a fully recognized academic discipline (Chen 2007; Portewig 2004). It is postulated there would be an advantage to the practice, teaching and research of design if everyday use of a design language included shared understanding. The shared meaning and language of design would allow words to be brought to life in action settings (Beverland and Farrelly 2011; Boland and Collopy 2004). In effect, these settings would involve different professionals who speak the same language.

This paper examines how Australian businesses use the word 'design' in online job recruitment advertisements used to employ and deploy human resources. It investigates the use of the word

Designing competitive edge through job ads: A content analysis of seek.com.au

through a content analysis of 399 job listings on seek.com.au, a leading employment, recruitment and career portal in Australia and New Zealand. The research examines the use of the keyword 'design' within the listings regardless of discipline. The research questions ask what design knowledge is requested by employers in their job advertisements, what industries and professions are presented by job advertisements in which design features, and whether and how design is acknowledged as a competitive advantage. The paper outlines a description of the methods used to construct an instrument for the collection of pilot data through a content analysis of selected job listings, before the data collected from the 399 job listings is discussed. Results are presented in tables and diagrams to demonstrate the wide-ranging use of design in relation to diverse fields and industries. The paper concludes with a discussion on the growing centrality of design in the knowledge economy, and then proposes directions for further research.

Design meaning

The polysemy of design can be attributed in part to the multiple parts of speech for which the word may be used. 'Design' may be used as a verb, such as 'to design' and 'to plan' (which describes an idea or process), or as a noun, such as 'the design' or 'the plan' (depicting an item or service) (Borja De Mozota 2003). It appears that the more diversity of backgrounds and disciplines there is among collaborators, the more potential there is for misunderstanding and ineffective communication about design, thereby furthering its polysemic nature: 'The fragmenting force of social complexity can make effective communication very difficult. Social complexity requires new understandings, processes, and tools that are attuned to the fundamentally social and conversational nature of work' (Conklin 2005: 3).

The word 'design' has become associated with multiple trades, industries and professions. Its meaning is reliant both on perception assigned by individuals and a wide variety of design disciplines. For instance, the engineer is taught that design is a process in order to achieve a specific outcome. Graphic design has a visual and aesthetic focus that may or may not solve a problem (Main 2002). The Design Institute of Australia lists fourteen distinct design disciplines on their website ('Design professions'). Categories include industrial design, interior design, interior decoration, graphic design, textile design, exhibition design, fashion design, TV, film and set design, design management, design education, jewellery design, furniture design, digital media design and 'other disciplines'. seek.com.au, a leading employment, recruitment and career portal in Australia and New Zealand, applies design to 24 of its 30 category listings.

Design is hard to define. Academically, it does not have a clear epistemological foundation, and is often considered incidental in overall business strategy (Melvin 1993). The origins of the word 'design' can be traced back to the Latin word *designare*, adopted by the late Middle English language as 'to designate'. This in turn can be traced back to the Latin *sigmun,* which can be translated as 'a mark'. The term *désigner* and the noun 'design', meanwhile, originate from French via the Italian language (Borja De Mozota 2003; Julier 2008). The Italian Renaissance word *disegno* was used to describe the process of separating drawing from a finished article, thereby defining a division of labour that required intellectual thought and the disconnection of concept from execution. This apparent division of labour is referred to as design's 'first phase' (Balcioglu 1994, cited in Julier 2008: 42). In the second half of the twentieth century, design was associated with mass manufacturing and marketing of consumer products

(Runco and Pritzker 1999). However, it was not until the design methods movement emerged in the 1960s that the need for a better understanding of design was highlighted (Goldschmidt 1999).

Digital design literacy

An understanding of design cannot be separated from advances occurring in technology and media. Indeed, the ability to work with software such as Adobe Photoshop and other industry standard software is increasingly expected outside the art and design professions, such as journalism, education and medicine (Adobe Education 2011: 1). Although, academic acknowledgment of the software as an assistant to design outcomes or as a production tool is inconsistent, 'no theory or pedagogical practice yet exists to address the role these commercially developed and distributed digital technologies play in shaping and describing design's visual language' (Lupton 2007: 149).

Design, design thinking and creativity

Design in business management has been aligned with a problem-solving process, thus resulting in the concept of 'design thinking'. In this way, design thinking is considered a human-centred approach to problem-solving. For instance, Tim Brown, CEO of IDEO, classifies Thomas Edison as the epitome of a design thinker. He writes that Edison's ability to first visualize how humans would interact with his innovations is a fundamental step in the design thinking process (Brown 2008; Julier 2008). Like design itself, design thinking is considered by some to be a confusing term (Rylander 2009). Like many terms that gain common currency, 'design thinking' has entered common usage for what appears to be a desire to find competitive advantage. Design thinking as a human-centred approach to problem-solving is considered a driving force behind business innovation and economic growth (Brown 2008; Julier 2008). It is described as a powerful way to overcome limited thinking and to provide support for analytical experiential engagement (Buchanan 1992; Teal 2010).

Cameron Tonkinwise, Associate Professor and Director of Design Studies at Carnegie Mellon University, observes that current research into design thinking rarely acknowledges the 'Design Thinking Research Symposium', 'which has been collating and initiating innovative yet careful and extensive research into the nature of the design process for two decades' (Tonkinwise 2011: 533). He argues the businesses' application of design thinking has created a process of design that removes the aesthetics (or giving style to a form) usually associated with design in order to make design understandable to non-designers. The aesthetic associated with design is considered by some to be a subjective element. Tonkinwise (2011: 534) argues that it is a fundamental skill to a designer, as they are 'constantly critiquing with a distinctive lexicon the aesthetic quality of the designed output'.

Bruce Nussbaum is a recognized and outspoken advocate for design thinking, and was named one of the 40 most powerful people in design in 2005 by *I.D.* magazine. In 2009, he claimed that managers were embracing design thinking while designers were not (Nussbaum 2009). In 2011, he expressed frustration that the construction, framing and perception of design thinking was actually doing more harm than good for business outcomes. He suggested that the next phase for design in business would be a more humanistic approach. Nussbaum (2011) more recently argued that the next phase for design in business would activate a shift in management leadership from traditional and analytical thinking towards creativity and innovation. Business leaders will be expected to embrace knowledge workers who will create teams formed from multiple generations.

Designing competitive edge through job ads: A content analysis of seek.com.au

In 1959, Peter Drucker foresaw that the economy in the twenty-first century would be transformative (Drucker 1994). He argued that wealth in the economy would be created through knowledge and self-reliance. He predicted that rapidly evolving technology would create a new type of worker, one that was mobile and therefore not confined by previously accepted workplace boundaries. He devised the term 'knowledge worker' in order to label this type of human resource produced by and for the knowledge economy. The shifts occurring in business today can be linked to the permeable boundaries around specialized design fields. These boundaries are dissolving as the technologically enabled and mobile knowledge worker is released from a geographically and ideologically constrained workplace (Drucker 1994). Given that they are able to collaborate on a global stage, knowledge workers are using design as a central component for solving world issues (Margolin 2009). Consistent with the views expressed by Nussbaum (2011), *The Futurist* (2012) predicts the knowledge worker to be in transition to a newer economy, one in keeping with the transformation occurring in organizations. It refers to this environment as the Creative Molecular Economy, and positions it as emerging over the next ten to fifteen years. The new economy will, among others things, connect 'new knowledge to new resources in the creation of transformational projects' (The Futurist 2012: para 5).

Discourse about building competitive advantage is equally important for knowledge workers, who compete in a global market rather than a geographically confined one. Consequently, communication across this international stage will determine professional and business influence. Absence of a common language between design and management leads to misunderstandings, even when there is a will to communicate (Melvin 1993). Engineering design serves as an example. It is complex, and often involves other disciplines, technical and scientific problem-solving processes, as well as teams working together. Engineer designers are often stereotyped as lacking communication skills. However, in keeping with the development of design thinking, there is a renewed focus on the 'humanity of engineering design'.

As cognitive studies begin to investigate design thinking, similar questions are being asked of design language, such as 'Is there a designerly way of talking?' (Lloyd and Busby 2001). Problematically, the conversation is fluid. Any shift in dialogue from design to creativity and innovation in the Creative Molecular Economy could, in itself, be considered confusing for communication between design and business leaders on an international stage. Creativity is integral to design education, but is also viewed as an isolating practice (Melvin 1993). Technologically driven present and future cultures require a definition of design that is not separated from or aligned with any one trade or profession (Buchanan 1992). The definition must be overtly attached to the word, as it is used to advise knowledge workers of the sense in which the word is used.

Research questions

1. What form of design knowledge is requested by employers in their job recruitment advertisements/listings?

 » What kinds of design knowledge?

 » How much design knowledge?

 » How central or peripheral is design knowledge?

2. What industries and professions are represented in these jobs advertisements/listings?

3. How is design a competitive advantage according to these advertisements/listings?

Methods

Content analysis was chosen to explore the place of design in seek.com.au job listings. Content analysis is an empirical, quantitative tool that allows researchers to document the presence of both manifest (objective and obvious) and latent (interpreted and nuanced) presentations of content in many different forms of communication (Neuendorf 2002).

The content analysis approach uses a standardized code sheet to ensure that measures are made as reliably and objectively as possible, while accepting and accounting for human bias and inter-coder variations, which are checked using an inter-coder reliability statistic. The code sheet is designed in reference to research questions or hypotheses, and the characteristics of the communication and medium to be coded. Depending on the complexity and size of the population of artefacts or content objects in question, probability sampling is sought as the gold standard allowing for generalization to the population. Data collection is normally undertaken by multiple coders so that the relative replicability of the process can be determined. Depending on the nature of the research question and problem at hand, the unit of analysis may be anything from words or seconds of recordings to sizes of headings, or from individual articles, segments, chapters or listings to issues, shows or editions. For online job listings and questions about the presence of the word 'design' in them, the nature of the medium means that the individual listing itself is an ideal unit of analysis, and the sample is necessarily cross-sectional and limited by the dynamic and rolling nature of the content.

Instrument

The code sheet was designed to measure the appearance and use of the word 'design' in all seek.com.au job listings on one given day, and to assess an individual job listing as the unit of analysis. It was created in reference to the way listings appear on seek.com.au, and looked at job listing variables including the date the job was posted, the explicitly stated job title, the location of the job, the salary, the type of work available (e.g. full-time or part-time), the set 30 pre-defined industry classifications and countless subclassifications, as well as required qualifications and necessary experience. These measures would apply to all job listings on seek.com.au regardless of the multiple keywords featured in them.

Design-specific variables, by comparison, were measured so as to explore the research questions specifically, and often reflected the unique characteristics of various design fields. They were developed based on the design industries literature, and by reading many job listings and categorizing them according to design fields, design specializations, web design, design software such as Adobe Creative Suite (CS), productivity software, and required soft skills such as communication and teamwork. The location of the word 'design' (job heading, listing body or both) was also measured.

In all, eighteen variables were created, many of which were made up of multiple observable items, thereby resulting in 104 measures.

The instrument was constructed and hosted on SurveyMonkey.com, an online data-collection tool designed primarily for market and social research surveys. The product allows for moderately complex survey forms; it allows researchers to set whether every entry on the survey must come from a different computer or, for data entry like that required in content analysis, multiple completions may come from the same computer. The benefits of using SurveyMonkey include: (1) the reduction in handling, so that a code sheet form need not be manually entered into a statistics application from paper forms;

Designing competitive edge through job ads: A content analysis of seek.com.au

(2) automated logic for contingency measures ('if the answer is Web Design, go to the next question...'); (3) readily extensible and controllable use for different purposes (such as a pilot study, main study data collection and inter-coder reliability); and (4) readily available, if somewhat simple, statistical and graphical reporting tools.[1]

Sample

The whole of the seek.com.au job listing database presents between 100,000 and 200,000 job listings in Australia at any one time. According to the site, there are currently over 120,000 job listings presented.

The sample frame for this research consisted of all listings returned for the search word 'design', which produced more than 15,000 listings. For comparison, 'manage' returns approximately 21,000 listings; 'build' returns 14,700 results; and 'teach' returns just under 600 listings. Focusing on a prescribed role (such as 'designer' rather than 'design') changes the dimensions: 'designer' returns 2600 listings; 'manager' returns 48,000 listings; 'builder' gives 2100 listings; and 'teacher' gives 3500 listings. The focus in this study was on the meaning, use and apparent competitive advantage of design, rather than on the role of a designer per se.

The target sample from the sample frame of over 15,000 listings was 400 job listings. In order to permit inferences to be made about the population of job listings that use the word 'design', a systematic random sample (SRS) of every 37 listings was attempted.

Pilot

The dynamic nature of the site makes a 'snapshot' of the sample frame impossible; therefore a perfect SRS is infeasible. Listings are added and removed continuously, and even those listings containing the word 'design' change hourly. Moreover, the page-display settings on seek.com.au are invariable at twenty listings per page, and after 200 page displays, no more listings can be returned to a single user based on the research team's tests. Consequently, a systematic sample of one listing (the twentieth) on every even page was assigned to one coder, and every last listing on every odd page was assigned to another coder.

The instrument was trialled by the authors in early January 2013. It was refined to ensure variables and their measures were exhaustive and mutually exclusive in relation to the medium and the design job listings.

Data collection

A sample of 400 listings was achieved. The sampling procedure was undertaken on 30 January and 1 February 2013. Two postgraduate research assistants served as coders. These coders had trained with the authors during a full morning session in which coding definitions and instructions were refined. This was to ensure consensus on coding categories and meanings. A code sheet with a collection of job listings featuring the word 'design' was used on SurveyMonkey.

The procedure required the researchers to institute a search at the same moment and then proceed to 'print' a PDF image of every twentieth listing (one per page) on every returned and displayed even or odd page (one or the other assigned to a different researcher). Once these pages were saved as digital copies, coding proceeded for a period of three days.

Results

Many job listings on seek.com.au use the word 'design' as a fashionable and trendy form of window dressing for industrial, retail and technical positions, suggestive of the view that design provides a competitive edge. However, the findings illustrate that in other job listings, the word 'design' is meaningful,

		%
Job location	Sydney	31
	Melbourne	28
	Brisbane	14
	Perth	12
	Adelaide	3
Salary	Not Stated	61
Job Duration	Full-time	82
	Contract/Temp	15
	Part-time	2
Classification	IT	26
	Engineering	20
	Design & Architecture	14
	Mining, Resources & Energy	7
	Marketing & Communications	5
Field or Discipline	Engineering and Mechanical	37
	Design Management	25
	Telecommunications	18
	Multimedia/Web Design	12
	Communication, Advertising/Marketing	11
	Architecture	11
Specialization	Project Management	51
	Not Stated	32
	Client or Customer Service and Management	18
	Research and Development	12
Highest Qualification Required	None stated	56
	Tertiary	30
	Formal	9
Experience	Generic 'Experience required'	48
	3–5 years	15
	6–10 years	13
	None stated	13

Table 1: Univariate descriptive results for job listing details.

essential and a clear advantage for many positions and fields. Descriptive statistics for the sample are presented first; following this, the findings are presented for each research question.

Sample findings
Sydney led locations for listings, followed by Melbourne, Brisbane, Perth and Adelaide (see the univariate descriptive results in Table 1). Other locations, such as Gold Coast, Canberra and many regional areas, were represented less frequently; Hobart, Darwin, Regional Tasmania and Regional NT were notable in their absence of listings for jobs with the word 'design'. Few listings identified salary levels, but most were for full-time employment. Information technology (IT) led the classification list, followed by engineering, design & architecture, mining, resources & energy and marketing & communications. Many other classifications included 'design' in the job listing, and among the 30 classifications, only six showed no listings: call centre & customer service; CEO & general management; farming, animals & conservation; self-employment; sport & recreation; and other. Among the 22 fields represented (as opposed to classifications), all but one (jewellery design) featured at least one listing, with engineering & mechanical and design management represented most frequently. Project management is in high demand as a specialization, but notably absent (except for a few cases) is the request for specializations in animation, 2D & 3D illustration, interface design and sound.

Although most listings do not specify education, a third clearly calls for tertiary qualifications. A clear majority of job listings state that experience is a necessary prerequisite for the position.

Design representation findings
'Design' is featured in over a quarter of job headings

and in nearly all body text in job listings; in other words, 'design' features in both heading and body in a quarter of all job listings (see Table 2). The use of 'design' in the job listing body text is rarely associated with web design or jobs requiring Adobe Creative Suite software skills. Website design job listings explicitly stating HTML, CSS and moderate programming skills such as JavaScript and JQuery collectively amount for less than one-fifth of the listings. About a tenth of the listings mention Creative Suite, Photoshop, Illustrator, InDesign or Dreamweaver by name.

Moreover, although nearly half of the listings make no mention of specialist design or job-related software skills, over a third call for skills with either named or job-related software knowledge. Office productivity and project management software combined account for about a fifth of the software abilities in these job listings. These categories are not mutually exclusive, so many listings mention multiple specialist or productivity software capacity.

Communication skills are featured frequently among the 'soft' skills, being either explicitly or generally noted in the job listings: nearly half make a general reference, with almost a quarter noting writing skills and a fifth asking for verbal skills. Design thinking can be observed in almost a quarter and creative thinking in a sixth. These are reflected in explicitly stated responsibilities and expectations, with management or leadership of teams in under half of listings, and working in teams featuring in under half. Ability to work collaboratively features in a fifth of the listings.

The standout 'latent' or subjective measure in the content analysis is an estimate of the use of the word 'design' in relation to the business or organization hiring for the position. However, the

Variable	Categories	%
Design Appearance	Heading	27
	Body	98
Website Design	None stated	86
	Moderate Programming Skills	8
	HTML	7
	CSS	5
Adobe Creative Suite Skills	None stated	93
	All Creative Suite	4
	Photoshop	3
	Illustrator	3
Productivity Software Skills	None stated	47
	Specialist Software	38
	Computer Aided Design Software	12
	Microsoft Office	11
	Project Management	9
Communication Skills/ Thinking	Communication Skills	48
	None stated	25
	Writing Skills	23
	Design Thinking	23
	Verbal Skills	19
Responsibilities/ Expectations	Manage/Coordinate/Lead... Teams/Others	43
	Work in Teams	37
	Work Collaboratively	21
	None stated	19
	Quality Assurance	15
	Time Management	15
	Work Independently	14
	Problem-Solving	14
Use of the Word 'Design'	Verb	60
	Adjective	34
	Noun	33

Table 2: Univariate descriptive results for design in job listings.

three categories (verb, adjective, noun) are not mutually exclusive, i.e. a job listing might deploy all three senses of the word. In over half of the listings, coders judged that the word 'design' was used as a verb to describe the activity and process of design as a function of the business. In a third, design was used as an adjective to indicate that the business associates with the broader characteristic of design. Also in a third, design was used as a noun to indicate the business deals with a design product or service.

Research question results
The descriptive summary of the findings goes some way to answering the research questions, particularly research question one. However, a number of simple cross-tabulation (bivariate) analyses reveal clearer answers to research questions two and three.

Research question one asked, 'What form of design knowledge is requested by employers in their job recruitment advertisements/listings?', and featured three sub-questions. The first asked, 'What kinds of design knowledge are requested?' The findings (Table 2) that website design, Adobe Creative Suite and visual design are minority knowledge domains for design job listings, and that listings for design job specializations seldom call for traditional media and visual design abilities, indicates that design knowledge is seen to be a broader and widely applicable knowledge domain across many fields.

The second sub-question, 'How much design knowledge is requested?' can be considered in light of the educational and experience measures. The job listings required either no stated education or tertiary education. On this basis, tertiary knowledge is desired a third of the time. However, nearly half of all listings require experience, while only 13 per cent fail to state or establish whether prior employment experience is required. These findings do not vary by field, software or other skill areas. On this basis,

design knowledge is not well understood or quantified by organizations. Indeed, it seems that design can be applied to a wide range of fields and that design knowledge is a fuzzy concept across these fields.

The third sub-question asked, 'How central or peripheral is design knowledge?' On the basis of our findings (Table 2) – that explicitly stated design specializations favour project management (52 per cent of listings) and the rest tend not to be stated – it seems design is more like window dressing than a focal-point knowledge requirement in these job listings.

Research question two asked, 'What industries and professions are represented in these jobs advertisements/listings?' To answer the question, we considered the most frequently advertised design fields or disciplines identified within the top five of the standard 30 job classifications appearing on seek.com.au (Figure 1). Design disciplines were sometimes presented together, presumably to ensure the listing 'captured' suitable applicants; therefore, these categories were not mutually exclusive.

We found that engineering and mechanical design and production in engineering, mining and telecommunications classifications were the most frequently represented among the listings, accounting for 47%. This sense and application of design revolves around infrastructure and civil works rather than aesthetics and content. Design management, however, suggested senior and managerial industries' primacy over the 'creative industries', accounting for 23% of the listings and ranking second, barely ahead of specialized telecommunications, which accounted for 23%. Multimedia, web design and digital publishing ranked fourth, and accounted for 15% of all listings. Architecture (13%) and graphic design and

Designing competitive edge through job ads: A content analysis of seek.com.au

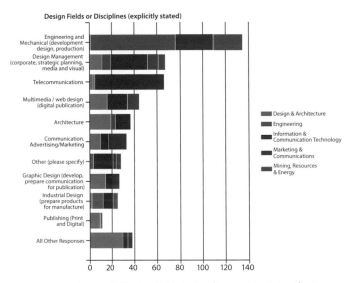

Design Fields or Disciplines (explicitly stated)

Legend:
- Design & Architecture
- Engineering
- Information & Communication Technology
- Marketing & Communications
- Mining, Resources & Energy

Figure 1: Design fields by top five standard classifications.

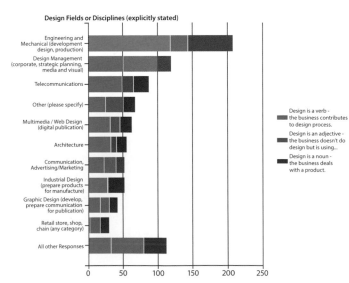

Design Fields or Disciplines (explicitly stated)

Legend:
- Design is a verb - the business contributes to design process.
- Design is an adjective - the business doesn't do design but is using...
- Design is a noun - the business deals with a product.

Figure 2: Design usage by field of discipline.

publication (9%) rounded out the top five industry and professional fields in which design was located. On this basis, it appears that both traditional and non-traditional design fields are represented in contemporary Australian listings.

Research question three asked, 'How is design a competitive advantage according to these advertisements/listings?' To answer this question, we conducted two cross-tabulations using the question about how 'design' was used in the job listings (as verb, adjective or noun) as our base measure. The first analysis sought to observe whether job listing writers include 'design' as an attractor. We therefore examined the extent to which the adjectival use of the word features in listings. We reasoned that if 'design' is used as an adjective to associate the word, without the job entailing designing or trading designed goods or services, then it is viewed by job listing writers to be a competitive tool. The results (Table 3) suggest that 'design' is not deployed heavily as an adjective descriptor in the heading. There is no variation in the way the term is used in body text (although nearly all listings use 'design' in the body, it was used invariably in all senses). It was used less often in the headings as an adjective than as a verb or noun.

The second analysis sought to examine whether 'design' as an adjective was used more within the organization by looking at its use in the design fields, or in disciplines that dealt with marketing and selling (as opposed to production or publication). Indeed, the application of 'design' in management and strategic planning was more prominent than in other fields. The findings suggest that in this context, design is seen as a competitive advantage by those involved in strategy.

	Design in Title/Heading	Design in Text Body
'Design' as verb (the business designs)	31%	98%
'Design' as adjective (associates with design)	22%	98%
'Design' as noun (trades design products)	32%	99%

Table 3: Design usage by location in job listing.

Taken together, the first and second findings may be reconciled by noting that job listing writers and recruiters may not see design skills and design ideas as a competitive advantage, but managers and strategic planners in organizations do. Indeed, design is used in the great majority of the job classifications used for jobs in seek.com.au. Furthermore, the fact that it features in a relatively large number of listings compared with other terms we attempted with searches of the site suggests to us that design is viewed generally as a modest competitive advantage.

Discussion

Online job recruitment organization seek.com.au was chosen as the source for the content analysis because it is listed as the leading job site by Nielsen/Netratings and claims 14.7 million visits each month. The purpose of this research is to determine whether the keyword 'design' has a consistent meaning across a variety of disciplines in a job search.

To assist the advertiser, the seek.com.au website offers multiple resources, including job advertisement templates, interviewing tips and other information.

However, inconsistencies were prevalent across various aspects of the website. For example, inconsistencies were found when a seek.com.au category indicated job duration (as opposed to load) as full-time despite the individual listing referring to it as a contract position with a limited time frame. Furthermore, employers have the power to choose the category (placement) of their listings or pay a premium rate in order to have a more prominent placement within the website across multiple categories; as such, the researchers found the placement of job advertisements may not be consistent.

The following example advertisements illustrate the absence of standards for the meaning of 'design' in the job listings. Some advertisements appeared to have no obvious relevance to design; others used expressions that were confusing, misleading or unprofessional. Statements such as 'You must have a passion for life and a spark for design', 'You will be improved', 'graphic designer with design skills', 'Reporting to our super friendly Project Manager', 'This is your chance to earn the BIG BUCKS', 'Great working conditions, casual dress & pub lunches',

Designing competitive edge through job ads: A content analysis of seek.com.au

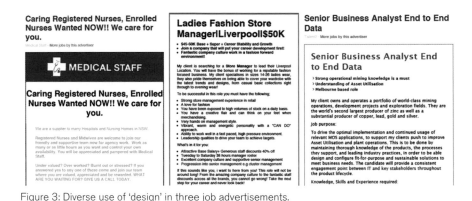

Figure 3: Diverse use of 'design' in three job advertisements.

We were just wondering...

From the information on this page, are you confident you can tell whether this job is relevant?

| Yes | Kind of | Not really |

No

Figure 4: A survey by seek.com.au to determine job advertising relevance.

'Unique benefits including a paid day off on your birthday' and 'will idolise your experience' all appear to assume an understanding of shared meaning. Figure 3 illustrates the variety of job advertisements that may be returned from entering the keyword 'design' in seek.com.au.

However, it should be noted that measures have been taken by seek.com.au to reduce confusion resulting from the language used in the job ads. At the bottom of the web page, viewers are requested to complete a simple survey about whether they understand the relevance of the job from the information provided. Figure 4 shows an image representation of the feedback survey provided by seek.com.au.

Inconsistency in the language used to request graphic design software skills was noted. Of the 399 job listings analysed, only 7 per cent explicitly stated the software listed under the Adobe Creative Suite. This software includes Photoshop, Illustrator and InDesign among others, which are the accepted industry standard software packages (Lupton 2007). When the keywords 'Adobe Creative Suite' were entered directly into seek.com.au, a response of 273

job listings was returned; meanwhile, 'Adobe Photoshop' returned 205 listings, but 'Photoshop' entered as a single keyword returned 674 listings. These findings were not analysed as part of this research, but are mentioned here to highlight findings by Adobe Corporation that digital design skills are required in non-design jobs (Adobe Education 2011). In contemporary job ads, trending language may be obtuse for many reasons; a primary reason could be that those writing the job listings do not have specific enough knowledge of the field, specialization or tools required to fulfil the job requirements. The researchers noted that job ads written in the second person were easier to understand and appeared to have clearer outlines of specific job expectations and requirements than those in the third person.

Results show that 30% of the job listings asked for tertiary qualification, 9% used the word 'formal', but 56% did not state education as a requirement. Moreover, the seek.com.au category education & training produced only a 1% response for the keyword 'design'. This result could demonstrate that design educators are employed through other specific, or more specialist, websites or methods. In addition, the limited amount of job listings specifically for creative industries and graphic design on seek. com.au suggests that many creative businesses or professional designers are not using the site for their requirements.

The results show that 60 per cent of the listings did not state a salary or monetary payment. Of those that do mention salary, the categories are predominantly related to mining industries. The question could be asked of whether this reflects a business management perception of design as a necessary but undervalued attribute, or whether it is a deliberate omission to allow the job applicant and the employer to negotiate further without preconceptions.

Conclusion and further research

Of the 399 advertisements analysed, only engineering listings used the word 'design' in a consistent manner, indicating design serves as a competitive advantage in that field. Other disciplines or categories are not so clearly defined, and design is consequently used inconsistently and for a wider range of functions. For the remaining multitude of disciplines, divining the meaning of design and design thinking requires further observation and measurement.

One measure that may have provided more clarity about the (implicit) meaning of design would have been whether the position advertised required applicants to submit or produce a portfolio. In addition to providing additional information about experience required, a measure of portfolio requirement in the job ad may establish (or confirm) whether creative output is an element of design thinking required in particular job categories. Other keywords emerged from the job listings, such as 'innovation', 'creativity' and 'mentoring', and these were noted for inclusion in future research.

This paper presents whether and how a design language of shared meaning is feasible. It is envisaged that a common language will provide greater clarity for the purposes of professional development and exchange in human resources and industrial planning.

Acknowledgments

We would like to acknowledge the assistance of research assistants Dr Pascaline Lorentz and postgraduate student Kelsey Seeger.

References

Adobe Education (2011), *The Silent Transformation: Evolution and Impact of Digital Communication Skills Development in Post-Secondary Education,* http://www.adobeeducationevents.com/whitepapers/HED_DigitalCommSkills/higher_education_silent_transformation_white_paper_ue_r4.pdf. Accessed 12 February 2012.

Australian Design Alliance (2012), 'National cultural policy: Australian Design Alliance submission', http://australiandesignalliance.com/Library/files/ADA%20NCP%20Submission%5B1%5D.pdf. Accessed 12 February 2012.

Australian Government, Department of Industry (2012), 'Smarter manufacturing for a smarter Australia', Non-government members report, http://www.innovation.gov.au/Industry/Manufacturing/Taskforce/Pages/Library%20Card/SmarterManufacturing.aspx. Accessed 12 February 2012.

Berman, D. B. (2009), *Do Good Design: How Designers Can Change the World,* California: New Riders.

Beverland, B. M. and Farrelly, F. J. (2011), 'Designers and marketers: Toward a shared understanding', *The Design Management Review,* 22: 3, pp. 62–70.

Boland, R. J. Jr. and Collopy, F. (eds) (2004), *Managing as Designing,* Stanford, CA: Stanford University Press.

Borja De Mozota, B. (2003), *Design Management: Using Design to Build Brand Value and Corporate Innovation,* New York: Allworth Press.

Brown, T. (2008), 'Design thinking', *Harvard Business Review,* June, pp. 85–95.

Buchanan, R. (1992), 'Wicked problems in design thinking', *Design Issues,* 8: 2, pp. 5–21.

Chen, L.-L. (2007), 'International journal of design: A step forward', *International Journal of Design,* 1: 1, pp. 1–2.

Conklin, J. (2005), *Wicked Problems and Social Complexity,* http://www.cs.uml.edu/radical-design/uploads/Main/WickedProblems.pdf. Accessed 12 February 2012.

Design Institute of Australia (n.d.), 'Design professions', http://www.dia.org.au/index.cfm?id=103. Accessed 30 January 2013.

Drucker, P. F. (1994), 'The age of social transformation', *The Atlantic,* November, http://www.theatlantic.com/past/docs/issues/95dec/chilearn/druker.htm. Accessed 12 February 2012.

The Futurist (2012), 'Building and connecting communities for the future', *The Futurist,* 46: 4, http://www.wfs.org/futurist/july-august-2012-vol-46-no-4/building-and-connecting-communities-for-future. Accessed 12 February 2012.

Goldschmidt, G. (1999), 'Design', in M. A. Runco and S. R. Pritzker (eds), *Encyclopedia of Creativity* (vol. a–h,), London: Academic Press, pp. 525–535.

Jeong Song, M. and Chung, K. (2008), 'The role of chief executive officers in design management exercises: content analysis and case studies', *Design Management Journal,* 4: 1, pp. 32–44.

Julier, G. (2008), *The Culture of Design* (2nd ed.), London: SAGE.

Kotler, P. and Rath, G. A. (1984), 'Design: A powerful but neglected strategic tool', *Journal of Business Strategy,* 5: 2, pp. 16–21.

Lloyd, P. and Busby, J. (2001), 'Softening up the facts: Engineers in design meetings', *Design Issues,* 17: 3, pp. 67–82.

Lupton, E. (2007), 'Learning to love software: A bridge between theory and practice', *Artifact,* 1: 3, pp. 149–158.

Main, B. W. (2002), 'Design reviews: Checkpoints for design', *Professional Safety,* 47: 1, pp. 27-33.

Margolin, V. (2009), 'Design, in history', *Design Issues,* 25: 2, pp. 94–105.

Melvin, J. (1993), 'Design and the creation of job

satisfaction', *Facilities,* 11: 4, pp. 15–18.

Neuendorf, K. A. (2002), *The Content Analysis Guidebook,* London: SAGE.

Nussbaum, B. (2007), 'CEO's must be designers, not just hire them: Think Steve Jobs and iPhone', *Bloomberg Businessweek,* 28 June,

http://www.businessweek.com/innovate/NussbaumOnDesign/archives/2007/06/ceos_must_be_de.html. Accessed 12 February 2012.

Nussbaum, B. (2009), 'Design thinking battle: Managers embrace design thinking, designers reject it', *Bloomberg Businessweek,* 10 July,

http://www.businessweek.com/innovate/NussbaumOnDesign/archives/2009/07/design_thinking_3.html. Accessed 12 February 2012.

Nussbaum, B. (2011), 'Design thinking is a failed experiment. So what's next?', *Fast Code Design,* 5 April, http://www.fastcodesign.com/1663558/design-thinking-is-a-failed-experiment-so-whats-next. Accessed 12 February 2012.

Portewig, T. (2004), 'Making sense of the visual in technical communication: A visual literacy approach to pedagogy', *Journal of Technical Writing and Communication,* 34: 1–2, pp. 31–42.

Runco, M. A. and Pritzker, S. R. (eds) (1999), *Encyclopedia of Creativity* (vol. a–h), London: Academic Press.

Rylander, A. (2009), 'Design thinking as knowledge work: Epistemological foundations and practical implications', *Design Management Journal,* 4: 1, pp. 7–19.

Teal, R. (2010), 'Developing a (non-linear) practice of design thinking', *The International Journal of Art & Design Education,* 29: 3, pp. 294–302.

Tonkinwise, C. (2011), 'A taste for practices: Unrepressing style in design thinking', *Design Studies,* 32: 6, pp. 515–610.

(Endnotes)

1. Readers may wish to review and engage with the code sheet at the following link: https://www.surveymonkey.com/s/FYS5MFV.

Robert Crocker
University of South
Australia

With a doctorate in the
history of early modern
science and ideas from the
University of Oxford, Robert
Crocker teaches
sustainable design theory
in the Master of
Sustainable Design
program and the history
and theory of design to
Visual Communications and
Product Design
undergraduates at the
University of South
Australia. He also teaches
research methods to
Honours Interior
Architecture, Master of
Design and Master of
Sustainable Design
students and supervises
honours, coursework
masters and Ph.D. students.
He is an active researcher
and member of the Zero
Waste South Australia and
the Sustainable Behaviour
Research Centre. He is
also a co-editor of a series
of books (published by
Routledge) on design,
sustainability and behaviour
change.

'Ethicalization' and greenwashing: Business, sustainability and design

As a commitment to sustainability implies wanting to save the planet, 'going green' has for some years now become a target for corporate spin. Creative accounting with emissions, glossy annual reports, showcase 'green' offices, celebrity endorsements, isolated but well-publicized behaviour change programs, and large but often tainted donations to NGOs have now become obligatory in many corporate HQs, especially those wishing to conceal or divert attention from their often much larger 'brown' commitments or investments. While there are genuinely 'green' companies making important progress in reducing emissions, transforming their supply chains and their own behaviour, the rush to look green amongst many corporations – especially, it is argued, those with most to hide – is a search for legitimation and ethical 'meaning making' in a field that is being shaped by a larger public culture demanding the 'ethicalization' of businesses. Referring to recent examples and contemporary discussions about greenwashing and corporate social responsibility (CSR), this paper will argue that it is more useful for designers to understand greenwashing (in the context of marketing and PR) as an attempt to 'buy' reputation or legitimation – a legitimation best served through recourse to sustainable design. This is defined here as a practice that seeks to reconfigure social and material relationships towards greater sustainability.

Keywords:
sustainability
business strategy
green marketing
sustainable design
greenwashing

Introduction: The problem with 'sunk-cost effects'

If you had heard some time ago that a famous stage show from Broadway was coming to town and had not been that interested, but then suddenly, a day before the show, someone had given you a $200 ticket to go and see it, what would you do? I should explain here that you would prefer to go home and read a book you are really enjoying. But here you are with your $200 ticket, and it's free! What do you do? It's too late to find someone else to take your place. Do you go? Or would you stay at home feeling guilty for 'wasting' $200 by not going? (Cunha and Caldieraro 2009; Kelly 2004).

Most people will go to the 'big' show they don't want to see, simply because 'throwing away' that $200 seems wrong, and the more expensive and long term the prior investment, the 'more wrong' such avoidance or 'waste' seems. Termed the 'sunk-cost effect', the powerful 'influence of prior irrecoverable costs on decision-making' is familiar territory in history, psychology, anthropology, sociology and philosophy. In these disciplines, it is widely recognized that prior commitments or investments will influence or skew the perceptions of individuals or groups when making decisions, even if following such a prior commitment is likely to be disastrous (Cunha and Caldieraro 2009; Janssen, Kohler and Scheffer 2003; Kelly 2004).

The central problem with the many 'sunk-cost effects' of our unsustainable ways of doing things – particularly in the ways we currently extract, make, build, promote, sell, use and dispose of goods and services – is that they are profitable, employ many people and appear to fuel the growth that ensures economic stability. But, in truth, they are also now locking us into 'the show at the end of the world', a show we don't really want to see. But our jobs, our livelihoods, the very 'success' of our companies, all seem to depend on making the show go on (Hamilton 2010). On the other hand, technological and media changes have also meant that large transnational corporations can no longer escape public scrutiny of their unsustainable practices, but must do battle with often hostile NGOs ready to hold their actions to account (Holzer 2010). For large, established corporations, especially in areas known to be environmentally dirty or socially risky – and especially when their main business requires dealing directly with the public (such as oil companies, car manufacturers, electronic equipment manufacturers, banks and insurance companies) – the risks presented by this public scrutiny seem particularly pressing. Their reputation and legitimacy appear to be constantly brought into question by the public's growing understanding of the environmental costs their activities incur (Ihlen 2009). For this reason, somewhat paradoxically, CSR and sustainability reporting now seem to be most carefully attended to amongst those most likely to look 'guilty' of damage to the environment, or amongst those open to a public perception that they are (Ihlen 2009).

Bolstered by the 'ticked box' of a 'good' or passable CSR strategy in their annual reports, many of these 'dirty' companies go on to draw attention to this new argument for their legitimacy as a marketing tool. In doing so, they are using ethical or sustainable hyperbole in their promotional material, often without really understanding the possible risks this might involve. Wanting to be seen as one of the 'good guys', or at least no longer one of the 'bad guys', this situation can lead some companies to change at

least some of the ways in which they behave so as to improve their moral standing – a sort of 'ethicalization' that results from the increased scrutiny they are now subject to (A. Arvidsson 2010; Holzer 2010). But this can also lead some to engage in a PR-led counter-ploy that amounts only to pro-environmental or pro-ethical spin, and which may in fact have little to do with their real environmental or social performance (Pearse 2012).

Much like CSR reporting itself, this 'greenwashing' is driven by concerns with reputation, and a fear of losing public respect in the face of increasingly easy access to potentially damaging knowledge, as well as to increasing public expectations of ethical behaviour (S. Arvidsson 2010; Vos 2009). Greenwashing typically now involves using specialist charities or NGOs to somehow 'verify' a company's progress towards greater sustainability (think of all the fleet cars and airlines 'offsetting' their polluting journeys with planting trees), using distraction through metaphorically 'off-setting' a dirty or brown product or service with a green one (such as the Toyota Prius in a range of otherwise fairly standard polluting vehicles); or using expert lobbyists to change the requirements of the rules a company is subject to; or to create a public 'mood' that such a change is justified (think of climate change denial or the activities of food industry lobbyists; see Vincent and Ryan 2013). Pearse (2012) lists many companies and products or services following these and similar strategies, as does Beder (2002).

Greenwashing as PR is not easy to manage. A few days before the fateful Deepwater Horizon disaster in the Gulf of Mexico, despite much evidence from inside and outside the company that their environmental and social standards were not adequate, BP issued an upbeat CSR report justifying its strategies and practices as the 'best' in the business – an approach Balmer (2010) rather politely terms 'brand exuberance'. This communicative

'overreach' in BP's case led to a terrible fall, a 'brand collapse', when the whole fabric of the company's 'brand philosophy' was stripped bare in public by subsequent events (Balmer, Powell and Greyser 2011). No doubt BP's earlier CSR report from this period is destined to become a classic text for discussion amongst students of business ethics and PR. Perhaps it will also become one more nail in the coffin of the 'classical' approach to business ethics (and to PR), where the purpose of business is thought to be increasing shareholder value alone – at least within the requirements of the law – whatever these interests happen to be on the high seas of the global economy (Muratovski 2013; Yani-de-Soriano and Slater 2009).

'Ethicalization', greenwashing and sub-ethical sunk-cost effects

The problem for many large businesses such as BP is that the sunk-cost effects within their organizations may have been 50 or 100 years or more in the making, and changing the methods of a corporation that has always drilled, processed and sold petroleum, for example, is extremely difficult (Balmer 2010; Janssen, Kohler and Scheffer 2003). Furthermore, the classic historical framing of the corporation is of a legal commercial entity that in its structure and obligations is directed largely to its shareholder owners, and not to sometimes influential 'stakeholders' such as their customers or interested NGOs; nor is it directed to the 'externalities' of the social and environmental impacts of what they are doing, which is, after all, what we are concerned with here (see Rodin 2005). This has led to Barkan's (2004: 60ff) notorious description of the corporation itself as an essentially 'externalizing machine', where all deferred or distanced social and environmental costs are shifted outwards to become 'somebody else's problem' (Crocker 2012b; Princen 2002b). This leads to a self-reinforcing style of sub-ethical business practice that invariably favours profit-making over social or environmental negatives; this is

a common complaint apparent in many of the more thoughtful pieces on business ethics, sustainable development, environmental politics and international relations (see Barkan 2004; Maniates 2002; Moncrieff 2011; Princen 2002a).

Perhaps the most effective and self-serving reason why businesses should take CSR seriously is simply to preserve their own reputation and that of their brands. Over the last three decades, a further integration between PR, marketing and advertising strategies has become more common amongst large, transnational corporations, and this total brand or corporate 'philosophy' now invariably involves 'ethical' claims, if not an integrated cycle of regular CSR and sustainability reporting (S. Arvidsson 2010). This reflects a growing concern with reputation in a world of increasingly demanding standards, ensuring that the brand not only appears 'strong' but also 'ethical' (Holzer 2010). The widespread belief amongst corporate managers seems to be that CSR and sustainability reporting present valuable opportunities to attain greater public recognition and legitimation, and thus more effective marketing (Marais 2010). In this way, CSR and sustainability reporting have been seen increasingly by some managers as media and marketing opportunities for transforming or concealing the 'bad news' of other core business activities, or what Princen (2002b) memorably terms 'shading' (see also Laufer 2003).

The techniques for achieving such a 'green shine' are well-known and widely practiced, and not only by petroleum companies (Laufer 2003; Pearse 2012). These can include purchasing a green start-up to bask in its light (e.g. BP Solar); supporting or becoming directly involved in an environmental or developmental charity or NGO whose legitimacy can be metaphorically if not substantially borrowed (e.g. most banks and their sponsored charities); developing a green product or service that can 'feature' in your own green ads or brochures, even if

this represents a very small portion of what you actually do (e.g. Toyota Prius); or creating a service or product that is greener than your core business and can be used to show off your good intentions (Laufer 2003; Pearse 2012). Through many examples, Pearse (2012) details the kind of contemporary corporate greenwashing that results from this desire to 'ethicalize' core activities: marginally 'greener' cars and jets introduced as 'niche' products that can nevertheless become 'brand carriers' used to move attention away from an even bigger and growing avalanche of browner ones made by the same companies (think of the new Asian 'brown' markets captured by Toyota and Boeing); greener petrol or alternative fuels (a sort of psychological 'offset' for the bulk 'black' category); greener, 'smarter' plastic throwaway drink bottles and wrappers (think of Coca-Cola's emphasis on its 'greener' bottles); greener tourist ventures with no real benefits for the environment or local people; supposedly greener credit cards (often produced by banks heavily involved in investing in 'brown' industries); and even 'greener' but more deadly weapons.

While none of this does any real credit to the companies involved, this greenwashing typically involves an energetic 'creation of meaning' through visual or material associations, in line with standard marketing and branding practices. The main purpose of this 'green' trajectory, however, is to distract from, or somehow appear to make up for, mainstream 'sub-ethical' money-making activities, perhaps a 'sunk-cost effect' that appears to be hard or impossible to change (A. Arvidsson 2010; Ewen 1996). This approach strategically attempts to counter the claims of environmentalists that the companies concerned are damaging the environment or the well-being of various groups of people by using the more positive assertion that they are simultaneously 'engaged' in social or environmental activities that are 'good' (Beder 2002; Holzer 2010). The aim of this 'green marketing' is to enhance a

company's reputation or legitimacy – and deflect criticism of their more standard 'classical' (and now 'sub-ethical') brown practices – through what appears to be a frequent assertion of 'positive' news of change or impending change. For instance, in a recent article in *The Conversation,* Powell (2013) describes Coca-Cola's foray into a PR-driven health 'education' program in schools in the United States as an attempt to blunt increasingly justified criticism relating to childhood obesity and related conditions. Interestingly, the thrust of the program, according to Powell (2013), is to individualize the problem of obesity, thereby again shifting attention away from the systemic (and corporate) root of the problem.

While programs like these clearly emerge from the traditions of PR (Ewen 1996), they can also be seen as part of a broader societal 'ethicalization', wherein more and more consumers have come to expect higher standards of behaviour than are typically exhibited by the owners of the brands they use (A. Arvidsson 2010; Holzer 2010). This is in part a result of the 'perfectionism' of the brands themselves, whose idealized representations in the media naturally lend themselves to the idea that they are also 'perfect', or at least above reproach, in their social and environmental origins (Binkley 2009). Moreover, those brands that have been attacked or sullied by association with less than perfect origin stories can go on the attack and redefine their origins using one of many greenwashing strategies. So 'engaging with' a known socially beneficial activity, such as providing some educational program, running or contributing to schemes that provide clean drinking water in Africa or sponsoring partnerships with large charities doing other good work amongst the distanced 'disadvantaged' in the Third World, seems to lift an increasingly tarnished corporate reputation closer to the 'perfection' suggested by the brand (A. Arvidsson 2010; Laufer 2003). In a recent case study of this kind of strategy, Brei and Bohm (2011) show how major bottled water companies in

Europe, in response to mounting environmental criticism of their largely destructive environmental activities, all now have positive CSR programs in place, often implemented through third parties who link their branded products to potable water schemes for the 'poor' in the (distant) 'developing world'.

While these more 'positive' or 'aggressive' forms of greenwashing sometimes directly benefit the victims it attempts to aid, this is not just an attempt to distract attention from what is usually an unsustainable product or service; rather, they more actively excite the emotions and evoke the trust of western consumers, who paradoxically, unlike their African counterparts, have easy and continued access to clean, potable water through their own taps. As Brei and Bohm (2011) argue, the prime purpose of these marketing campaigns is not just to passively increase the legitimacy of companies like Danone and Coca-Cola, but to actively increase their market share. This inscribes a powerful symbolic and emotive meaning onto their branded products – a 'meaning making' exercise that 'remakes' a damaged reputation in the eyes of the target market. This is especially important in the case of bottled water, since this market is constantly in danger of dissolving into the product's otherwise banal and largely unsustainable constitutive parts: filtered, and sometimes flavoured, water, usually derived from local tap water or groundwater supplies, and encased in a standard but also polluting PET bottle (Brei and Bohm 2011). The fact that the product itself is neither worse nor better for you than tap water, but 100 times more expensive, somehow must be rendered invisible through the 'magic' of design and advertising in order not to give the game away. This is a classic form of 'shading' (Princen 2002b).

As this example suggests, a desire to create meaning that will move the consumer towards your product or service involves a tension between hyperbole and reality, between the implied or genuine promise of

corporate change and the reality of the 'sunk-cost effect'; that is, of doing business the dirty, but immediately profitable way. Like a man struggling with a heavy load attempting to drag himself up a steep ramp and out of a dark cellar, the greenwashing company, faced with an increasingly concerned public, is forever in anxious dialogue with itself and its customers about just how good it really is, and seemingly asking for our approval: 'Am I good enough now?' (Holzer 2010). When claiming too much, or painting too much of a glowing picture that does not match what is happening on the ground, the dangers can be very great – an accident waiting to happen. The story of BP (now supposed to mean 'Beyond Petroleum') and its Deepwater Horizon disaster demonstrates just how bad this kind of communication 'overreach' can become. When one of the company's oil wells unleashed one of America's largest maritime environmental disasters, the 'brand philosophy' was found not only to be untrue but positively deceitful (Balmer, Powell and Greyser 2010). No amount of subsequent PR and tame news-making could quite conceal what actually happened.

Greenwashing, 'ethicalization' and shame

I have thus far made a number of general points about greenwashing. Firstly, greenwashing is not just the result of some sub-ethical individual opportunism – as suggested by the way it is described and decried by many of its critics (Pearse 2012) – but rather a widespread, institutionalized, systemic and seemingly important part of contemporary promotional culture and corporate PR. As I have suggested, this is partly due to corporations responding to an increasing social and cultural 'ethicalization', where more and more consumers, in response to well-founded fears of the global consequences of environmental degradation and social injustice, are demanding higher standards from the makers or distributors of the goods and services they use. This 'ethical response' may in part be the

result of a mediated market oversaturated in branded products and services implying a 'perfect' origin story. This 'positive' narrative can be undermined and exposed as lies by vigilant NGOs and others, whose access to the media even the largest corporations cannot fully control. As this suggests, greenwashing is symptomatic of a global struggle between conflicting and still competing visions and standards: between the need to promote goods and services to appear 'perfect' and 'look good'; for immediate economic benefit; and to avoid the 'shame' of doing business in a way that damages the environment or certain vulnerable social groups.

Secondly, as claimed by many of the scholars and writers cited here, greenwashing's immediate commercial and marketing role is an attempt to assert the reputation, legitimacy and 'ethical' values supposedly embedded in a particular company's products or services. The aim of this is to gain greater market acceptance – and hopefully greater market share – in the face of mounting public criticism and rising consumer expectations (Holzer 2010). This is partly a response to the perceived 'value-action gap' created by the 'brand philosophies' themselves: the always 'good-looking', apparently 'perfect' and 'ethical' products and services of marketing propaganda are bound to disappoint when it is discovered that all is not what it seems behind the glittering façade of promotion (Higginbottom 2007). Like the corporate PR and lobbying it ultimately descends from, greenwashing belatedly attempts to 'shape' the media environment in favour of the commercial interests of the corporation itself, attempting in the process to disguise or make less visible its traditional externalization of the environmental and social costs of its core activities (Barkan 2004; Beder 2002).

Thirdly, this hoped-for legitimization of the branded product's reputation, I would like to suggest here, echoes Norbert Elias' interpretation of the avoidance

of shame in his 1939 *Civilizing Process* thesis (cited in Mennell 1989: 104–105; see also Binkley 2009). For Elias, modernization, starting in the Renaissance, involved raising standards of internalized, habitual self-restraint, often shaped by changing understandings of what was to be seen as 'shameful' (cited in Mennell 1989: 104; see also Binkley 2009). Responding to the felt need to legitimize existing unsustainable approaches and practices, and to avoid the 'shame' and likely damage to reputation from an ever closer public scrutiny, greenwashing businesses attempt to draw attention to their willing conformity with what has become a rising tide of ethical and environmental expectation (Binkley 2009; Holzer 2010). Inheriting the 'sunk costs' of previously more limited standards of public accountability and scrutiny, corporate activities cannot now be so easily hidden from view, as new media and the ability of 'bad news' to travel more quickly progressively removes the intended cloak of invisibility and 'distance' once enjoyed by many businesses. In fact, most advances in the discipline of management theory – from Peter Drucker onwards – can be read as attempts to broaden the legal and historical frame of an increasing movement towards global corporate responsibility. This aims to turn against the reactive, conservative, so-called 'classical' models of business ethics and practice now rebadged by neo-classical economic theory as being concerned only with increasing shareholder value (Rodin 2005; Yani-de-Soriano and Slater 2009). As this suggests, greenwashing has to be understood in the context of a typical corporate strategy of 'reputation management'; of attempting to raise the profile of a particular company without damaging the 'money tree' on which that company has depended, often for many years.

Consumerism, design and sustainable design

Colin Campbell, in a memorable essay entitled 'I shop therefore I know that I am' (2004), suggests that modern consumerism is characterized by an 'emotional ontology' in which we look to how we 'feel' about particular products and services before using them to variously enhance, express or transform ourselves through our ownership or experience of them. From this perspective, purchasing a brand becomes a path to risk or shame avoidance (through social conformity), and more personally, a path to reducing the risks involved in the emotive business of choosing certain products or services over others that might be very similar in what they offer. In a memorable metaphor, Zygmunt Bauman (cited in A. Arvidsson 2010: 20) refers to the role of the brand in the dilemma of consumer choice as a 'lifesaver' on a beach, where we (the consumers) imagine there might be sharks, and so would otherwise choose not to swim.

Design's role in all this deserves closer attention. Most commercial design is a 'directive practice' aimed at increasing sales and intensifying consumption, regardless of the branded product's environmental or social consequences (Fry 2009). It attempts to realize and materialize the brand 'philosophy' associated with a product or service, and will attempt to create an emotive impact that will differentiate the branded product or service from its rivals. The distinctive work of Apple's designers, for example, expresses its 'think different' brand philosophy, and has led the company to an extraordinary market dominance (Crocker 2012a). Apple has been attempting more recently to map the sources of the rare and often ethically-tainted rare metals used by its suppliers (Crocker 2012b; Monbiot 2013). This quiet, background attempt to make more ethical sense of the complexities of global supply chains shamefully entangled in West African civil wars and child labour issues suggests that Apple's management has become more determined to avoid the kind of 'shame' they were

exposed to by the spate of recent suicides amongst workers at the Chinese manufacturing plants it has been using (Monbiot 2013).

Like most of its rivals, Apple is stuck on a 'ramp' of ethicalization because of its global reach, with the sunk-cost effect of ethically problematic global supply chains at the bottom, and the widely admired totem of the brand at the top. In Apple's case, as in many smaller, more agile and creative companies, a more active design involvement, and a more active attempt to analyse the dependent social and material relationships behind its products, has been understood to be a means of initializing some progress towards sustainability (Monbiot 2013). This analysis of the material and social relationships within supply chains is in many respects analogous to the techniques involved in life cycle assessment commonly used in sustainable design (Vezzoli and Manzini 2010), and thus has the potential in very large companies like Apple to have significant and positive impacts on the global environment and the social sustainability of developing nations. One recent study urges policy-makers and activists to stop waiting for often conservative western governments to implement constraining legislation and work more directly with transnational corporations. They argue that the economic weight of a Walmart, an IKEA or an Apple is such that improved conditions along their supply chains and within their products can have measurable impacts as great as legislative improvements may do, albeit in a manner that is likely to be much quicker in its effects, including in places not now known for their ability to initiate effective environmental and social governance regimes (Dauvergne and Lister 2012).

Above and beyond the social and technical problems associated with supply chains for products like the iPhone or iPad is the equally important but often neglected one of unsustainable marketing strategies, and the social and technological acceleration this has continued to entail (Crocker 2012a, 2012b). Within a year or so of purchase, products in an increasing range of categories – from smartphones and tablets to printers and sound systems – are perceived to be obsolete, eclipsed by the march of technological innovation and fashion-conscious consumer expectation (Crocker 2012b; Park 2010). The average lifespans of more and more products are steadily falling, while supplies of the materials required for the more essential componentry of these products are becoming scarcer. Caught in the scissors of reducing lifespans and resource scarcity, designers are becoming more interested in modularization (whereby component parts can be more easily reused or replaced) and product service systems (where ownership can be exchanged for leasing agreements, and products can be serviced, repaired or reengineered and used again) (Vezzoli and Manzini 2010). Designers are also increasingly interested in different ways of designing, marketing and selling products to not only enhance their longevity, but also our attachment to them, such as ensuring a product is internally upgradeable and sufficiently robust to withstand the small accidents of life in use, and attractive enough in use to remain something we can value for longer (Crocker 2012b; Saini 2011; Vertu 2013).

These movements towards reconsidering and reconfiguring the material and social relationships involved in consumption are too large to consider here, but are clearly tied in to the 'ethicalization' I have tried to draw attention to. Paradoxically and contradictorily, consumerism seems to be pulling us in two directions simultaneously: towards an accelerating and increasingly unsustainable cycle of consumption, use and discard; and towards an increasingly anxious and demanding awareness of the destructive consequences of such an intensification of 'excess' consumption (Crocker 2012a). Even though this does not necessarily lead to a change in behaviour, this 'ethicalization' is

sufficient to make most companies look to their reputations with an anxious eye, and to at least consider sustainable design as an option that might rescue them from the 'shame' of failing to 'look good' at a time of steadily rising standards.

Conclusion

Increasingly attached to the Pole Star of sustainability, design is slowly becoming what Tony Fry (2009) calls a 're-directive practice': a process whose aim is to reconfigure the many relationships behind the 'face' of the branded product, building or system, and align these often lengthy and complex chains of dependence more intelligibly and consciously towards identifiably sustainable goals. So instead of aiming only to increase the volume and frequency of sales transactions, designers are increasingly being asked to integrate a series of sustainability criteria into their work, from material reduction and substitution to lifecycle analysis.

As we must expect from the above discussion, this work seems on the surface inherently contradictory, pulled in one direction by the immediate goal of business profitability, and in the other by the increasingly urgent requirements of sustainability (Charlton 2011). The promotional culture in which these changes are taking place suffers from a similarly contradictory condition, requiring not just 'selling the sizzle and not the sausage', but also making sure that the metaphorical sausage improves measurably in quality and flavour. In response to the increasing risks and anxieties associated with our environmental crisis, a deepening ethicalization of public life and consumption is pressuring businesses to respond. That many are cheating and engaging in various forms of 'brand exuberance' or just plain greenwashing need not be excused, but does need to be understood within this larger, historical context in which sustainable design is in itself a critical, potentially transformative factor.

References

Arvidsson, A. (2010), 'Speaking out: The ethical economy: New forms of value in the information age?', *Organization*, 17, pp. 637–644. doi: 10.1177/13505841 0372512

Arvidsson, S. (2010), 'Communication of corporate social responsibility: A study of the views of management teams in large companies', *Journal of Business Ethics*, 96, pp. 339–354. doi: 10.1007/s10551-010-0469-2

Balmer, J. M. T. (2010), 'The BP Deepwater Horizon debacle and corporate brand exuberance', *Journal of Brand Management*, 18, pp. 97–104. doi:10.1057/bm.2010.33

Balmer, J. M. T., Powell, S. M. and Greyser, S. A. (2011), 'Explicating ethical corporate marketing: Insights from the BP Deepwater Horizon catastrophe: The ethical brand that exploded and then imploded', *Journal of Business Ethics*, 102, pp. 1–14. doi: 10.1007/s10551-011-0902-1

Barkan, J. (2004), *The Corporation: The Pathological Pursuit of Profit and Power*, New York: Viking & Penguin.

Beder, S. (2002), *Global Spin: The Corporate Assault on the Environment* (3rd ed.), Totnes: Green Books.

Binkley, S. (2009), 'The civilized brand: Shifting shame thresholds and the dissemination of consumer lifestyles', *European Journal of Cultural Studies*, 12, pp. 21–38. doi: 10.117/136754949408 099703

Brei, V. and Bohm, S. (2011), 'Corporate social responsibility as cultural meaning management: A critique of the marketing of "ethical" bottled water', *Business Ethics: A European Review*, 20, pp. 233–251. doi: 10.1111/j.1467-8608.2011.01626.x

Campbell, C. (2004), 'I shop therefore I know that I am: The metaphysical basis of modern consumerism', in K. H. Ekstrom and H. Brembek (eds), *Elusive Consumption*, Oxford: Berg, pp. 27–44.

Charlton, A. (2011), 'Man-made world: Choosing between progress and the planet', *Quarterly Essay*, 44, pp. 1–72.

Clacher, I. and Hagendorff, J. (2012), 'Do announcements about corporate social responsibility create or destroy shareholder wealth? Evidence from the UK', *Journal of Business Ethics*, 106, pp. 253–266. doi: 10.1007/s 10551-011-1004-9

Crocker, R. (2012a), 'Getting closer to zero waste in the new mobile communications paradigm: A social and cultural perspective', in S. Lehmann and R. Crocker (eds), *Designing for Zero Waste: Consumption, Technologies and the Built Environment*, London: Routledge, pp. 115–130.

Crocker, R. (2012b), '"Somebody else's problem": Consumer culture, waste and behaviour change: the case of walking', in S. Lehmann and R. Crocker (eds), *Designing for Zero Waste: Consumption, Technologies and the Built Environment*, London: Routledge, pp. 11–34.

Cunha, M. and Caldieraro, F. (2009), 'Sunk-cost effects on purely behavioral investments', *Cognitive Science*, 33, pp. 105–113. doi: 10.1111/j.1551-6709.2008.01005.x

Dauvergne, P. and Lister, J. (2012), 'Big brand sustainability: Governance prospects and environmental limits', *Global Environmental Change*, 22: 1, pp. 36–45. doi: 10.1016/j.gloenvcha.2011.10.007

Elias, N. (2000), *The Civilizing Process: Sociogenetic and Psychogenetic Investigations* (2nd ed.), Oxford: Blackwell.

Ewen, S. (1996), *PR! A Social History of Spin*, New York: Basic Books.

Fry, T. (2009), *Design Futuring: Sustainability, Ethics and New Practice*, Oxford: Berg.

Hamilton, C. (2010), *Requiem for a Species: Why we resist the Truth about Climate Change*, Melbourne: Allen and Unwin.

Higginbottom, A. (2007), 'Killer Coke', in W. Dinan and D. Miller (eds), *Faker, Spinner, Spy: Corporate PR and the Assault on Democracy*, London: Pluto Press, pp. 278–294.

Holzer, B. (2010), *Moralizing the Corporation: Transnational Activism and Corporate Accountability*, Cheltenham: Edgar Elgar.

Ihlen, O. (2009), 'Business and climate change: The climate response of the world's 30 largest corporations', *Environmental Communication: A Journal of Nature and Culture*, 3, pp. 244–262. doi: 10.1080/1752 4030902916632

Janssen, M. A., Kohler, T. A. and Scheffer, M. (2003),

'Sunk-cost effects and vulnerability to collapse in ancient societies', *Current Anthropology,* 44: 5, pp. 722–728. doi: 10.1086/379261

Kelly, T. (2004), 'Sunk costs, rationality and acting for the sake of the past', *Nous,* 38, pp. 60–85. doi: 10.1111/j.1468 -0068. 2004.00462.x

Laufer, W. S. (2003), 'Social accountability and corporate greenwashing', *Journal of Business Ethics,* 43, pp. 253–261.

Maniates, M. F. (2002), 'Individualization: Plant a tree, ride a bike, save the world?', in T. Princen, M. F. Maniates and K. Conca (eds), *Confronting Consumption,* Cambridge, MA: MIT Press, pp. 43–66.

Marais, M. (2010), 'CEO rhetorical strategies for corporate social responsibility (CSR)', *Society and Business Review,* 7: 3, pp. 223–243. doi: 10.1108/174 65681211271314

Mennell, S. (1989), *Norbert Elias: An Introduction,* Dublin: University College Dublin Press.

Monbiot, G. (2013), 'My search for a smartphone that is not soaked in blood', *The Guardian,* 11 March, http://www.guardian.co.uk/ commentisfree/2013/ mar/11/search-smartphone-soaked-blood. Accessed 11 March 2013.

Moncrieff, L. M. (2011), 'The Molotov milkshake: Corporate social responsibility and the market', *Law Critique,* 22, pp. 273–293. doi: 10.1007/ s10978-011-9092-3

Muratovski, G. (2013), 'Advertising, public relations and social marketing: shaping behaviour towards sustainable consumption', in R. Crocker and S. Lehmann (eds), *Motivating Change: Sustainable Design and Behaviour in the Built Environment,* London: Earthscan, pp. 178–197.

Park, M. (2010), 'Defying obsolescence', in T. Cooper (ed.), *Longer Lasting Products: Alternatives to the Throwaway Society,* Farnham, UK: Gower, pp. 77–106.

Pearse, G. (2012), *Greenwash: Big Brands and Carbon Scams,* Melbourne: Black Inc.

Powell, D. (2013), 'Coca-Cola part of the solution to obesity? Yeah, right!', *The Conversation,* 18 January, http://theconversation.edu. au/coca-cola-part-of-the-solution-to-obesity-yeah-right-11662. Accessed 18 January 2013.

Princen, T. (2002a), 'Consumption and its externalities: Where consumption meets ecology', in T. Princen, M. F. Maniates and K. Conca (eds), *Confronting Consumption,* Cambridge, MA: MIT Press, pp. 23–42.

Princen, T. (2002b), 'Distancing: Consumption and the severing of feedback', in T. Princen, M. F. Maniates and K. Conca (eds), *Confronting Consumption,* Cambridge, MA: MIT Press, pp. 103–131.

Rodin, D. (2005), 'What's wrong with business ethics', *International Social Science Journal,* 57, pp. 561–571. doi: 10.1111/j.1468.2451. 2005.00571.x

Saini, A. (2011), 'Why you may never need a new mobile', *The Guardian,* 2 October, http:// www.guardian.co.uk/ technology/2011/oct/02/ electronic-gadgets-last-for-ever. Accessed 15 January 2013.

Vertu (2013), 'Homepage', http://www.vertu.com. Accessed 15 January 2013.

Vezzoli, C. and Manzini, E. (2010), *Design for Environmental Sustainability,* London: Springer.

Vincent, M. and Ryan, C. (2013), 'New diet guidelines spark sugar debate', *ABC News,* 19 February, http://www.abc. net.au/news/2013-02-19/ new-diet-guidelines-spark-debate-on-sugar/4526174. Accessed 22 February 2013.

Vos, J. (2009), 'Actions speak louder than words: Greenwashing in corporate America', *Notre Dame Journal of Law, Ethics and Public Policy,* 23, pp. 673–697.

Yani-de-Soriano, M. and Slater, S. (2009), 'Revising Drucker's theory', *Journal of Management History,* 15, pp. 452–466. doi: 10.1108/ 17511340910987347

Elaine Saunders
Blamey Saunders hears

Jessica Taft
Blamey Saunders hears

David Jenkinson
DIJ Strategy

Dr Elaine Saunders is the managing director of Blamey Saunders hears, which supplies affordable, discrete and highly effective hearing aids through an innovative online telehealth service and clinic based in East Melbourne. Originally from the UK, Elaine has a master's in audiological science, a doctorate in biomedical engineering, a diploma in technology management and is a graduate of the Australian Institute of Company Directors. Elaine is a Churchill Fellow and winner of the National Telstra Business Woman of the Year competition, Corporate and Private sector (2004); the American Academy of Audiology's Samuel F. Lybarger Award for Achievement in Industry (2010); and the City of Melbourne's 2012 Melbourne Award for Community Contribution by an Individual.

Jessica Taft is a research officer and staff writer at Blamey Saunders hears, where she provides strategic research, business writing and communications support across the business. Jessica is concurrently a Ph.D. candidate at Monash University, where she holds the Vice Chancellor's Honours-Ph.D. scholarship on behalf of the Monash Arts Faculty. She has won numerous academic prizes, and has presented and published her postgraduate research both in Australia and internationally. Jessica started her career as a lawyer, and prior to commencing her Ph.D. candidature and her work at Blamey Saunders hears, she trained at a premier Australian law firm.

David Jenkinson is a strategic design consultant working with a variety of design firms. His passion is helping companies develop their 'offer', either through identifying new opportunities for growth or enhancing the experience they offer to their customers. He believes that understanding consumers' motivations by using the principles of branding and applying design thinking are the new requirements for future business success. David started his career as a research physicist, creating the first ever flat-screen TVs. He then went on to study for a MSc. in Management Sciences and an MBA, which took him into the world of branding. He was one of the founding developers and vice president of Y&R's global brand consultancy practice, Brand Asset Valuator.

Design thinking to grow the market: Developing products that address industry and consumer need

Design thinking has the power to not only add value to a business, but to disrupt and transform an established product industry and drive sector growth. In this paper, the authors explore the role and value of strategic design thinking in developing and marketing disruptive technology. They do so through a detailed case study of the technology and design partnership between Blamey Saunders hears (BSH) and Designworks – a partnership which began in early 2012 and culminated in the major rebranding of BSH at the end of that year. BSH is an award winning online hearing aid company that sells self-fitting hearing aids that use bionic ear technology. The hearing aids are sold at a fraction of the price of other hearing aids in Australia, and BSH provides customers with ongoing expert audiological and technical support through remote access and, for those who prefer face-to-face service, through BSH's East Melbourne clinic.

Keywords
hearing aid perception change
design thinking

Introduction

Design thinking lies at the intersection of strategy, brand positioning and design. It is seen as a human-centred approach to designing and developing products, which from the outset is designed to address an unmet consumer need. The business and technology story of Blamey Saunders hears (BSH) – inventors of the self-fit hearing aid with bionic ear technology – is an example of the use of design thinking in the hearing device industry. In this paper, the authors present the BSH organizational journey and their partnership with Designworks as a single descriptive case study. The single case study was the most appropriate method to contribute to knowledge on strategic design thinking, because it enabled the authors to capture all the detail and complexity of the context. The Blamey Saunders and Designworks case study (hereafter: BSD case study) will be used to analyse how design thinking is a strategic resource throughout all stages of product development, and moreover, that it is multidisciplinary.

Strategic design thinking was used by the product inventors at BSH throughout the entire life cycle of the product development and its path to market; from its conception, prototyping and clinical trials through to its aesthetics and packaging. It enabled the founders of BSH to create an entirely innovative type of hearing aid that could keep costs low, and provide consumers with what they did not even know they wanted or needed. This was achievable with in-depth industry knowledge, an understanding of consumer challenges with hearing loss and hearing aid uptake, and the application of design principles. The partnership between BSH and Designworks in 2012 was the culmination of the design thinking process in the development of BSH's products and branding. Design thinking at that stage clarified BSH's

organizational purpose, and gave effect to this purpose through its brand messaging and product aesthetic.

To expand on the key concepts of design thinking, the paper will develop the case study sequentially, and explain the industry context and the product development process. The first section will explore the uses of case studies as one amongst many methods of qualitative research, and explain why a case study is appropriate for understanding design thinking in BSH's product development. This will be followed by an explanation of the design thinking concept in business and academic commentary, and thus provide the theoretical basis for the case study. The paper will then outline the challenges of the hearing aid industry as the context for using design thinking to grow a product category and meet consumer needs. Finally, the paper will explain in detail the development of the BSH product and branding – from its inception to its packaging – and illustrate how design thinking is embedded in each stage of the process.

The case study method: A useful approach for studying design thinking

The authors chose a case study because it has the qualities of an in-depth analysis which can expand knowledge where other quantitative methods are not available or possible. The case study is a well-established method of qualitative research, and is capable of developing knowledge so long as one understands its strengths and limitations (Yin 2009). The case study allows for an in-depth analysis of a real-life phenomenon in its complexity, and enables researchers to generate insights into issues and phenomena that are very current (Yin 2009: 4). It is a useful investigative tool in cases where phenomena cannot be separated from their context, and which involve complex interrelationships and variables (Yin 2011: 4). It allows the researcher to rely on many sources of evidence where single data collection

Design thinking to grow the market: Developing products that address industry and consumer need

methods are not feasible (Yin 2011). Case studies provide flexibility in research strategy, allowing data for the study can be gathered retrospectively (Seuring 2005: 238; Yin 2011: 7). In addition, the authors can broadly determine the features and purpose of the study before selecting the key example of strategic design thinking.

Though the strengths of case studies are well understood, they also have their inherent limitations. One criticism or concern with case studies is that analysis of a single case provides a limited empirical basis for generalized conclusions (Yin 2009: 15). According to Yin (2009), there is still a tendency to view different social science methods hierarchically and regard case studies as only appropriate for the early exploratory stages of investigation, while assigning surveys and repeated experiments as more appropriate for explanatory and causal analysis (Stuart et al. 2002: 421). This criticism of case studies confuses the purpose and method of a case study that uses other social science methods. A case study cannot provide (and is not intended to provide) a representative sample of data in the same manner a survey or series of experiments would. It cannot explain the prevalence of a phenomenon or predict future outcomes. A case study, like a single experiment, serves to expand theories, and is not designed to make generalizations about populations (Yin 2009: 15). Another concern about case study research is that it can lack a theoretical framework, and researchers can fail to locate the case study within a body of knowledge, even if the body of knowledge is underdeveloped (Meredith 1998; Stuart et al. 2002: 423). This criticism relates to the manner in which case studies are conducted.

The appropriateness of a case study, as opposed to a survey or archival research, depends on the type of research question being asked (Yin 2009). In this case, the authors began their inquiry with explanatory research questions: Why is design thinking so important for value creation? And how does design thinking work in practice? The authors regarded a case study as an effective method for answering these research questions. As such, this is a single descriptive case study of the development of the BSH product and its use of design thinking. The authors decided to approach the research question with a single descriptive case study because the BSH approach to design thinking and the product development process is closely related to the unique industry context in which BSH operates. The extent of BSH's innovation can only really be understood in context of the hearing device industry in Australia, and the challenges it presents for innovation and reaching consumers. Once this is understood, it will be possible to draw analytic generalizations that will expand knowledge on design thinking, and be useful for designers and innovators across industries.

The above-mentioned research questions were accompanied by some key propositions. The first is that design thinking is a way to address consumer need and be at the leading edge of an industry. The second is that design thinking is a multidisciplinary activity and occurs in all stages of product development – from prototyping to aesthetics and packaging, incorporating user involvement throughout. These propositions are based on existing academic commentary and other examples of case studies conducted in this area. The unit of analysis was the development of the Blamey Saunders product, whose uniqueness in its industry can yield new insights into how design thinking can help a business be truly innovative. The BSD case study will illustrate these propositions by showing how design thinking can be used to redefine a category of product and grow the market in a well-established industry. Accordingly, the following sections will provide a complete description of the life cycle of Blamey Saunders' product and service innovation within its industry context, and will also be located within the academic commentary on design thinking.

The study will then discuss the industry context in which BSH's innovations are so closely related. The following sections will describe the product development process and illustrate the presence of design thinking at each stage. The case study will then link back to the broader propositions to show how design thinking enabled Blamey Saunders to achieve greater clarity of purpose, and make the crucial distinction between creating a rival, competitive product and growing a new category to create market opportunities. The BSD case study will also demonstrate how design thinking that is truly innovative is multidisciplinary, and involves all parties to think like designers and have meaningful collaboration.

Design thinking: The conceptual framework

The BSH case study evolved from and seeks to address a broader conceptual issue of what design thinking means, as opposed to design or branding. The transformative quality of strategic design thinking for value creation and long-term competitive advantage is well understood amongst business commentators. Both scholarly literature and general business commentary has sought to understand and explicate the concept of design thinking as a subset of strategy and management innovation (Brown 2008, 2009; Brown and Katz 2011; Leavy 2010; Martin 2009, 2010; Verganti 2006, 2009). Design thinking, or design-driven innovation, has been understood as an innovation strategy that often overlaps with radical technological innovations so as to dramatically improve a product's performance and thereby give it new meaning (Verganti 2009: 4).

As an innovation strategy, design thinking is proactive and pre-emptive: it gives the product a new meaning that consumers did not realize they actually wanted (Verganti 2009: 4). This is as opposed to incrementally improving a product and finding product solutions through improving market and

consumer analysis (Verganti 2009: 5). Commentators have also used case studies to explicate how design-driven innovation occurs. Authors have engaged in extensive company research, in the dual process of accumulating and categorizing qualitative case studies, to deduce organizing themes and stages in the design innovation process (Brown 2008; Martin 2009; Verganti 2009).

The meaning of design thinking as a management concept has now become reasonably clear. Design thinking is not solely the aesthetic design and final packaging of a product, nor is it properly explained as the technological breakthrough of a disruptive innovation. Rather, put simply, design thinking is a product development strategy whereby products are conceived and designed from end-to-end according to what consumers want and need. Design thinking can also be applied to the development of services and processes (Brown 2008). When it is incorporated into all phases of product development, as opposed to engaging designers to 'put a beautiful wrapper around the idea' (Brown 2008: 2), it is associated with dramatic increases in a product's value creation and market opportunity. Perspectives on processes of strategic design thinking – i.e. how design thinking happens – vary, yet have overlapping concepts. Martin (2010) described part of the process as a 'funnel' or advancement of knowledge from a hunch to heuristic and then to algorithmic codification. Brown (2008: 5) discusses a cycle of inspiration, ideation and implementation. All these explanations contemplate that these processes are nonlinear and scenarios are infinitely variable; in other words, there is no one way or process in the continuum of innovation (Brown 2009).

The industry context

The context of this study is the nature and workings of the hearing device industry in Australia, and hence cannot be distinguished from the Blamey Saunders product and technology journey. The industry context

is crucial to understand why and how BSH and Designworks reconfigured the meaning of hearing aids and sought to grow the market. The following section illustrates the industry and market challenges faced by BSH, and how these made design thinking integral to inventing and developing the BSH product.

Evidence provided by the Australian government has suggested that hearing loss is a major public health problem, estimated to affect one out of every six Australians (Access Economics 2006: 5). In 2005, conservative figures suggested hearing loss cost Australia $11.75 billion and 1.4 per cent of its gross domestic product (Access Economics 2006). Hearing loss increases in prevalence with age, and is estimated to affect three in every four people who are over 70 years old (Access Economics 2006). It is projected to increase in its prevalence to affect one in every four Australians by 2050 (Access Economics 2006). Untreated hearing loss is known to lead to further problems of isolation, depression, underemployment and premature retirement. Despite this, only one out of every five Australians who could benefit from a hearing device actually uses one (Access Economics 2006), and the market is only around 20 per cent penetrated. The main players in hearing aid distribution focus on competing to retain this existing market share rather than expanding the market. Acquisitions tend to be the primary drivers of increasing market share amongst key players – a recent example being Italian group Amplifon's acquisition of Australia's National Hearing Care in 2010 for $460 million.

Hearing aids are currently not a mass market product. In traditional hearing aid distribution systems, hearing aids are very cheap to manufacture yet remain expensive for the consumer. The hearing aid industry is strongly vertically integrated and predominantly foreign owned. The majority of global hearing aid distribution is shared by six companies

whose retail operations are highly profitable. The industry is heavily cross-subsidized: manufacturers can supply hearing aids for bulk purchase, private label and government hearing aid schemes in Australia, and cross-subsidize this with private hearing aid supplies. Current retailers support a model of cross-subsidies and high retail profit, and do not anticipate a change in the current rebate model. According to Global Business Intelligence Research on the Ear Nose and Throat (ENT) devices market, the hearing aid market in 2010 was valued at US$6.6 billion worldwide, and is forecast to grow at a compound annual growth rate (CAGR) of 6% by 2017 (GBI Research 2010: 3). The Australian hearing aid devices market had revenue of $225 million in 2010 and grew at a CAGR of 9.8% during 2003–10 (GBI Research 2010: 61). The hearing aid devices market revenue in Australia is forecast to rise to $300 million in 2015 and grow at a CAGR of 6% during 2010–17 (GBI Research 2010: 62). Hearing devices have been reported to account for around 86% of the global ENT devices market (GBI Research 2010: 3).

This vertically integrated industry model is time-consuming for the hearing aid user and keeps the cost of services very high. Recruitment of hearing aid customers by the larger retail chains is typically made by a call centre model, followed by a free four-frequency hearing test of threshold. Generally, this is followed by a more comprehensive assessment by an audiologist in a retail facility, or occasionally in a hospital environment. If the client is likely to be helped with selecting a hearing aid, the audiologist will often recommend hearing aids manufactured by the supplier affiliated with the clinic (or even a manufacturer who owns it). After the hearing aids are fitted, a number of other appointments may be needed in order to personalize the aids. This is made more difficult by the advanced age of the client, which typically means they can go upwards of twelve years without hearing aids. This entire process is

often priced at a bundled cost of around $10,000 for the consumer.

This process creates a cycle. The expense means that young people typically delay seeking hearing help until their hearing loss is severe and they have developed complex additional problems; these people with complex hearing and health problems struggle to use hearing aids without help; audiologists then find themselves overloaded with a high-needs caseload; this drives up the cost of audiological services because they are outside the mass market. This in turn reinforces the stereotype that hearing aids are for 'very old people' and are associated with mental health issues, which then means that clients do not seek early treatment for hearing loss when their symptoms are mild, which is the optimal time for hearing treatment. In addition, there are high rates of industrial hearing loss in rural or remote areas, which, if untreated, causes considerable fatigue, isolation and depression. People in rural or remote areas cannot easily reach an audiologist or hearing aid retailer and not least without prohibitive expense.

The Australian government does have a subsidized hearing scheme in place to try and address the need to reduce the incidence of untreated hearing loss, and therefore provide access to quality hearing devices. The Department of Health and Ageing oversees the Office of Hearing Services, which oversees Australian Hearing. Australian Hearing, which operates under the Australian Hearing Services Act 1991, is the government agency charged with delivering hearing aids and hearing services to children and pensioners. The National Acoustics Laboratory (NAL) is the research division of Australian Hearing and determines the research criteria for hearing aid fitting. The Hearing Services Program has two streams – the Community Service Obligation (CSO) program and the Voucher program. They are the sole provider of services to children under 26 years old, indigenous adults over 50 and adults with complex hearing needs. In addition to the

services provided by Australian Hearing, there are at least 215 private service providers for voucher program clients (people with pension concession cards and Department of Veteran Affairs gold cards, among others).

Thus the hearing device market in Australia is not an efficient market in the way that consumers are accustomed to in other technology markets. It is caught in a cycle where costs are high and price does not reflect quality. The combination of high prices, a reputation for poor hearing outcomes and the enduring social stigma of hearing aids all prove to be major barriers to hearing aid uptake. Because of the tendency to bundle product and service costs in audiology, and the dominance of a small number of multinational suppliers, consumers have limited product choice and are not as well informed about the products as they would be for other purchases, such as for cars, eyewear and mobile phone technology. It is also a market in which it is difficult for new players to enter and innovate.

The industry context in which the founders of BSH wanted to innovate reinforces the concept that design thinking is an unsolicited product addressing what consumers did not even realize they needed. The consumer need is not always clearly explicated or subject to extensive market research; it is often subtle or consumers are not even aware of it themselves. In this case, it was unsolicited because consumers were not necessarily knowledgeable about the existing products in the marketplace, and therefore may not be at a stage where they can explicate their needs, i.e. the need to treat hearing loss early, and the need for improved quality products, lower prices and convenience. Consumers are not necessarily demanding less expensive and better quality hearing aids, or calling for new technology. Often consumers are not even aware that their hearing loss is at a level where they would benefit from a hearing device. Rather, improvements to devices and the establishment of disruptive,

competitive business models are on the initiative of those who are deep within the industry.

Design thinking at the first stages of product development: Addressing barriers to hearing aid uptake

Design thinking was crucial from the outset when the founders and inventors at BSH wanted to create a hearing device that could address the community's need for hearing solutions. The product needed to overcome the problems associated with hearing aids already on the market, and at the same time needed to create new market opportunities outside the existing distribution model for hearing aids. The aim was – and would continue to be – to develop an entirely new category for the product and grow the market, though there would still be some emphasis on competing with other brands for existing market share. As such, the inventors at BSH began their product development knowing that the hearing aids had to be substantially less expensive than their competitors'. They also had a design goal of keeping costs low, and it had to be simpler and more aesthetically pleasing so that people would want to wear them. Crucially, the sound quality had to be noticeably better than the existing hearing aid technology in the market. Finally, underlying all these elements, there had to be something about this particular hearing aid product that would completely change the way in which hearing devices and assistance was delivered in order for it to reach the mass market.

With these design strategies in mind, the founders and inventors at BSH developed and commercialized a self-fit hearing aid system. The founders commenced the design of the product without any legacy products, and this was part of the reason that they could use design thinking from the outset to produce an entirely new end-to-end solution to treating hearing loss, rather than merely developing existing hearing aid products incrementally with formal market research. The earliest stages of the product design involved the invention of sound processing technology that would provide better quality, more natural sound. This was the invention of sound processing called Adaptive Dynamic Range Optimization, or ADRO®. The ADRO® digital sound processor is the core technology in BSH hearing aids. It was invented in the CRC Hear, and commercialized via the spin-off company Dynamic Hearing Pty Ltd, founded by Professor Blamey and Dr Saunders in 2002. ADRO® is an entirely different form of sound processing than that which is used in other hearing aids. ADRO® has a minimum of 32 channels of sound processing, and puts environmental sound into the audible and comfortable range of the user. It is used effectively in cochlear implants (the bionic ear) and in Bluetooth headsets.

ADRO® is a marked advance in hearing aid technology, where hearing aids have typically used audio-wide dynamic range compression ('compression') for the past 35 years. The founders of BSH led to the integration of ADRO® sound processing with adaptive directional microphones, advanced feedback cancellation and noise reduction so as to produce a complete, end-to-end solution for a leading quality hearing aid. The technology in other hearing aids' compression has been known to introduce sound distortion. ADRO® was clinically trialled by the CRC for Cochlear Implant and Hearing Aid Innovation and outperformed state-of-the-art compression hearing aids. Once the hearing aids with ADRO® were clinically trialled, the founders knew they had a product that could provide the type of sound quality that potential hearing aid users would want, even if the market was as yet unaware of how natural hearing aids could sound with the right technology.

Aesthetically, the hearing aids were designed to look as discrete as possible, and to address the known social stigma involved in wearing hearing aids, which is a barrier to expanding the market. The aids were

designed to be minute in size, and coloured by skin and hair tones to look discreet. The aids sit behind the ear, with a clear thin sound tube that runs from behind the ear into the ear canal. The technology in the aids also had high feedback cancellation. This means that when volume is turned up high, the user will not suffer as much from a feedback loop, and therefore more people with hearing loss can wear the discrete behind-the-ear aids. Though the aesthetics of the hearing aid was not the dominant issue in the product design, it was still an important factor to consider from the outset: to make the hearing aids visually appealing and to reach a market of people with hearing loss who are still self-conscious about being seen wearing them.

Another aspect of design thinking in these stages of product development was that the inventors could plan in advance for the product to be a fully integrated solution for the end user. A key feature of the ADRO® sound processing method is that, due to the way it processes sound and adjusts it to the comfort levels of the user, ADRO® makes a hearing aid capable of being self-fitted and fine-tuned by the user (this is rather than relying entirely on an audiologist or third party to tune the hearing aid). In the early prototyping and trial stages, the inventors found that when people were trying the hearing aids and getting the aids fine-tuned, people would often get onto the computer and take the mouse from the inventors' hands and want to try to program the aids themselves. This inspired the founders and inventors to develop further technologies in the next phase of product development that make it possible for a hearing aid user to adjust the hearing aids using a home computer. The self-fitting system for the hearing aids is called IHearYou®. The IHearYou® system is comprised of a programmer and the IHearYou® computer software program. The interface has a simple, clean design that can, with a useful instruction booklet, be mastered by anyone

with basic computer literacy. The customer connects the programmer to the hearing aids and the computer, and then uses the software to fit the hearing aids to their individual hearing preferences.

Today, Blamey Saunders' main business is to sell their hearing aids and IHearYou® system online, predominantly to customers with mild to moderate hearing loss who have basic computer literacy. Blamey Saunders have sought to grow a hearing device market for a generation of people who are Internet and computer literate, and who, with the right product, can discreetly and comfortably purchase hearing aids online (or over the telephone) and set them up to function optimally in their own listening environments. For customers who still prefer a face-to-face service, BSH runs the audiology clinic at their headquarters in East Melbourne. The clinic is a fee-for-service model, which is unusual in the hearing aid industry, as most audiologists offer a bundled service. This makes it impossible to determine the price of the hearing aids as separate from the audiological services.

Whether a customer purchased Blamey Saunders hearing aids online, on the telephone or in person through the clinic, all customers can have as much telecommunications support from BSH as they need throughout the entire process. BSH staff provide audiological and technological guidance to customers by e-mail and telephone, both before and after the customer purchases the products. Customers also receive assistance in setting up their hearing aids at home through remote access. By being both the inventors selling directly to the consumer and the ones providing remote telecommunications services to customers, BSH is able to sell premium quality hearing aids and software at a third of the price of other hearing aids sold through traditional distribution channels. The BSH invention of hearing aids and self-fitting

software, all within a fully integrated telehealth service model, is design thinking in the creation of a product and a service. It was designed, from end to end, to be capable of being a high-quality but low-cost hearing aid that would be more appealing to the mass market. Design thinking was used strategically from the outset to tailor the product to reach the 80 per cent of the market that had not been penetrated by competitors.

Branding, strategy and messaging: Changing the meaning of hearing aids and growing the industry category

This final section will discuss how strategic design thinking worked in the final stages of the path to market, when the company was creating the product and packaging its aesthetic. Design thinking applies from a product's inception, but is still important in these latter stages of the product life cycle. At this stage in the product development, design thinking is used to strategically position the brand around disruptive technology, and transform a category that so far has had very little consumer engagement. The BSH partnership with Designworks – which gained momentum around March 2012 – was a design relationship which was crucial to crystallizing the BSH brand.

Both in inventing a new product and collaborating with Designworks, BSH used design thinking to change the meaning of hearing aids from a stigmatized, expensive medical device for the elderly that required dependence on allied health engagement and signified disability, to an exciting affordable piece of sound technology that people could purchase independently and set up themselves, thereby signifying empowerment and wellness. Hence, in terms of meaning, the strategy was to de-medicalize hearing devices and make them a mass market product that people would buy with the same enthusiasm as buying a new hi-fi sound

system. The process of using design thinking to change a product's meaning was germane when the product was invented as a hearing device that could be fine-tuned on a home computer. This process of changing meaning was important again at the packaging stage, when clear messaging and aesthetics could be used to explicate the changed meaning of hearing aids from a medical device to a piece of sound technology.

The first step in the design relationship between Blamey Saunders and Designworks was to explore all facets of market and consumer need, in addition to the inventors' deep knowledge of the hearing aid industry. Design thinking does not necessarily require formal market research, as consumers' needs can be discovered and explored in more subtle ways. However, it was believed that once the BSH product had already been invented, it would still be beneficial for BSH to undertake consumer research to gain a deeper understanding of the dynamics of the category. Designworks interviewed both existing wearers of hearing aids to understand their experiences and drivers of choice in selecting a hearing aid, and also those people who knew that their hearing was not functioning as well as it should be, but who had failed to address the problem or had not followed through in managing their hearing. This consumer research deepened an understanding of the barriers that exist in the market from the consumer perspective.

Following the consumer and market research, the critical stage in the design relationship was to explore alternative positioning territories so as to define the core of the business. The dilemma concerned where BSH could optimally sit on the positioning spectrum. It might have been possible to define BSH as a technology innovator: the inventors of a revolutionary hearing aid solution. Alternatively, the approach that BSH has taken thus far – to

deliver a hearing aid that the customer can source directly and tune for themselves – was also explored. However, Designworks and BSH together reached the realization that the driving purpose of the organization was the passion and beliefs of the founders (Blamey and Saunders: the professor and the doctor), who have invested their life's work into reinventing how people can hear.

Assisting BSH to find its place on the positioning spectrum fostered greater clarity of purpose as an organization. BSH had already achieved some strong early growth based on public relations around their science story and word-of-mouth recommendations. Yet through their design relationship with Designworks, BSH's clarity of positioning and purpose could be brought to life with strategic design thinking. Author and leadership expert Simon Sinek described this process as the 'golden circle'. He has argued that successful organizations start their product development and marketing process with the 'why': understanding for themselves why their organization exists and what their purpose and cause is (Sinek 2010, 2011). Once this is intimately understood, organizations can then proceed to plan the 'how' and the 'what'. The 'why' – what makes the leaders of an organization get out of bed in the morning – is the constant guiding force for the organization, and something that will give it an innovative edge over its competitors.

In defining its organizational purpose, it was understood by both BSH and Designworks that BSH's brand was nothing like existing category players. Category players typically appeal to images of proficient medical professionals and youthful looking grandparents engaging with their grandchildren. BSH was determined that their guiding organizational purpose was to improve people's quality of life and hearing health by making cutting-edge hearing technology accessible. It was to be a dynamic force for change in an industry which, BSH believed, had an entrenched model that was not adequately servicing a major health need. BSH's staff knew that they were passionate about thinking differently, empowering the consumer to take control of their hearing health, and generating optimism and positive experiences around hearing aid usage.

Once BSH had defined the 'why' and achieved deeper clarity of purpose, it was possible to determine the 'how'. In doing so, the BSH and Designworks partnership needed to address a multiplicity of challenges, and in particular, address all of the barriers that exist within the category. Some of the challenges faced could be listed as follows:

- Negative category association: hearing aids carry social stigma and, put crudely, their uptake is seen as being a step away from aging-related illness or even death. The challenge was to make wearing a hearing aid symbolize leading a rich, fulfilling life.

- Disruptive technology: whilst both BSH and Designworks passionately believe in the product's capabilities, they were focused on how it can enhance their customers' lives.

- Medical 'experts': many medical businesses treat their customers as 'patients', and usually wait for patients to come to them. BSH and Designworks sought to reach out to the consumer, and empower customers to improve their own hearing.

- Affordable delivery: in categories where customers know so little, price becomes the de facto for quality (you get what you pay for). BSH has a different business model so that they can deliver a superior outcome for a significantly cheaper price.

- Service support: given all of the reservations customers have about getting a hearing aid, they will want the support of an expert. The expectation is that an online business is unable to support its customers. BSH had to get across in its messaging that they are in fact far more accessible because of their telehealth service model.

- Empowering the customer: whilst many customers want a scientific measure as to the quality of their hearing, BSH believe – and Designworks understands – that hearing is uniquely personal: only you truly know if you can hear clearly. They encourage self-diagnosis rather than relying upon a test that bears little relationship to real-world hearing challenges.

- End usage: the norm in the category is that over half of all hearing aids are never used. Once sold, few companies would care if it is used. BSH does its utmost to ensure its customers are inspired and excited to receive their hearing aid and encourage ongoing usage.

Whilst many of these challenges are due to the inherent barriers within the category, others were driven by customer misconceptions surrounding a medical business that predominantly sells its product online direct to the public. BSH and Designworks needed to use strategic design to overcome these challenges, and ensure that the BSH brand was positioned so that its organizational purpose could be conveyed to the market powerfully and consistently. Whilst this is an ongoing journey, BSH and Designworks have developed some key strategies to address these challenges, which seek to change the meaning of hearing aids and reframe the category:

- BSH spend much of their energy in promoting their beliefs and principles as to the role that hearing aids can play in enhancing the richness of life, as well as trying to reframe the category. This is done through radio interviews, newspaper articles, presentations to interest groups, and so forth.

- A redevelopment of the BSH website that moved away from its technology focus and towards a more customer-centred approach. This was believed to convey how BSH is able to empower the customer to take control of their own hearing.

- Product packaging that not only ensures that the product arrives to the customer in pristine form, but inspires the user to embrace the wearing of the hearing aid.

- The production of 'The Little Book of Sound', an educational piece that teaches people how to improve their ability to hear in different situations in which they would be likely to experience difficulties, such as social events and places with background noise.

The last two strategies concern how aesthetics can be used strategically for branding and messaging. The discussion thus far is about design thinking in product development and defining organizational purpose. But branding in packaging and aesthetics is still an important aspect of the overall design thinking process, and was central to the design relationship between BSH and Designworks. The aesthetics of the hearing aid system and packaging needed to reflect the organizational purpose and extent of the technological innovation. The hearing aids themselves were already minute in size and discrete; they were coloured beige, grey or brown to suit most people's colouring, and to sit behind the ear rather than in the ear canal. Yet it was still important for the packaging to be sleek, stylish and simple; the

companies wanted customers to receive their hearing aid package in the mail and open it with the excitement and optimism that comes with receiving any new technology purchase.

With the aesthetic assistance of Designworks, BSH products had a bright pleasing colour scheme, and the aids had a stylish hard carry case in a similar design to what one would expect from a designer glasses case. Size was a central motif in the packaging design. All the aspects of the packaging – the packaging box, the storage jar for the hearing aids and instruction manuals – were made significantly smaller in order to emphasize simplicity in design, and to noticeably differentiate the BSH brand from other hearing aids on the market. Through design aesthetics, customers needed to feel less like they had a medical device, and more like they proudly carried a new piece of technology associated with wellness and quality of life.

Its promotional materials and instructions welcomed customers to an exciting new world of sound, emphasizing the empowerment that the customer will feel by choosing BSH, and by purchasing and customizing their own hearing aids. Welcoming the customer to a new world also inspires optimism. Materials also encouraged customers to join the 'quiet revolution'. Through its use of this brand messaging, BSH engages customers to share its organizational purpose and beliefs. The consumer response, in the form of customer confidence to purchase self-fitting hearing aids online, is a by-product of this customer relationship built on common purpose. Through the use of design aesthetics in packaging, together with the design strategy in the earlier development of the product, BSH has sought to change the meaning of hearing aids and drive sector growth.

Conclusion

This case study can demonstrate that design thinking yields its most game-changing innovations when it is applied from a product's inception. It is fundamentally a strategy for creating an unsolicited product, and determining the brand positioning in a way that addresses a consumer need. This is as distinct to incrementally improving an existing product using formal market research and improved packaging. The BSH innovation in hearing aids is a helpful illustration of this distinction. Arguably, BSH's innovations in hearing aids may not have been possible if the inventors were building on legacy products. Rather, it was necessary to create entirely new technology and design the devices from the outset so as to produce a hearing solution that could grow the market.

The product innovations were designed and brought to market with in-depth industry knowledge. For the BSD case study, the hearing device industry in Australia was the crucial context for their product development and organizational journey; as such, the extent of the innovation in the product cannot be understood separately from the industry. The industry challenges with respect to price, quality of technology, social stigma and barriers to entry guided the design of the self-fitting hearing aid system. For BSH, knowing the unmet consumer need evolved in a subtle way over time, and involved understanding the complex relationship between the way an industry operates and the extent of the consumer market. This knowledge guided the BSH founders on how to tap into the unpenetrated market rather than compete against key players for existing market share. This knowledge was deepened by formal consumer research undertaken by Designworks, which explored how hearing aids are perceived by people and what the barriers are to purchase. Both industry knowledge and consumer research – in both subtle and formal inquiries – were important in

guiding the design of the product to address consumer needs and position the brand.

Ultimately, this case study illustrates that design thinking is not a linear process that falls into neat stages and generalizations. It occurs from the outset and is revisited continually throughout the product's life cycle. This is because the key component of design thinking is to use design to change the meaning of a product. In this case, it was to use technological and aesthetic design to change the meaning of hearing aids from a medical device signifying aging and disability into a new piece of sound technology signifying wellness and being part of a technology revolution. It may be surprising for a business as new as BSH to undertake a design project with Designworks so early in its development. Yet the BSD case study can at least signify that strategic design thinking is multidisciplinary, collaborative and occurs in all stages of product development. Engaging design thinking early in a company's journey is crucial to be truly innovative and disruptive. For BSH, design thinking existed in the earliest stages of product invention, and together with its branding project with Designworks has laid essential foundations for success.

The design relationship between BSH and Designworks will be an ongoing partnership as the product journey continues to unfold. Though currently a small business, where all staff interface with one other, the design and branding thus far stands BSH in good stead to take its product to the world, and to expand through bringing in new staff who share BSH's organizational purpose. What can be sure is that design will always be part of the process.

References

Access Economics Pty Ltd. (2006), *Listen Hear! The Economic Impact and Cost of Hearing Loss in Australia,* http://www.audiology.asn. au/pdf/listenhearfinal. pdf. Accessed 29 January 2013.

Brown, T. (2008), 'Design thinking', *Harvard Business Review,* 86: 6, p. 84.

Brown, T. (2009), *Change by Design: How Design Thinking Transforms Organizations and Inspires Innovation,* New York: HarperBusiness.

Brown, T. and Katz, B. (2011), 'Change by design', *Journal of Product Innovation Management,* 28: 3, pp. 381–383.

Dunne, D. and Martin, R. (2006), 'Design thinking and how it will change management education: An interview and discussion', *Academy of Management Learning & Education,* 5: 4, pp. 512–523.

GBI Research (2010), 'ENT devices market to 2017 – Cochlear implants and bone anchored hearing implants are the fastest growing segments', *Market Research.com,* http:// www.marketresearch.com/ GBI-Research-v3759/ENT-Devices-Cochlear-Implants-Bone-6444696/. Accessed 29 January 2013.

Leavy, B. (2010), 'Design thinking – a new mental model of value innovation', *Strategy & Leadership,* 38: 3, pp. 5–14.

Martin, R. (2009), *The Design of Business: Why Design Thinking Is the Next Competitive Advantage,* Boston, MA: Harvard Business Press.

Martin, R, (2010), 'Design thinking: Achieving insights via the knowledge funnel', *Strategy and Leadership,* 38: 2, pp. 37–41.

Meredith, J. (1998), 'Building operations management theory through case and field research', *Journal of Operations Management,* 16: 4, pp. 441–454.

Seuring, S. (2005), 'Case study research in supply chains – An outline and three examples', in H. Kotzab, S. Seuring, M. Muller and G. Reiner (eds), Research Methodologies in Supply Chain Management, New York: Physica, pp. 235–250.

Sinek, S. (2010), 'How great leaders inspire action', *TED. com,* May, http://www.ted. com/talks/simon_sinek_ how_great_leaders_inspire_ action.html. Accessed 29 January 2013.

Sinek, S. (2011), *Start With Why: How Great Leaders Inspire Everyone To Take Action,* New York: Penguin.

Stuart, I., McCutcheon, D., Handfield, R., McLachlin, R. and Samson, D. (2002), 'Effective case research in operations management: A process perspective', *Journal of Operations Management,* 20: 5, pp.

419–433.

Verganti, R. (2006), 'Innovating through design', *Harvard Business Review,* 84: 12, p. 114.

Verganti, R. (2009), *Design Driven Innovation: Changing the Rules of Competition by Radically Innovating What Things Mean,* Cambridge, MA: Harvard Business Press.

Yin, R. K. (2009), *Case Study Research: Design and Methods* (vol. 5), Thousand Oaks, CA: SAGE.

Yin, R. K. (2011), *Applications of Case Study Research* (vol. 34), Thousand Oaks, CA: SAGE.

Dan Formosa
Smart Design USA

As a founding member of
the cutting-edge industrial
design studio Smart
Design, Dr Dan Formosa
specializes in ergonomic
research, user interface
design and product criteria
for global corporations.
With a bachelor's in product
design, and a master's and
doctorate in ergonomics
and biomechanics, his work
focuses on ways design
can improve our lives. Dan
is a recipient of the
Smithsonian's Cooper-
Hewitt National Design
Award, and helped
establish the Masters in
Branding program at the
School of Visual Arts in
New York City.

Gjoko Muratovski
Auckland University of
Technology

Dr Gjoko Muratovski has
twenty years of
multidisciplinary design
experience in Asia,
Australia, Europe and the
USA. He has collaborated
with a range of
organizations, including the
UN Association of
Australia, Toyota,
Greenpeace and the World
Health Organization. Dr
Muratovski is an advisor on
brand development
strategies for the
European-based agency
IDEA Plus
Communications, whose
clients include Audi, the
Heineken Group,
McDonald's, Porsche and
Volkswagen. He is also the
chairman of the 'agIdeas
International Research
Conference: Design for
Business', Area Chairman
for Business at the Popular
Culture Association of
Australia and New Zealand,
principal editor of the
*International Journal of
Design Research*, and book
series editor of *Design for
Business*.

Design Research: Past and Future - Conversation with Dan Formosa

'As a young guy, I had gone through the whole 1960s and '70s student revolution in the US, which was all about a culture change. By the time I got out of school, for our generation of designers, design was about what we could do with it that would help change the world. It was then when I realized that what we really need to do is focus on people, not things'.

Dr Dan Formosa

Introduction

This edited transcript is based on an interview between Dr Gjoko Muratovski and Dr Dan Formosa. Dan is a New York-based design consultant and design researcher. He is an award-winning designer who holds a bachelor's in product design, and a master's and a doctorate in ergonomics and biomechanics. Over the course of many years, he has worked with companies such as Ford, HP, Johnson & Johnson, LG Electronics, Microsoft, and many others. Dan was also a part of the design team that worked on the very first IBM PC back in 1977. He is also one of the founding members of the iconic Smart Design studio, and is behind the world's first Masters in Branding degree at New York's School of Visual Arts. This interview took place on 30 April 2013 during the agIdeas International Research Conference: Design for Business.

Dr Gjoko Muratovski

Welcome to agIdeas, Dan.

Today we will be talking about design research — the origins of design research in the US and your experience of it in the early days. We will be talking about the future of design research and where we are heading as a profession. But before we do that, I would like to begin our conversation by reflecting on the presentation we've just seen. The previous speakers from BHS and Designworks presented a very interesting case study about hearing aids that brings together biotechnology, engineering, design and branding.[1] You happen to have experience in designing for health care and medical purposes. How do you see this project in comparison to some of the things you've done?

Dr Dan Formosa

This is a brilliant project. The time that elapses between when you need a hearing aid and the time you get one is seven years — at least it is in the US. That's a long time, and the reason you actually end up getting a hearing aid is because your family forces you to do it. Because they just can't stand being with you anymore; they have to say everything three times and you still get it wrong. So it's probably the same here in Australia, right?

The process of eliminating the stigma associated with getting a hearing aid is a major issue in health care. BHS and Designworks have overcome this problem really well. Design in this case not only significantly reduces the cost, but the stigma as well, and you can tell this just by the packaging of the product and the associated graphics. This no longer looks like a medical device, but as a consumer product. The packaging is beautiful, but the design here goes beyond the packaging. I think it's the whole 'out-of-the-box' experience that they were going for here. As a designer, you don't want to think of the packaging just as a box. It really is, 'how is that first day' or 'how is that first week using the product' that has a huge effect. And this is not only true for hearing aids, but for pharmaceuticals as well. The first time you're on a drug regimen — that first day or first week, and definitely the first couple of months of using it — is critical because the 'drop-off' rate. There is a short time frame that you have to engage the user before the product ends up in the drawer — and this is probably the same with the hearing aids.

Dr Gjoko Muratovski

You have worked with pharmaceuticals. Traditionally, there have been very big business opportunities for designers working in this area. In principle, there's a lot of funding available in pharmaceutical design and basically in health-care design. What kind of challenges have you experienced in using design in the pharmaceutical business?

Dr Dan Formosa

I think more and more drug companies are realizing that they need to be about something more than the pill. Typically, drug companies own a branded drug which they promote, and it's worth a gazillion dollars to that drug company. But that pill is just part of the solution that a patient may have. The 'drop-off' rate, as I was saying, of drugs — pharmaceuticals — is something like 30 to 50 per cent in the first three to six months. So, as you can imagine, that much loss in health care is not good for the patient. This not good for the drug company; it's not good for the pharmacy; it's not good for the health-care system. It's not good for anybody. So if you can bring design to the forefront; if you can understand people — and understand why people are dropping off of a regimen — if you can do something design-wise that can improve the situation even by a couple of per cent, then you've made an incredible progress. Not just financially for the pharmaceutical company, but also for the patients as well. The

use of design in this case is a very simple opportunity for a drug or pharmaceutical company to innovate. If a drug company has to innovate on a drug, it's going to take them literally several hundred million dollars and five to ten years. But for a drug company to innovate on design is far more cost effective. Design is so close at hand. And because many pharmaceutical companies, for instance, have not even considered design yet, the opportunities for us are huge.

Dr Gjoko Muratovski
Another thing that you have experienced over the many years of experience in the field is how design has changed and evolved. The attitudes designers used to hold in terms of how they used to approach a particular project and how they deal with a particular client has changed over the course of time. How would you say design has evolved since the 1970s, when you started your design career?

Dr Dan Formosa
When I started designing in the late 1970s, design research was not a 'thing'. It wasn't something that you can see or touch. And what was very interesting was that design for many decades – the '50s, '60s, '70s – was all based on 'the thing'. The design profession was all based on the object – and the object, if you're talking about physical design, was idolized. There was very little work in design research. There were some great examples, of course, but 99 per cent of the work that was going on was very superficial. The use of 'design' at the time was really an effort by companies to try to sell things that have already been designed, such as by renewing something. In most cases, design would be the last thing that happens. Once everything is done, the entire project is then handed off to the design team, who can't change a thing other than the colours and surfaces, shapes and textures, radius, things like that. So that was the design profession coming out of

school when I was in the late 1970s. In other words, design was very superficial, and designers seemed to be at least content to work in that way.

As a young guy, I had gone through the whole 1960s and '70s student revolution in the US, which was all about a culture change. By the time I got out of school, for our generation of designers, design was about what we could do with it that would help change the world. It was then when I realized that what we really need to do is focus on people, not things. In other words, if we're going to understand design, we should really understand people first. This meant that we needed to go out and do design research. And that did not sit well with most of the companies – actually any of the companies – because the marketing groups felt they were in charge of the people as consumers, and we had no business as designers to go out in the field. So it was a culture clash for many years, and us saying, 'Hey, we're designers. We need to go out and do things'.

At the time, we actually started out calling this 'market research'. We would write these proposals, these project plans, and we would say, 'The first thing we need to do is market research'. And guess what the marketing groups thought within the company when we said we would do the market research? We then decided, 'Let's change that. Let's call that "consumer research", because this doesn't sound like you're doing market research'. Even then, this didn't work. This was still too uncomfortable for some people within the company. So we ended up saying, 'Well, let's just call it "design research", because it starts with the word "design" and we're the designers', and we would kind of own that. It wasn't common. It was really quite a struggle through the '80s to convince companies, or convince everyone within a company, that we had to go out in the field and talk to people, and watch people and look at people. That being said, we did some of it so we had

some very early successes doing that, but this way of designing wasn't the norm in the field of design at the time.

Dr Gjoko Muratovski

You have been through this whole process, and you have witnessed how the whole design industry is changing and evolving. From the position where you are sitting right now, how do you see the future of design? How do you see future changes happening? Where do you think the field of design is going? What do you think we should expect is going to happen? We've come quite a long way in a reasonably short amount of time as a profession, but where are we going?

Dr Dan Formosa

It's interesting if you think about the full spectrum of design research. It's going to include biomechanics, ergonomics, physical issues, cognitive issues, physiology and social issues; there's a whole spectrum of topics that would entail design research. So it's a whole pie. What most design research is relegated to is a small slice of that pie, which often is a slice of the pie that's easiest to do, or that companies feel like they are comfortable with. The problem is that there are not enough psychologists in design, or anthropologists, or biomechanics experts, or people who really can fill that entire pie of design research.

Another thing that is interesting though is that companies are realizing that they are no longer in charge of their brands. They are no longer in charge of the messaging of their products. The way people buy products is no longer based on a 'top-down' advertising model. Companies used to control the media. They used to be in print ads, television ads; they were telling us what they make and what we need – but that is not the case anymore. We now own the media. When you go out and buy products, you don't look at companies' websites: you go to Amazon, or you watch the Food Channel, or you go to discussion groups. You are now the media. If something doesn't work, you tell people, you warn people, but you also go to that as a resource. Companies are now realizing this, even though this has gone on for some time – but companies tend to react slowly, or at least it seems that way. Now they're realizing they need five-star reviews, and they don't want any one-stars because those one-stars carry a lot of weight. When you go to Amazon and you see lots of five-star reviews and you see a couple of one-star reviews, which ones do you read? The one-star reviews, right? So those people who are having trouble or difficulties using a product or a service carry a lot of weight; they're very influential in purchases. So now companies are realizing they need to design for everybody. They don't want those one-star reviews: they have a negative effect. Therefore they're coming to design firms for more and more design research. However, most of what they will explain in the design brief is the portion of design research that is closest to what they know. They very rarely come in and say we need a biomechanics study, or a task analysis, or a psychology study, or perception study on our products. They would say, 'We need you to talk to our consumers'. So we get interviews, and questions and answers, and surveys in design research; but there's still a huge opportunity to fill out that entire pie.

Dr Gjoko Muratovski

How do you normally conduct your field tests and your field research?

Dr Dan Formosa

It depends on the product. There's no specific way to do it: there's a lot of user observation, which helps; there's a lot of task analysis, which could be biomechanics analysis if it's a physical product; it could also be perception or usability analysis. We

usually start out with building physical shapes. We don't do a lot of sketching.

Dr Gjoko Muratovski
You mean, you start making prototypes early in the design process?

Dr Dan Formosa
Yes. We rarely ever do sketches in design, which is often seen as the traditional design approach. We've always done what we call 3D sketches. We'll take something out of cardboard or buy a product, and cut them in half or modify it because it helps us to have the physical thing in front of us. And very early on we'll either do our own simulations, or we'll show it to people and watch people use the prototype. Basically, we work with people, but as individuals – never in a group. We usually work one-on-one because you get much better information that way. And very often we'll look at people. If it's a physical product like something for the home, or the kitchen, or the yard or for gardening, we'll observe people in these environments. We'll also look at people who'll have difficulties in performing certain tasks because of problems with vision or arthritis, let's say.

A couple of weeks ago, I was telling you about my idea of talking to blind people about design. And I was saying that if this was the late 1970s, and if I sat in front of a group of designers and said, 'I want to go talk to a bunch of blind people about design', I would just be laughed at. Don't ask me how I know this, but I would be laughed at. The same was true through the 1980s. If you said, 'I want to talk to people who are blind, about design' by the late 1980s, you'd still get laughed at, but the laughs may not be as loud. By the late 1990s, this was more like giggles. But now, I can sit in front of a group of designers, like here today, and say, 'Blind people know a lot about design', and everyone will get it. All product designers today understand that every click, every motion, every beep, every radius, every little

detent on a knob… everything makes a difference when you can't see. Today, you don't need to talk to blind people because you're designing products that are exclusive to them; you do that because you want to understand usability better, and that's a pretty good test. We also do that if we're designing handheld products. We look at people who have arthritis because they're our 'litmus test'. They're really sensitive to any sort of unfortunate design elements that we may create. So if you design something that will work for people who have some physical difficulties, or vision difficulties or whatever, you pretty much know you've got it. You pretty much know you nailed it if it works for those extreme groups.

Dr Gjoko Muratovski
Would you say you are a believer in 'universal design' principles, or do you have another position on this issue?

Dr Dan Formosa
Yeah, you know, I never use the term 'universal design' unless I want to be searched on a website, because 'universal design' means different things to different people.

Dr Gjoko Muratovski
I know, and there has been a lot of controversy over the issue in the past decade or so as well, in terms of accepting or rejecting the whole idea of universal design on an ideological level.

Dr Dan Formosa
Yeah, so when we started, the idea of design for everybody was more about eliminating segregation. The idea of designing for 18–34 year olds was what we've always heard when we were given design briefs: it was a form of segregation. So what you're doing is you're eliminating people through design. You are alienating people. If you change the type on the newspaper, you don't have to touch the person to

disable them. The term 'to be able' or 'disabled', 'included' or 'not included', really depends on the environment, and really the designers are the ones who define this issue. In that case, with that thought process, designers have a great influence on people's health and well-being, because we decide who's in and who's out.

Dr Gjoko Muratovski

The issue of segregation goes beyond identifying a particular target group of users for which you are designing. The idea of target groups is a typically western, capitalist approach. From a Soviet, socialist design perspective, for example, target groups were non-existent in the design brief. And this was seen as an ideological position of the time. I have studied design in many countries around the world, and I also studied industrial design in Eastern Europe, where all my lecturers were Soviet-era designers. For them, a good designer was one able to design products that would be used by everyone, regardless of age, gender, background or geographical location. This is a very utopian idea and a very challenging thing to do. In return, the end result was rarely aesthetically pleasant due to the extraordinary amount of constraints that needed to be taken into consideration, but the design process was nevertheless very rigorous. Like yourself, I also studied ergonomics, and the interesting thing for me was that we've had to work with the '2 percentile' rule in mind. The principle was always to exclude the top 2 and bottom 2 per cent of the population, because those were the two extremes that would need customized designs made especially for them – meaning people that are abnormally tall or short, or have special needs. This also corresponds with the 'Neufert' architectural standards – German design principles that I was trained in while I was studying interior and furniture design back in Europe. All these standards were based on the average person, and for us this was the 'golden' standard. But you have a different approach to this, do you?

Dr Dan Formosa

When I was in design school it was always the 5th and 95th percentile rule for us. So what that means is that you design for the 90 per cent in the middle, and you can eliminate or not think about the rest. But that's one in ten people. So, by that logic, even in this group there'll be at least ten or twelve people that we're not designing for, just in this room alone.

Dr Gjoko Muratovski

What do you think that you can learn from these extreme ends of the population? Do you think we can get information that will potentially be revolutionary in terms of how we change certain things when we design?

Dr Dan Formosa

Yes. Working for them can be very informative, you know; it triggers a lot of ideas. Often, there's not that much information – at least to me – in the middle of the population. But you can find a lot of information at the edges. For example, if you have a product and you identify the fastest and slowest person getting a grasp of this product, you will get a great deal of information from them. For example, you can learn what makes the fastest person fast, and why the slowest person is slow at working out this product. Understanding both of them can be a lot more interesting than understanding the person right in the middle. You can't really learn much from an average person on how you can improve the design. In other words, I'm not a big fan of the average person. I never design for the average person. I don't like the average person. And this makes me popular at parties. [Laughs]

Dr Gjoko Muratovski

I agree with you on this. Throughout the years I have learnt that there is no one way to look at design, and that design is an ever-changing and ever-evolving field that can provide us with infinite possibilities and alternatives if we keep our minds open.

Dr Dan Formosa

Yeah. And as you know, it's actually hard to find the average person. They don't exist, right? I never warmed to the idea of the average person, because it didn't seem like a real person. It seemed like you're imaginary friend, you know. Same thing with the development of 'personas' as a design research method. Does anybody here use personas? I can never warm to personas – it's just an imaginary person.

Dr Gjoko Muratovski

Yeah, I never picked the personas as part of research either. I know that they are quite popular in many design circles, but I think that there is a very limited possibility for using personas. I find them more useful for design direction, like when it comes to certain types of branding or in terms of creative direction for lifestyle magazines. *Cosmopolitan,* for example, uses that approach. But I am with you here: I don't think that you can learn anything from an imaginary person.

Dr Dan Formosa

I've never been to a design presentation where the design group said, 'I designed this for my persona. But when I sold it to my persona, my persona thought it sucked'. You never hear that right?

Dr Gjoko Muratovski

Exactly! I think that most designers create personas around their designs as a way of justifying what they do, rather than to really challenge themselves by studying a real person that is peculiar, capricious and doesn't respond twice in the same manner.

Dr Dan Formosa

Yes. The persona always loves everything you do; it's an artificial person. There are 7 billion people in the world: you don't need to make one up. There are plenty of people out there – go out and find a few. If you do that, if you find some people and design for them, you'll find that it's (1) interesting and (2) not that easy. Designing for 10,000 people is really easy. Designing for 10 people that you actually know is really difficult. If you really want to innovate or understand problems and generate new answers, just find a handful of people that you know – and you can select them either randomly or strategically – and try to design for those people. Then you'll actually find some really interesting stories and anecdotes, quirks, and all sorts of very cool findings that can lead to either more innovations or just clever little design details.

Dr Gjoko Muratovski

I think that the new generation of designers will be part social scientists, part business entrepreneurs. It's interesting and exciting to see how we're changing and how we're looking for new possibilities and new opportunities as a profession. It's quite interesting to see how things change for us, and they are changing in a reasonably short amount of time. And probably in 50 years from now design will completely change again as a profession.

On another note, you also helped establish the world's first Masters in Branding. That's a big achievement, and this certainly reaffirms the notion of branding as a new emerging area, especially for designers. It just shows that design is becoming a broader field, and that we need to look at design from a different perspective than we are used to. This is most visible for designers that have come from a visual background, i.e. graphic designers, visual communication designers and communication designers. We can already see the tendencies in the profession where many graphic design agencies and studios reposition themselves as branding agencies. Many graphic designers have been rebadging themselves as branding specialists, even though this has been a field traditionally dominated by marketers. I've been having quite a lot of conversations with my colleagues from the Ehrenberg-Bass Institute for

Marketing Science on this issue, and we even held a branding debate together – 'Designers vs. Marketers' – where we discussed how we as designers can approach branding, and how marketers can do the same. It was quite interesting debate to have, because we do have these two divisions. Our position of branding comes more from the field of brand development, while their position comes more from the field of brand management. It's not a secret that we are always in a state of conflict with the marketers when it comes to branding.

So, I'm quite curious to know how you are working on bridging this gap at the School of Visual Arts in New York.

Dr Dan Formosa
The Masters in Branding program is also open to students that come from many different backgrounds, not only design. In fact, many of our students have no background in design at all. The diversity helps make the program interesting. We are in the third year of the program now, and this is really more of a business program than a design program. Actually, it's not a design program at all. The courses include things like brand valuation, the psychology of brands, the history of brands, the business of brands: it is full of brand junkies. The people who come in, the students, are totally into the idea of brands and a lot brand strategy, etc. My role in there is to talk about design, and make sure that the students understand design and design research – again, the full spectrum of design research that makes up a brand, not just the slice of the pie that has to do with the closest thing to market research. There is a fundamental difference between market research and design research, but many companies don't acknowledge that. As a matter of fact, a lot of design research has borrowed techniques from market research, which is kind of unfortunate – not because the market research is bad, but because it's one slice of that full pie of design research again. The course

is actually pretty fascinating in terms of the depth that it goes into in terms of brand development, brand equity, brand strategy, business, psychology and trend analysis; 'trend' in terms of giant world demographic trends – what's happening globally and what's happening locally. It's actually a really great course and the students are totally high energy, which is great. My course happens one semester, one night a week, so this is not a full-time gig, but it's very high energy.

Dr Gjoko Muratovski
Thanks for that, Dan. Let's open the floor for questions now. I am sure that our audience today would like to ask you few things.

Audience Question
Just on that course, it's obviously done in the US, so is there potential for that to go on an online format?

Dr Dan Formosa
No, we're thinking of doing executive programs. The course is in its third year, so we feel that it's under control. We're looking at executive programs or workshops or summer programs, things like that, that could involve people visiting New York. We could also take the show on the road, if that makes sense: to do it in other places in the country or round the world. But at this point you need to be there. The course goes the full year and it's pretty intense – it's a lot of work.

Audience Question
About a year ago, I saw this thing which was like a suit that doctors would wear in order to empathize with patients. It was a suit which made their fingers hurt. They couldn't touch anything; it was really hard to walk, hard to get up out of bed, that sort of thing. Like being in the shoes of an old person. I was really interested by that. I think it came out of Delft University of Technology. I was just wondering what sort of opportunities you see for that kind of thing for

designers. What's your view on changing behaviour with this kind of empathy role using designed devices and things like this?

Dr Dan Formosa

I think that really helps. It helps to meet people who have certain problems. One of the reasons that I avoid using the term 'universal design' is its connotations. If we go back to the hearing aids, there are as many younger people with hearing problems as there are older people (at least in the US), and it's the same thing with arthritis and vision problems. The reason is, if you look at the curve of the population, there are more young people in the population. So while your odds of having arthritis or hearing problems increase with age, there are more young people in the population, so that line is flatter than you would think. So designing for hearing problems or designing for arthritis helps as many younger people as older people. That's shocking to a lot of people unless you show them the statistics. That being said, getting back to your idea of simulating, this helps a lot. You should design things in the dark. Most people design things with the screen that's glowing and looking at them. Don't do that. Turn out the lights and design something, or put on glasses that make your eyes fuzzy, or put soap on your hands and try to use the product that you just designed.

Usually, my quick and easy advice if somebody is tinkering with mock-ups back in my office, and it's a physical thing like a kitchen item or something, I'd say use your opposite hand. So if you're right-handed, try to use it with your left hand, and before you do that, put soap all over it. It doesn't simulate arthritis exactly, but it'll tell you what's right and wrong about that design, and the balance and the leverage. It's revealing. So there are some simple things you can do to simulate issues. Also, it really helps to meet different people. And sometimes we just invite outside people to join the design team. We'll find people who have certain issues like back

problems or vision problems. We will talk to them not as subjects who we ask a lot of questions – and they're not designers necessarily – we'll just invite them on the team and we'll tell them our problems. We'll say, 'We've got this project and we've got to make it work… what would you do if you were us?' and they get into it. So we kind of extend our design team by bringing in prospective users within the team. We create a peripheral design team, if that makes sense, if that's a good way to describe it. We work by simulating things, understanding things and doing stuff to our own bodies to simulate problems. But also by getting to know people personally who may have specific physical issues. All that helps build a whole lot of empathy and understanding. It's also fun because we're doing it for people that we now know. We're not doing it for a faceless crowd on a bell curve: we're doing it for people who have names.

I will give you one example. I was working with a pharmaceutical company who was working on a very interesting medication for arthritis that was also extremely expensive. And they came to us with their information on their patients, their clinical studies with this drug, and they literally had over a thousand people in the UK that they'd tested this drug on. And they came in with all the data and they said, 'Here's our clinical studies of drugs'. While they were talking about all the people in their clinical study, I said, 'Can you name one?' and they said, 'What?' I said, 'Can you name one of those people? Do you know any of them?' and they go, 'No'. So we set out very early on to go meet people who had arthritis. They have lives, they have kitchens, they have families, and they have really interesting stories to tell. There was one guy, George, who was 64. He had arthritis and he just bought a Kawasaki 1600cc motorcycle. Now that's a big mother motorcycle. I said, 'George, why'd you get the motorcycle?' and he said, 'Well, if I don't get one now, when am I going to get one?' But that would not be the mindset of somebody who has significant arthritis, right? So clearly George's arthritis problems

are quite different to many other arthritis sufferers, yet he is lost in the average. You meet people and you get these anecdotes and stories, and it's really more interesting than what you see on those clinical studies where people are just reduced to statistics or numbers.

Dr Gjoko Muratovski

Dan, I like that you always have very interesting stories to share. It's a pleasure having you as a guest. Thank you for joining us today and for being a part of the agIdeas International Research Conference.

(Endnotes)

1. Editor's note: Please see the chapter by Elaine Saunders, Jessica Taft and David Jenkinson in this volume for a detailed reference on this project.

Acknowledgements

The Organizers
Dr Ken Cato, AO
President
Design Foundation

Kristin McCourtie
Manager and Director
Design Foundation

Dr Gjoko Muratovski
Chairman
agIdeas International
Research Conference

Advisory Board
Co-chairs
University Distinguished
Professor Ken Friedman
Faculty of Design
Swinburne University of
Technology

Professor George Cairns
Head: School of
Management
RMIT University

Members
Professor Clive Barstow
Head: School of
Communications and Arts
Edith Cowan University

Professor Mark Burry
Director: Design Research
Institute
RMIT University

Professor Cees de Bont
Dean: School of Design
Hong Kong Polytechnic
University

Professor Zeger Degraeve
Dean: Melbourne Business
School
Dean: Faculty of Business
and Economics
The University of Melbourne

Professor Barbara de la
Harpe
Pro Vice-Chancellor and
Vice President: College of
Design and Social Context
RMIT University

Professor Mads Gaardboe
Head: School of Art,
Architecture and Design
University of South
Australia

Professor Gerda Gemser
School of Economics,
Finance and Marketing,
Design Research Institute
RMIT University

Dr Swee Mak
Director: Future
Manufacturing Flagship
CSIRO

Professor Shane Murray
Dean: Faculty of Art and
Design
Monash University

Research Professor Jenni
Romaniuk
Associate Director
(International): Ehrenberg-
Bass Institute for Marketing
Science
University of South
Australia

Review Panel
Dr Agustin Chevez
Bernaldo de Quiros
Lecturer and Researcher:
Interior Architecture
Faculty of Design
Swinburne University of
Technology

Professor Alan Whitfield
Director: National Institute
for Design Research
Swinburne University of
Technology

Professor Barbara de la
Harpe
Pro Vice-Chancellor and
Vice President: College of
Design and Social Context
RMIT University

Dr Caroline Barnes
Senior Lecturer:
Communication Design
Faculty of Design
Swinburne University of
Technology

Professor Cees de Bont
Dean: School of Design
Hong Kong Polytechnic
University

Dr Christopher Kueh
Senior Lecturer and
Research Leader: Design
School of Communications
and Arts
Edith Cowan University

Professor Clive Barstow
Head: School of
Communications and Arts
Faculty of Education and
Arts
Edith Cowan University

Professor Gerda Gemser
School of Economics,
Finance and Marketing,
Design Research Institute
RMIT University

Dr Gjoko Muratovski
Head: Communication
Design
Faculty of Design and
Creative Technologies
Auckland University of
Technology

Professor Göran Roos
Faculty of Design
Swinburne University

Professor George Cairns
Head: School of
Management
RMIT University

Dr Ian White
Senior Lecturer: Digital
Design
University of the Sunshine
Coast

Associate Professor James
McArdle
School of Communication
and Creative Arts
Deakin University

Research Professor Jenni
Romaniuk
Ehrenberg-Bass Institute
for Marketing Science
University of South
Australia

Dr Kathleen Connellan
Senior Lecturer: Design
History and Theory
University of South
Australia

Dr Keith Robertson
Senior Lecturer:
Communication Design
Swinburne University of
Technology

Professor Mads Gaardboe
Head: School of Art,
Architecture and Design
University of South
Australia

Dr Melis Senova
Managing Director: Design
and Strategy
Huddle Design

Dr Myra Thiessen
Lecturer: Visual
Communication Design
University of South
Australia

Professor Peter Murphy
Head: School of Creative
Arts and Social Aesthetics
James Cook University

Dr Robbie Napper
Lecturer and Course
Coordinator: Industrial
Design
Monash University

Professor Sam Bucolo
Design and Innovation
Research Centre
University of Technology
Sydney

Dr Shane Moon
Director
Inner Truth
Professor Shane Murray
Dean: Faculty of Art and
Design
Monash University

Dr Simone Taffe
Senior Lecturer:
Communication Design
Swinburne University of
Technology

Dr Sonja Pedell
Senior Lecturer: Digital
Media Design
Swinburne University of
Technology

Dr Stuart Medley
Senior Lecturer: Graphic
Design
Edith Cowan University

Dr Swee Mak
Director: Future
Manufacturing Flagship
CSIRO

Dr Yoko Akama
Senior Lecturer:
Communication Design
RMIT University

Professor Zeger Degraeve
Dean: Melbourne Business
School
Dean: Faculty of Business
and Economics
The University of Melbourne

Presented by
agIdeas
In association with
School of Design,
Swinburne University of
Technology

Strategic partner
School of Art and Design
Auckland University of
Technology

With support from
Design Matters
State Government Victoria

Venue Partner
Australian Centre for
Moving Image (ACMI)